RUSTY DUCK

The Top 100 Most Beautiful Rustic Vacations of North America

Ranches, Lodges, Cabins & More!
- Second Edition -

by Dusty Dave

RUSTY DUCK

PRESS

❖

The Top 100 Most Beautiful Rustic Vacations of North America
Ranches, Lodges, Cabins and More!
- Second Edition -
by Dusty Dave

Published by
RUSTY DUCK PRESS
Telluride, Colorado U.S.A.

ISBN 0-9741537-1-0

Library of Congress Control Number: 2005935838

———◆———

———◆———

Book design & layout: ICE Design (www.ICEdesign.com)

Cover photo: Alta Lakes Observatory - Telluride, CO - by Dusty Dave

Back cover photo: Flying A Ranch - Pinedale, WY - by Dusty Dave

Direct all inquiries to: DustyDave@RusticVacations.com

Printed in Canada

———◆———

The information in this book is subject to change without notice.
The prices listed are only estimates and may vary greatly depending on the type of accommodations and activities you choose. We strongly recommend that you call ahead to verify everything before making reservations.

❖

ABOUT THIS BOOK

WHAT DOES RUSTIC MEAN?

The word "rustic" means a lot of different things to a lot of different people. The most important thing to realize about this book is that a "rustic" vacation does not necessarily mean sleeping bags and outhouses. On the contrary, almost all of the places in this book have comfortable beds, running water and indoor toilets. What "rustic" refers mostly to are cozy wooden cabins or lodges in remarkable forested settings! A typical rustic vacation spot that you are likely to find in this book goes something like this: A remote, backcountry log cabin on a crystal clear lake with a river-rock fireplace and nothing to do all day but go fishing, hiking, canoeing or relaxing on the porch with a good book. Sound good?

HOW WERE THESE PLACES CHOSEN?

First of all, it should be noted that none of the properties in this book have paid to be included. They were hand-picked by the author, Dusty Dave, based on a variety of important criteria, one of which is their extraordinarily beautiful wilderness surroundings. The author spends most of his time traveling all over the world in search of new and amazing rustic vacation destinations to add to his extensive online database (www.RusticVacations.com), which lists thousands of rustic ranches, lodges and cabins.

WHY TAKE A RUSTIC VACATION?

That's an easy one! Nothing revives the body and soul like spending time in the great outdoors. Clean, fresh mountain air and the soothing sound of a stream are the things that make life worth living. Whether you want to spend time with friends or family, everything is better when there are no annoyances such as cell phones or TVs.

WHEN IS THE BEST TIME TO GO?

NOW! Why wait? Life is way too short not to enjoy it. At least start planning a trip right away. You deserve it!

TABLE OF CONTENTS

3 ABOUT THIS BOOK: What does rustic mean? How were these places chosen?

6 RUSTIC IMAGES: Photos to get you in the mood: taken by the author, Dusty Dave

14 ALASKA
16 *Alaska* AFOGNAK WILDERNESS LODGE
18 *Alaska* BEAR TRACK INN
20 *Alaska* CARIBOU LODGE
22 *Alaska* REDOUBT MOUNTAIN LODGE
24 *Alaska* SADIE COVE WILDERNESS LODGE
26 *Alaska* WATERFALL RESORT

30 USA
32 *Arizona* PHANTOM RANCH
34 *Arizona* RANCHO DE LA OSA
36 *Arizona* TANQUE VERDE RANCH
38 *Arizona* WHITE STALLION RANCH
40 *California* ALISAL GUEST RANCH RESORT
42 *California* COSTANOA COASTAL LODGE & CAMP
44 *California* EVERGREEN LODGE
46 *California* HIGHLAND RANCH
48 *Colorado* ALTA LAKES OBSERVATORY
50 *Colorado* COLORADO CATTLE COMPANY
52 *Colorado* COULTER LAKE GUEST RANCH
54 *Colorado* DUNTON HOT SPRINGS
56 *Colorado* HIDDEN TREASURE YURTS
58 *Colorado* NORTH FORK RANCH
60 *Colorado* SMITH FORK RANCH
62 *Colorado* TARRYALL RIVER RANCH
64 *Colorado* WILDERNESS TRAILS RANCH
66 *Colorado* WIND RIVER RANCH
68 *Colorado* WIT'S END GUEST RANCH RESORT
70 *Idaho* 4D LONGHORN GUEST RANCH
72 *Idaho* INDIAN CREEK GUEST RANCH
74 *Idaho* SUN VALLEY TREKKING
76 *Idaho* TWIN PEAKS RANCH
78 *Maine* BIRCHES RESORT
80 *Maine* BRADFORD CAMPS
82 *Michigan* DOUBLE JJ RANCH RESORT
84 *Minnesota* GRAND VIEW LODGE
86 *Montana* 320 GUEST RANCH
88 *Montana* ABBOTT VALLEY HOMESTEAD
90 *Montana* AVERILL'S FLATHEAD LAKE LODGE
92 *Montana* ELKHORN RANCH
94 *Montana* PAPOOSE CREEK LODGE
96 *Montana* THE RESORT AT PAWS UP
98 *Montana* RYE CREEK LODGE
100 *Montana* SPERRY CHALET
102 *New Mexico* COW CREEK RANCH
104 *New Mexico* HACIENDA DEL CEREZO
106 *New Mexico* N BAR RANCH
108 *New York* CATSKILLS RETREAT CABIN
110 *New York* DRY ISLAND
112 *New York* ELK LAKE LODGE
114 *New York* LAKE PLACID LODGE
116 *New York* TIMBERLOCK
118 *North Carolina* TURNSTONE LOG CABINS
120 *Ohio* HEARTLAND COUNTRY RESORT
122 *Ohio* THE INN AT CEDAR FALLS
124 *Oklahoma* REBEL HILL RANCH
126 *Oregon* LAKE OF THE WOODS RESORT
128 *Oregon* OLALLIE LAKE RESORT

130	*Oregon*	OUT 'N' ABOUT TREESORT
132	*Oregon*	WEASKU INN
134	*Pennsylvania*	WEATHERBURY FARM
136	*Texas*	LAJITAS, THE ULTIMATE HIDEOUT
138	*Texas*	PIPE CREEK RANCH
140	*Utah*	THE LODGE AT RED RIVER RANCH
142	*Utah*	SORREL RIVER RANCH RESORT
144	*Vermont*	MOOSE MEADOW LODGE
146	*Virginia*	THREE SISTERS LOG CABIN
148	*Washington*	GUEST HOUSE LOG COTTAGES
150	*Washington*	MOUNTAIN SPRINGS LODGE
152	*Wisconsin*	JUSTIN TRAILS RESORT
154	*Wyoming*	FLYING A RANCH
156	*Wyoming*	THE HIDEOUT AT FLITNER RANCH
158	*Wyoming*	LAZY L & B RANCH
160	*Wyoming*	TRAIL CREEK RANCH B & B
164	CANADA	
166	*Alberta*	ALPINE VILLAGE
168	*Alberta*	THE FAIRMONT JASPER PARK LODGE
170	*Alberta*	HOLIDAY ON HORSEBACK
172	*Alberta*	PARADISE LODGE & BUNGALOWS
174	*British Columbia*	AMISKWI LODGE
176	*British Columbia*	BLACKFISH LODGE
178	*British Columbia*	CRAZY BEAR LAKE LODGE
180	*British Columbia*	ECHO VALLEY RANCH & SPA
182	*British Columbia*	GOLDEN ALPINE HOLIDAYS
184	*British Columbia*	ISLAND LAKE LODGE
186	*British Columbia*	KING PACIFIC LODGE
188	*British Columbia*	KING SALMON RESORT
190	*British Columbia*	KOOTENAY EXPERIENCE, YMIR YURTS
192	*British Columbia*	NATURE TRAILS WILDERNESS LODGE
194	*British Columbia*	PITT RIVER LODGE
196	*British Columbia*	PURCELL MOUNTAIN LODGE
198	*British Columbia*	SORCERER LODGE
200	*British Columbia*	STRATHCONA PARK LODGE
202	*British Columbia*	THREE BARS RANCH
204	*Quebec*	FAIRMONT KENAUK AT LE CHATEAU MONTEBELLO
206	*Saskatchewan*	FOREST HOUSE ECO-LODGE
208	*Yukon Territory*	TINCUP WILDERNESS LODGE
210	*Yukon Territory*	WILDERNESS FISHING YUKON
214	MEXICO	
216	*Baja California*	RANCHO LA PUERTA
218	*Durango*	RANCHO EL DURANGUENO
220	*Jalisco*	HOTELITO DESCONOCIDO
222	*Jalisco*	VERANA
224	*Mexico State*	RANCHO LAS CASCADAS
226	*Quintana Roo*	AZULIK

230 S'MORES & MORE: Learn how to make the perfect s'more, plus learn fun word games!

231 HELPFUL HIKING TIPS: What to pack and what to do if you get lost

232 JOKES FOR THE KIDS: Funny stuff for the little ones

234 ADULT HUMOR: A good laugh for the older folks

236 GHOST STORIES & URBAN LEGENDS: Fun for the campfire

237 GIDDY-UP COWBOY!: What to bring to a ranch and how to look like a real cowboy

238 INDEX: Which places offer Horseback Riding, Canoeing, Children's Programs, etc.

240 PHOTO CREDITS: Who took what

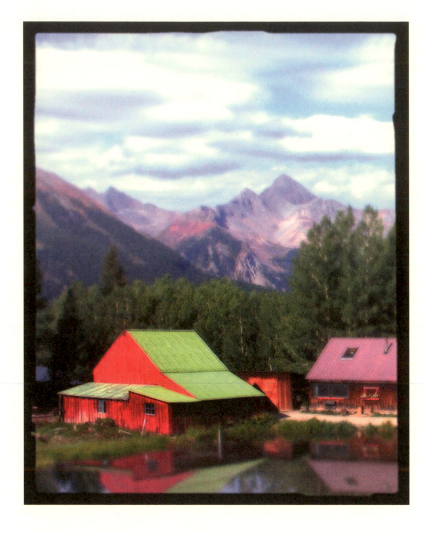

ALASKA

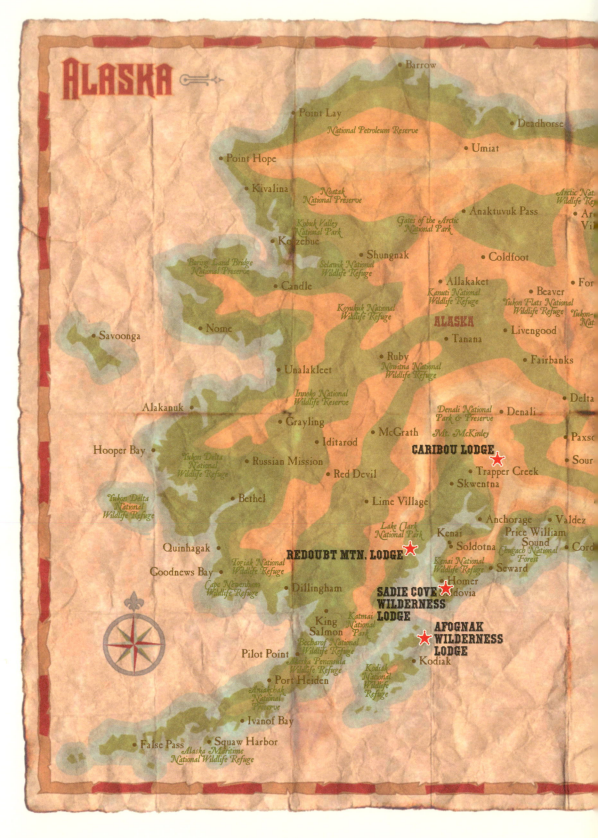

ALASKA

Barrow

Point Lay

National Petroleum Reserve

Deadhorse

Point Hope

Umiat

Kivalina

Noatak
National Preserve

Anaktuvuk Pass

Arctic Nat'l
Wildlife Ref.

Ar
Vil

Kobuk Valley
National Park

Gates of the Arctic
National Park

Kotzebue

Shungnak

Coldfoot

Bering Land Bridge
National Preserve

Selawik National
Wildlife Refuge

Candle

Allakaket

Kanuti National
Wildlife Refuge

Beaver

Yukon Flats National
Wildlife Refuge

For

Yukon-
Nat'l

Koyukuk National
Wildlife Refuge

ALASKA

Livengood

Savoonga

Nome

Tanana

Fairbanks

Ruby

Nowitna National
Wildlife Refuge

Unalakleet

Delta

Innoko National
Wildlife Reserve

Denali National
Park & Preserve

Denali

Alakanuk

Grayling

McGrath

Mt. McKinley

Paxso

Hooper Bay

Iditarod

CARIBOU LODGE ⭐

Sour

Yukon Delta
National
Wildlife Refuge

Russian Mission

Trapper Creek

Red Devil

Skwentna

Yukon Delta
National
Wildlife Refuge

Bethel

Lime Village

Anchorage

Valdez

Lake Clark
National Park

Kenai

Price William
Sound

Chugach National
Forest

Cord

Quinhagak

REDOUBT MTN. LODGE ⭐

Soldotna

Kenai National
Wildlife Refuge

Seward

Goodnews Bay

Togiak National
Wildlife Refuge

Cape Newenham
Wildlife Refuge

Dillingham

Homer
dovia ⭐

SADIE COVE
WILDERNESS
LODGE

King
Salmon

Katmai
National
Park

AFOGNAK ⭐
WILDERNESS
LODGE

Pilot Point

Becharof National
Wildlife Refuge

Alaska Peninsula
Wildlife Refuge

Kodiak

Kodiak
National
Wildlife
Refuge

Port Heiden

Aniakchak
National
Preserve

Ivanof Bay

False Pass

Squaw Harbor

Alaska Maritime
National Wildlife Refuge

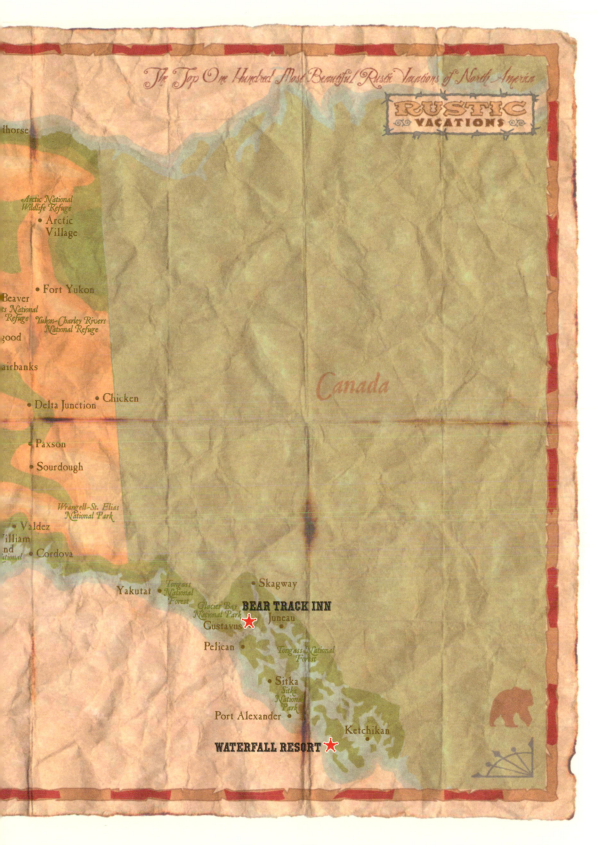

The Top One Hundred Most Beautiful Rustic Vacations of North America

RUSTIC VACATIONS

ihorse

Arctic National Wildlife Refuge
• Arctic Village

Beaver
National Refuge

• Fort Yukon

Yukon-Charley Rivers National Refuge

good

airbanks

• Delta Junction • Chicken

• Paxson

• Sourdough

Wrangell-St. Elias National Park

• Valdez

illiam
nd
ational • Cordova

Yakutat *Tongass National Forest* • Skagway

Glacier Bay National Park **BEAR TRACK INN**
Gustavus ★ Juneau

Pelican • *Tongass National Forest*

• Sitka
Sitka National Park

Port Alexander •

Ketchikan •

WATERFALL RESORT ★

Canada

Afognak Wilderness Lodge

Afognak Island / Kodiak
Alaska, USA

ACTIVITIES: Fishing, hiking, kayaking, beach combing, wildlife viewing & photography

PHONE: 800-478-6442 or 907-486-6442
WEB: www.AfognakLodge.com
CAPACITY: 12 people: 3 cabins, each with 2 bedrooms
OPEN: Mid May to late September, no minimum stay

RATES: Around $700 per person per day (half price for kids). Includes meals, fishing gear, boats & professional guides

LOCATION: Anchorage to Kodiak to Afognak

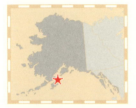

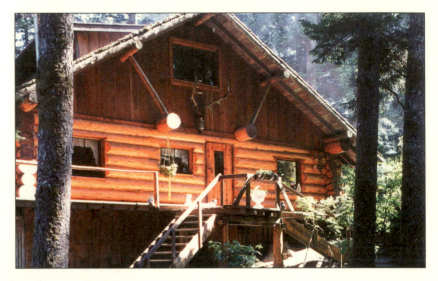

Anyone who is serious about fishing and wildlife viewing has almost certainly heard of the world-famous Kodiak Islands. Afognak Island is one of the most coveted in this chain.

Nowhere else will you find such a varied array of fishing opportunities. You can throw your line in for numerous freshwater or saltwater fish including sockeye salmon, pink salmon, silver salmon, rainbow trout, steelhead, Dolly Varden, giant halibut, flounder, red snapper, lingcod, sea bass and greenling.

Afognak is a photographer's dream. Awaiting your camera is a wide spectrum of wildlife including the famous Kodiak brown bear, assorted sea mammals, soaring bald eagles and comical puffins. If that's not enough excitement, you can spend the rest of your day kayaking, hiking or beach combing.

There are three, spacious log cabins nestled where the edge of the virgin forest meets the tranquil waters of a protected cove. At *Afognak Lodge* you can play hard, eat big and sleep deep!

Bear Track Inn

Gustavus
Alaska, USA

ACTIVITIES: Fishing, hiking, kayaking, flight-seeing, whale watching & glacier cruises

PHONE: 888-697-2284 or 907-697-3017
WEB: www.BearTrackInn.com
CAPACITY: 35 people: 14 rooms, each with 2 queen beds
OPEN: May through August, no minimum stay

RATES: Around $300-$400 per person per day. Includes meals & transportation to the lodge from Juneau

LOCATION: 85 miles from Juneau

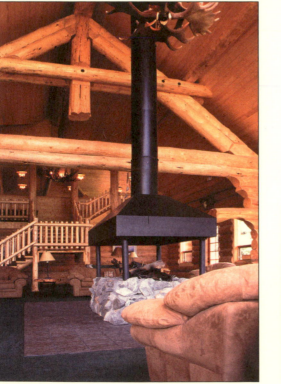

Hidden away in mystical Gustavus, Alaska, and surrounded by the pristine Glacier Bay National Park, the *Bear Track Inn* is a full-fledged, rustic, backwoods lodge. But don't let their remoteness fool you: They offer the finest food and service imaginable. There are 14 spacious guest rooms, each with private baths and two queen size beds. The lobby, stretching 30 feet from floor to ceiling, is the focal point of the inn, which offers inspiring views of streams, wildlife, the mountains and Icy Strait.

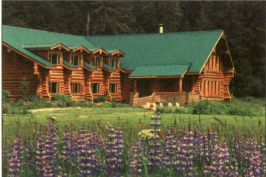

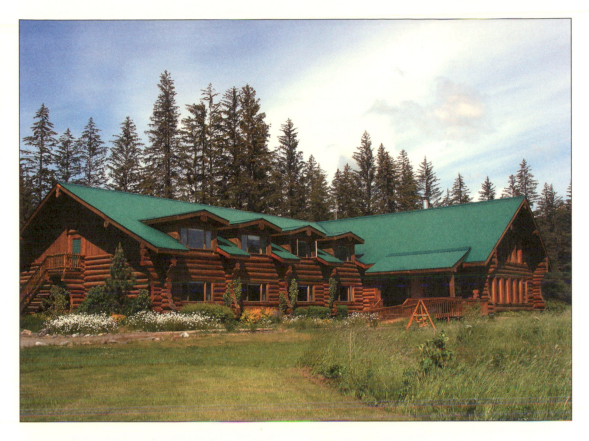

Fishermen, get ready. The area offers unlimited fishing for pink, silver, sockeye and chum salmon, halibut, Dolly Varden, cutthroat and steelhead. But they're not just a fishing lodge! You will have the option of a glacier tour or a whale-watching adventure, or you can hike into Glacier Bay National Park and see waterfalls, bears, moose or wolves. Of course, you could just as easily hang out at the lodge in front of the fireplace in one of their overstuffed suede couches.

Caribou Lodge

Talkeetna
Alaska, USA

ACTIVITIES: Hiking, backpacking, canoeing, dogsledding, snowshoeing & cross-country skiing

PHONE: 907-733-2163
WEB: www.CaribouLodgeAlaska.com
CAPACITY: 10 people: 4 rustic cabins
OPEN: Year-Round, 2 night minimum stay

RATES: Around $300 per person per day. Includes meals & guided hiking. Winter rates include daily, guided dogsled tours

LOCATION: 1 hour float-plane ride from Anchorage

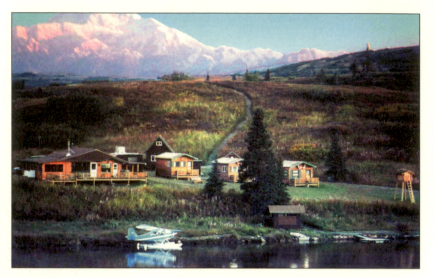

Looking for an extremely beautiful, secluded destination that offers year-round activities and is only accessible by float-plane? There is such a place, and it's called *Caribou Lodge*. This private paradise is located at timberline on an extremely remote lake in the Talkeetna Mountains just southeast of Denali National Park. Wildlife abounds here. Caribou, moose, grizzlies, black bears, wolves, coyotes, otters, eagles and Canadian geese are frequently observed from the comfort of the lodge.

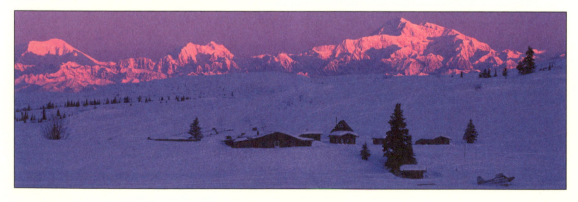

The cabins are comfy and cozy, with a centrally located shower-house and sauna. Delicious meals are served family-style in the lodge, highlighted by their sourdough pancakes and biscuits.

Activities abound, with excellent hiking and backpacking to nearby lakes, streams and beaver ponds. Less strenuous activities include gold panning, fishing or leisurely walks through the wildflowers. Winter is just as amazing with cross-country skiing, dogsledding, snowshoeing and the opportunity to view the northern lights.

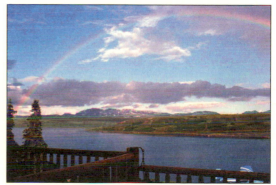

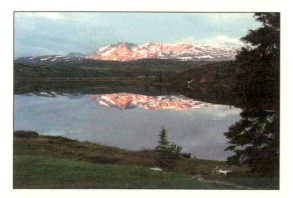

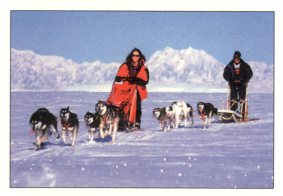

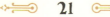

Redoubt Mountain Lodge

Crescent Lake
Alaska, USA

ACTIVITIES: Hiking, backpacking, fishing, sea kayaking & wildlife viewing

PHONE: 866-733-3034 or 907-733-3034
WEB: www.RedoubtLodge.com
CAPACITY: 10 people: 5 private cabins
OPEN: Summer only, 3 night minimum stay

RATES: Around $450 per person per day. Includes meals, guided fishing & all fishing gear

LOCATION: 1 hour plane ride (around $250) from Kenai or Anchorage

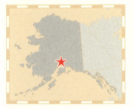

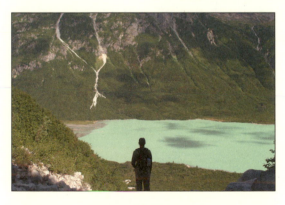

Without a question, Alaska is the last frontier, and *Redoubt Mountain Lodge* is one of the top backcountry lodges in Alaska. This fly-in-only adventure and fishing lodge offers everything you could possibly want and more in a wilderness vacation. Located in the heart of Lake Clark National Park on beautiful Crescent Lake in the Northern Aleutian Range, it is the Mecca for fishing and wildlife viewing. This is also the home to bear, moose, wolves, otter, beaver, mink and marten.

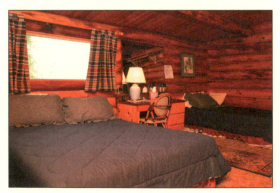

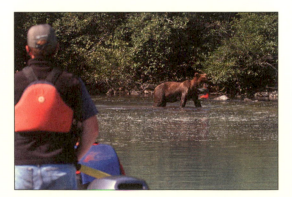

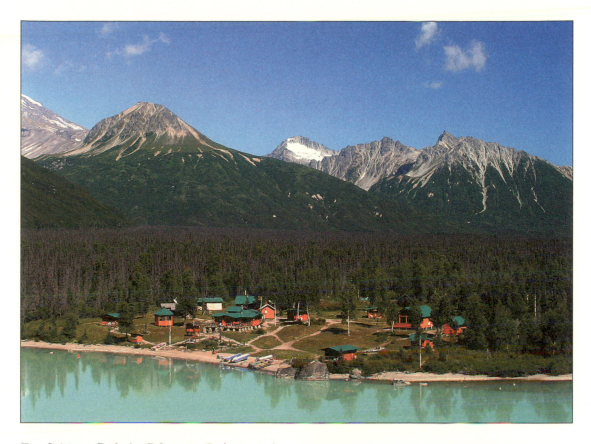

For fishing, *Redoubt Mountain Lodge* can't be matched. You will have the rare opportunity of catching kings, sockeye, coho, native lake trout, Dolly Varden and arctic char. If that's not enough, you can take a fly-out for kings and rainbow trout.

The main lodge and five guest cabins are situated on the only private acreage within a 25-mile radius. There's a common, screened-in gazebo with a hot tub for relaxing, in addition to private baths in each cabin.

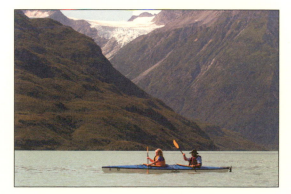

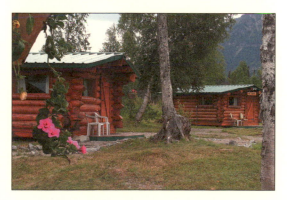

Sadie Cove Wilderness Lodge

Sadie Cove
Alaska, USA

ACTIVITIES: Hiking, sea kayaking, river rafting, fishing, bear viewing & clamming

PHONE: 888-283-7234 or 907-235-2350
WEB: www.SadieCove.com
CAPACITY: 10 people: 5 private cabins
OPEN: Year-Round, 2 night minimum stay

RATES: Around $300-$350 per person per day. Includes meals & use of kayaks

LOCATION: 30 minute water taxi ride from Homer ($75 round-trip)

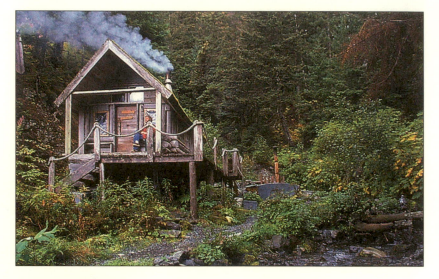

Custom built in the seventies from driftwood that was milled by hand, Alaska's *Sadie Cove Wilderness Lodge* is accessible only by boat, float-plane or helicopter. This environmentally friendly eco-lodge is run completely on a non-polluting alternative energy system of wind and hydro power. Full of character in every aspect, the atmosphere at *Sadie Cove* is laid back and peaceful, yet still very adventurous. Bear viewing, sea kayaking and glacier touring are just a few of the things that will keep you busy.

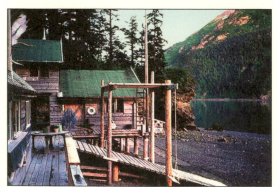

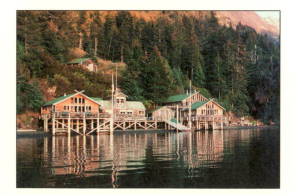

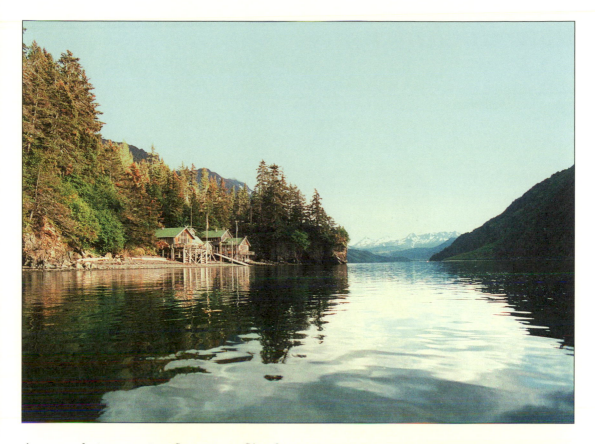

Accommodations consist of a variety of hand-crafted, rustic wooden cabins located between the dramatic vertical peaks of Sadie Fjord. Complete with running water, bathrooms and electricity, these cabins have everything you need for a very comfortable stay. Two of the cabins even have wood-burning fireplaces. There's also a dry-docked (not on the water) sailboat cabin, which has a working cast-iron fireplace, bathroom and outside deck. There's a creekside sauna and bath house for relaxing.

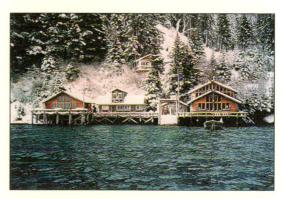

Waterfall Resort

Ketchikan
Alaska, USA

ACTIVITIES: Fishing for salmon, halibut, lingcod & wildlife viewing: puffins, sea lions & whales

PHONE: 800-544-5125
WEB: www.WaterfallResort.com
CAPACITY: 84 people: cottage or lodge accommodations
OPEN: June through October, 3 night minimum stay

RATES: Around $3,500 per person for 4 days. Includes meals, guided fishing & float-plane ride from Ketchikan to the resort

LOCATION: On Prince of Wales Island

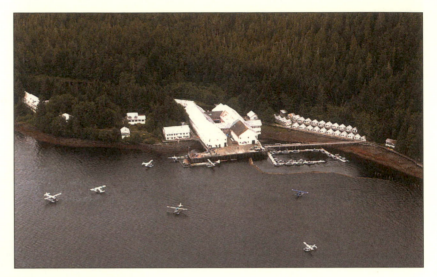

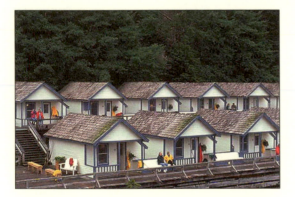

Your unforgettable journey begins with a breathtaking flight aboard a float-plane that takes you over the unspoiled Tongass National Forest and into the richest fishing grounds in North America. No other resort in Alaska offers such a rich blend of wilderness beauty, civilized pleasure and historic heritage. This amazing resort attracts anglers of all skill levels from around the world for the staggering number of trophy-size salmon, halibut and lingcod that return each season.

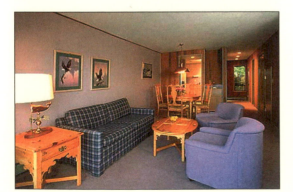

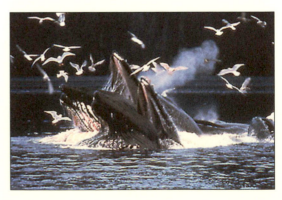

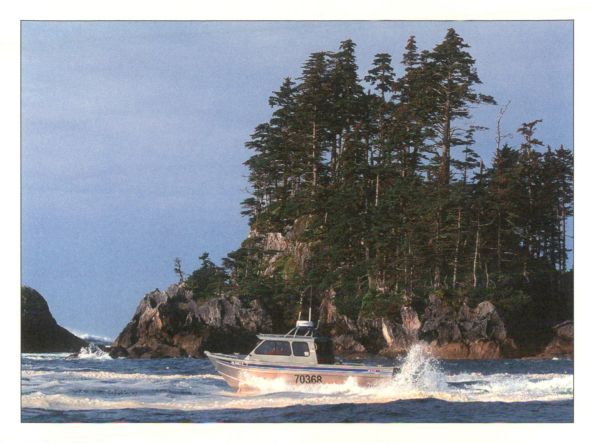

At *Waterfall Resort*, nature surrounds you. As you explore, don't be surprised to see a whale suddenly breech, shattering the silence as it splashes back into the water.

But it's not just the location that makes *Waterfall Resort* so special. They go the extra mile to provide their clients with state-of-the-art Almar cabin cruisers along with four-star Alaskan cuisine and accommodations, custom seafood processing and a one-to-one guest-to-staff ratio.

UNITED STATES

Contiguous Forty-eight

UNITED STATES

GUEST HOUSE LOG COTTAGES

MOUNTAIN SPRINGS LODGE

SPERRY CHALET

ABBOTT VALLEY HOMESTEAD

OLALLIE LAKE RESORT

AVERILL'S FLATHEAD LAKE LODGE

THE RESORT AT PAWS UP

WEASKU INN

INDIAN CREEK GUEST RANCH

RYE CREEK LODGE

ELKHORN RANCH

OUT 'N' ABOUT TREESORT

LAKE OF THE WOODS RESORT

TWIN PEAKS RANCH

4D LONGHORN RANCH

320 GUEST RANCH

HIDEOUT AT FLITNER RANCH

PAPOOSE CREEK LODGE

LAZY L & B RANCH

SUN VALLEY TREKKING

FLYING A RANCH

HIGHLAND RANCH

TRAIL CREEK RANCH

HIDDEN TREASURE YURTS

COLORADO CATTLE COMPANY

EVERGREEN LODGE

COULTER LAKE GUEST RANCH

COSTANOA

SMITH FORK RANCH

WIND RIVER RANCH

ALISAL GUEST RANCH

SORREL RIVER RANCH

NORTH FORK RANCH

LODGE AT RED RIVER RANCH

TARRYALL RIVER RANCH

ALTA LAKES OBSERVATORY

DUNTON HOT SPRINGS

WILDERNESS TRAILS RANCH

PHANTOM RANCH

WIT'S END GUEST RANCH

RANCHO TEMESCAL

HACIENDA DEL CEREZO

N BAR RANCH

COW CREEK RANCH

WHITE STALLION RANCH

TANQUE VERDE RANCH

RANCHO DE LA OSA GUEST RANCH

PIPE CREEK RANCH

LAJITAS, THE ULTIMATE HIDEOUT

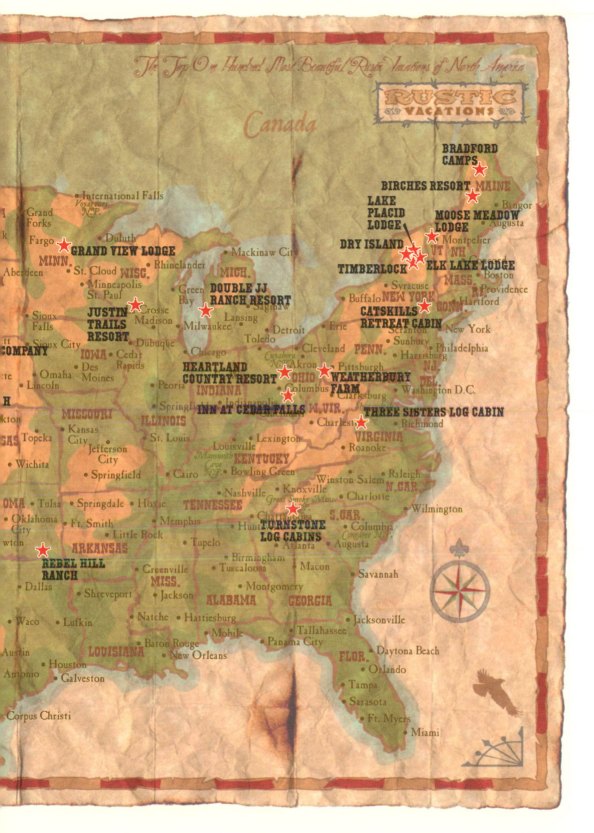

Phantom Ranch

ACTIVITIES: Wildlife viewing, rafting & hiking (the 1.5 mile "Bridge Loop" is an excellent trail)

PHONE: 888-297-2757 or 928-638-2631
WEB: www.GrandCanyonLodges.com
CAPACITY: 50 people: several cabins & dorm rooms
OPEN: Year-Round, no minimum stay

RATES: Around $400 per person for the overnight mule trip. Includes meals. $40 per person if you hike down & stay in the dorm

LOCATION: At the bottom of the Canyon, South Rim

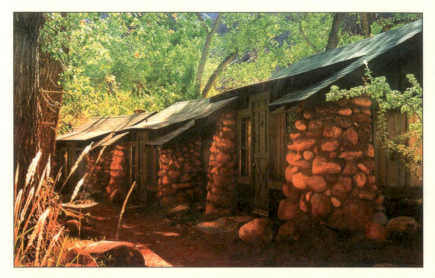

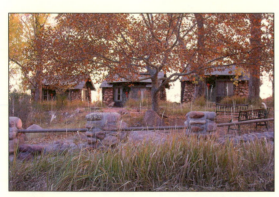

The famous *Phantom Ranch* is at the very bottom of the Grand Canyon and can be reached one of three ways: by foot, river rafting or on top of a mule. The mule trip is probably the most memorable option and certainly one of the most popular. Reservations need to be made at least eight months in advance. The mule trip includes lunch, dinner, an overnight stay and breakfast the next morning. The ride down is about ten miles and takes about six hours. The ride back is about seven miles and takes about five hours.

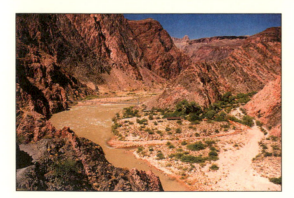

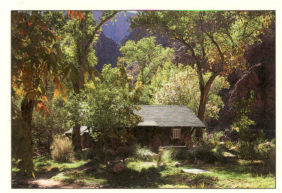

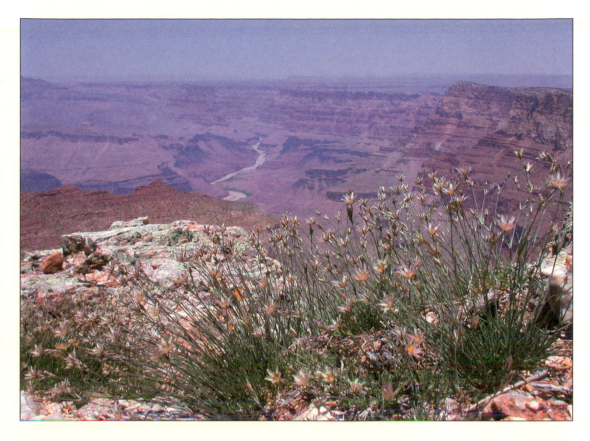

Accommodations at the ranch consist of cabins for the overnight mule trips and dorms for backpackers. Each of the cabins has bunk beds, linens, cold running water, towels and a toilet. Showers are at a central location. The dorms, which are separate for men and women, have bunk beds, a shower and a restroom. Meals are available if reserved in advance and there is a small store for purchasing beverages and sundries. No matter which option you decide on to get to the ranch, it will be the trip of a lifetime!

Rancho de la Osa

ACTIVITIES: Horseback riding, mountain biking, swimming, croquet, boccie & cooking classes

PHONE: 800-872-6240 or 520-823-4257
WEB: www.RanchoDeLaOsa.com
CAPACITY: 36 people: 18 Spanish-style rooms
OPEN: Year-Round, except August, 3 night minimum

RATES: Around $350 per person per day. Includes meals & all scheduled ranch activities

LOCATION: Near the Mexican border, 75 miles (2 hours) from Tucson

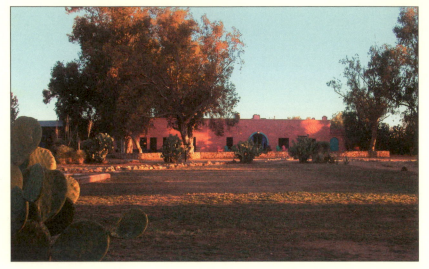

Bordering the Buenos Aires National Wildlife Refuge and nestled among towering eucalyptus trees, *Rancho de la Osa* is one of the last great Spanish haciendas still standing in America. Here you can experience the history and gracious lifestyle of the Old Southwest. A warm, comfortable feeling emanates from the brightly colored adobe walls, rustic wood furniture and friendly folk. The buildings date back to before the Mexican Revolution. Not only was the infamous Pancho Villa said to have fired shots at the Hacienda, but you can hold in your hands a Mexican cannonball that was found lodged in one of its walls.

Modern day *Rancho de la Osa* is much less hectic than in olden days. Today they appreciate a more relaxed way of life, where napping is considered an activity. Other pastimes include amazingly scenic horseback rides through dense forests of blooming cacti and even the unique opportunity of taking a southwestern-fusion cooking class. Just make sure to be back at the ranch by six for cocktails in the cantina.

In the late 17th Century, Father Eusebio Francisco Kino and his followers built a mission outpost on the ranch. This building was used for more than a century as a center to trade with the local Indians and Mexicans. The rare and historic adobe structure (reputed to be the oldest building in Arizona) still serves as a peaceful gathering place for guests to relax and mingle.

Rancho de la Osa is part of the original three-million-acre land grant from the king of Spain to the Ortiz brothers of Mexico in 1812. When the Gadsden Purchase was signed in 1854, the ranch fell within U.S. borders, and shortly afterward, cattle baron Colonel William Sturges began renovations on the main house and made the structure the center of his massive ranching empire.

Today, *Rancho de la Osa* invites guests to share in their fabled history while giving them the opportunity to create their own memories. It is a magical place that has transformed visitors for many years and it will continue to do so for many more to come.

Tanque Verde Ranch

Tucson
Arizona, USA

ACTIVITIES: Horseback riding, mountain biking, fishing, tennis, basketball, volleyball & swimming

PHONE: 800-234-3833 or 520-296-6275
WEB: www.TanqueVerdeRanch.com
CAPACITY: 150 people: 74 rooms & suites
OPEN: Year-Round, no minimum stay

RATES: Around $300-$400 per person per day. Includes meals & all ranch activities

LOCATION: Just outside Tucson, about 2 hours south of Phoenix

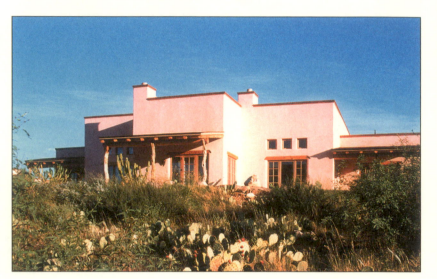

For one of the best guest ranch vacations that the beautiful Sonoran desert has to offer, head on out to Tucson, Arizona, and visit the amazing *Tanque Verde Ranch*. Here you will have the perfect opportunity to enjoy the best of a classic dude ranch along with the added features of a Southwestern resort and spa. Perfect for singles, couples or families, you will enjoy the scenic desert vistas on relaxing horseback rides. With over 150 horses, you are sure to find one that is just right for you.

The ranch's fully supervised children's program provides a fantastic experience for kids of all ages. The program offers horseback riding, tennis, swimming, nature programs and crafts classes. Parents can also choose to go on rides with their kids if they wish.

Situated on 640 acres in the foothills of the Rincon and the Catalina Mountains between the Coronado National Forest and the Saguaro National Park, *Tanque Verde Ranch* is an oasis of relaxation in a spectacular southwest setting.

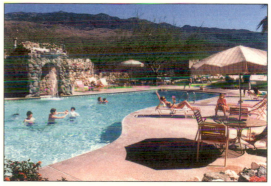

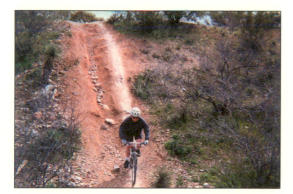

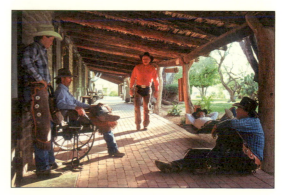

White Stallion Ranch

Tucson
Arizona, USA

ACTIVITIES: Horseback riding, hiking, basketball, tennis, volleyball, ping pong & horseshoes

PHONE: 888-977-2624 or 520-297-0252
WEB: www.WSRanch.com
CAPACITY: 75 people: 41 casitas
OPEN: September to mid June, 4 night minimum stay

RATES: Around $200 per person per day. Includes meals, riding, all ranch activities & Tucson airport transfers

LOCATION: 120 miles (2 hours) south of Phoenix

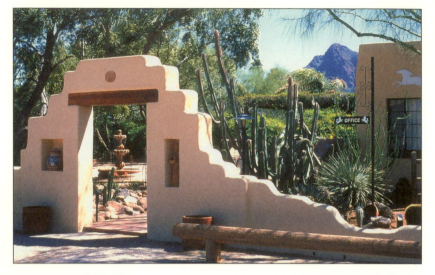

As you are riding through a forest of flowering Saguaro cacti, passing various lizards sunning themselves on hot rocks and listening to the cry of a hawk, you will feel like you are in the opening scene of an old Western. At the foot of the rugged Tucson Mountains, adjacent to the Saguaro National Park, is the *White Stallion Ranch.* This working cattle ranch has perfectly blended all the traditions of the southwestern cowboy with the comforts of a top resort. Your time here will be one of pure relaxation.

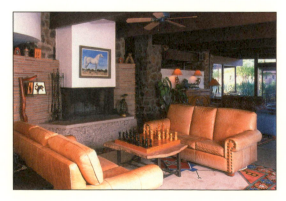

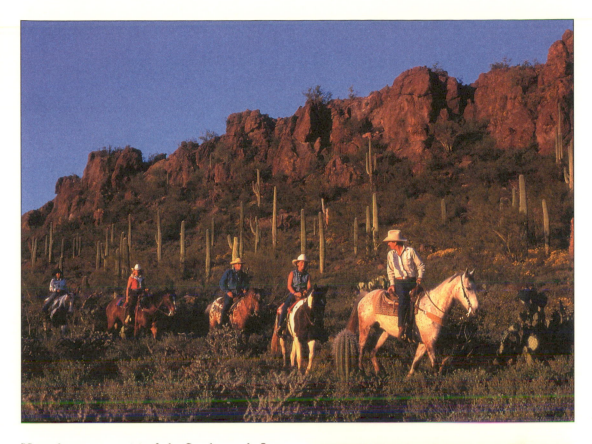

If you have never visited the Southwest before, chances are, you will be pleasantly surprised. There are thousands of amazing plants and animals that are unique to this area of the United States. The sweet smell of mesquite in the air after an early morning rain is something everyone should experience.

Also, if you prefer petting horses to riding them, don't worry, the ranch also offers tennis, basketball, volleyball, horseshoes and soaking in the hot tub. The kids will love the petting zoo!

Alisal Guest Ranch Resort

Solvang
California, USA

ACTIVITIES: Horseback riding, golfing, tennis, boating & fishing on their private lake

PHONE: 888-4ALISAL or 805-688-6411
WEB: www.Alisal.com
CAPACITY: 300 people: 73 units
OPEN: Year-Round, 2 night minimum stay

RATES: Around $500-$600 per couple per day. Includes meals & various resort activities

LOCATION: Santa Ynez Valley, 35 miles from Santa Barbara

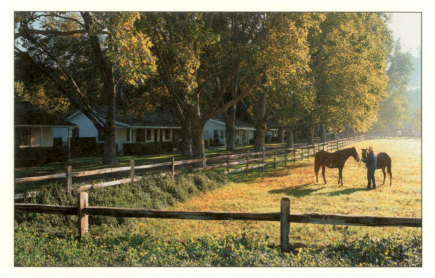

Enjoy rustic luxury at its finest, California-style. With 10,000 scenic acres of rolling hills in the Santa Ynez Valley, you will have plenty of elbow room to get your game on. Tennis buffs will love their seven top-notch tennis courts. Golfers will be in heaven on their two championship courses and everyone will appreciate *Alisal's* 100-acre private lake, where you can enjoy fishing or boating at your leisure. Then there's the amazing horseback riding with their string of more than 100 horses.

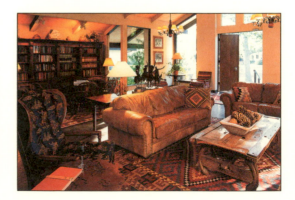

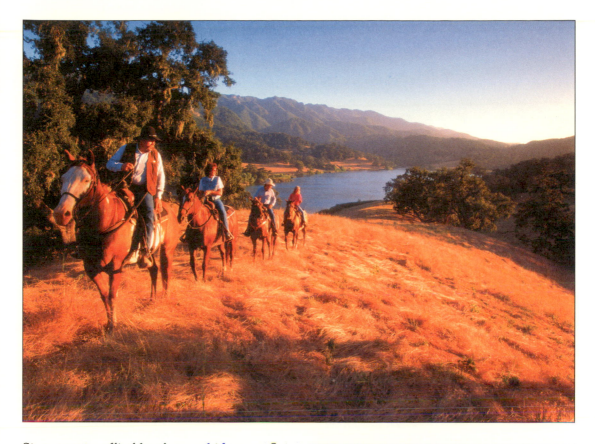

Since 1946, *Alisal* has been a hideaway for the outdoor enthusiast who doesn't necessarily want to rough it. There are a variety of different room options that range from spacious studios to very luxurious two-room suites. All rooms are free of telephones and televisions and offer wood-burning fireplaces, high-beamed ceilings, charming covered porches and a genuine sense of comfort. There is just the right amount of rusticness to remind you that, yes, you are at a ranch.

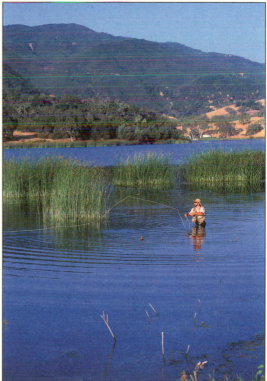

Costanoa Coastal Lodge & Camp

Pescadero
California, USA

ACTIVITIES: Hiking, biking, kayaking, windsurfing, bird watching, horseback riding & yoga

PHONE: 877-262-7848
WEB: www.Costanoa.com
CAPACITY: 300 people: 40 lodge rooms & 112 cabins
OPEN: Year-Round, no minimum stay

RATES: Around $250 per lodge room per day, $200 per cabin per day & $150 per canvas cabin per day

LOCATION: 55 miles from San Francisco, 25 miles from Santa Cruz

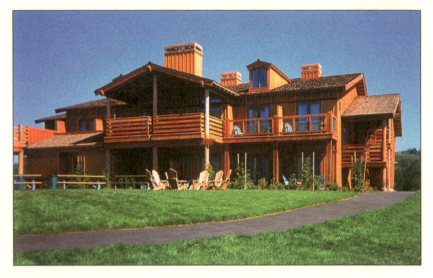

Costanoa's 40 acres of green grass and thick trees is an outdoor lover's oasis. Conveniently located just an hour from San Francisco, their beautiful undisturbed shores and rolling coastal hills await you. It is adjacent to four state parks, a wildlife reserve and 30,000 acres of foot trails. To the south is the nation's largest elephant seal reserve. To the east stand the majestic redwoods of Big Basin State Park. And to the north, the lighthouse at Pigeon Point towers gracefully.

The eco-friendly luxury camp and lodge features 40 lodge rooms, 12 cabins and 100 canvas cabins designed to offer a wilderness experience with hotel amenities. You can even pitch your own tent if you want to really rough it. Amenities and bathroom facilities vary depending on the type of accommodation you choose.

The activity list is long, but most involve the great outdoors with the coastal location in mind. Choose from relaxing yoga weekends, hiking, biking or guided kayak expeditions.

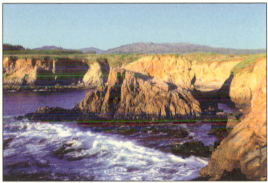

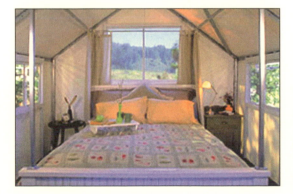

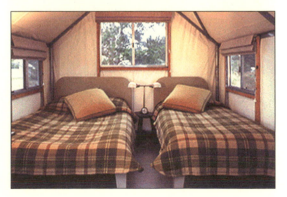

Evergreen Lodge

Yosemite
California, USA

ACTIVITIES: Hiking, biking, fly-fishing, rafting & sightseeing tours. Rentals: bikes, snowshoes & GPS units

PHONE: 800-93-LODGE or 209-379-2606
WEB: www.EvergreenLodge.com
CAPACITY: 200 people: 66 cabins (2-6 guests each)
OPEN: Year-Round, 2 night minimum stay (seasonal)

RATES: Around $100-$250 per cabin per day. Meals can be purchased in the main lodge

LOCATION: 3.5 hours from San Francisco, 1 mile from Yosemite National Park

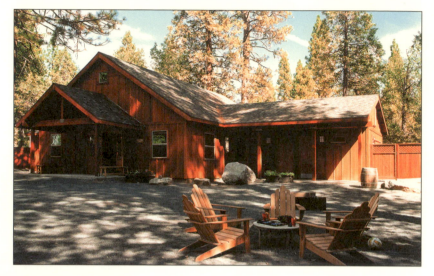

Just one mile from the western border of the spectacular Yosemite National Park, *Evergreen Lodge* is the perfect base for the family vacation you have always talked about. Nestled in the tall pines on the way to Hetch Hetchy Valley, you will be ideally located to explore the wonders of Yosemite Valley, including Half Dome, El Capitan and Yosemite Falls, as well as the splendor of Yosemite's high country and Tuolumne Meadows. Explore on your own, or try one of *Evergreen's* many guided trips.

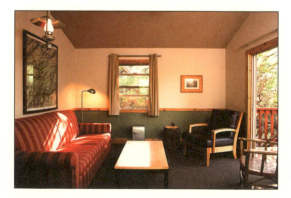

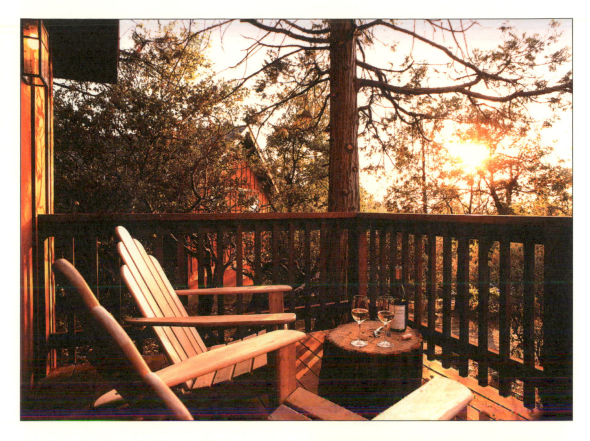

The historic main lodge houses their restaurant and tavern, which is the heart and soul of the property. *Evergreen's* recreation center, complete with an indoor/outdoor fireplace, is the perfect place to play games, make s'mores or plan the next day's hike. Nightly complimentary activities include campfires, movies and live music.

The cabins are very comfortable, with spacious bathrooms, private decks and ceiling fans. For serenity's sake, there are no phones or televisions in the cabins.

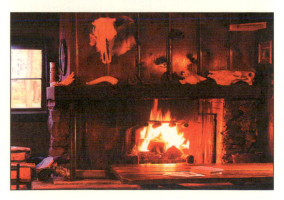

Highland Ranch

Philo
California, USA

ACTIVITIES: Horseback riding, fishing, hiking, swimming, tennis, yoga & trapshooting

PHONE: 707-895-3600
WEB: www.HighlandRanch.com
CAPACITY: 25 people: 8 private cabins
OPEN: Year-Round, 2 night minimum stay

RATES: Around $300 per person per day (less for kids). Includes meals, drinks & most activities. Pets & horses are allowed

LOCATION: 122 miles north of San Francisco

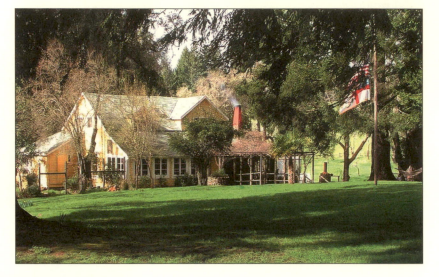

Just a couple hours from San Francisco is one of the country's best-kept secrets: *Highland Ranch*. Here, you will be able to go hiking or horseback riding through some of the most magnificent forests of towering redwoods on earth. Although your body may feel physically dwarfed, your heart and soul will soar. They also offer many other fantastic activities including tennis, yoga and trapshooting. And, if this still isn't enough, there are several lakes on the property for fishing and swimming.

There are eight cozy cabins with wonderful wood-burning fireplaces. Each has a private bathroom and redwood deck with rocking chairs at the ready. There's even a healthy supply of good books, just in case you forgot yours at home. One of the signature amenities at the ranch are the numerous hammocks that are scattered around the property. Don't be surprised to find yourself spending countless hours of quality time enjoying the peacefulness that these outdoor napping stations offer.

Alta Lakes Observatory

ACTIVITIES: Hiking, mountain biking, fishing, skiing, snowshoeing & snowmobiling

PHONE: 970-728-4645
WEB: www.AltaLakes.com
CAPACITY: 16 people: 3 sleeping rooms (1 private room)
OPEN: Year-Round, no minimum stay

RATES: Around $400 per day for the entire lodge (multi-night rates are available).
Pets are allowed

LOCATION: 30 minute drive from Telluride

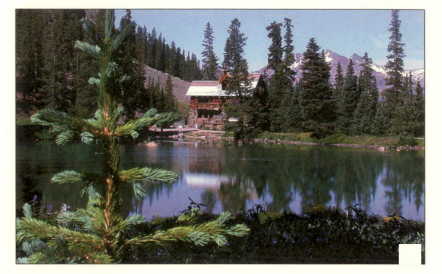

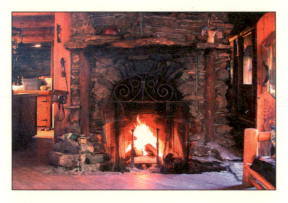

Alta Lakes Observatory is absolutely amazing! Situated on its own little lake, high up in the mountains, you will pinch yourself marveling that somewhere like this actually exists. Remote enough to feel like you and your friends are the only ones for hundreds of miles, it is actually only a short drive (partially on a rough dirt road) from the quaint resort town of Telluride. In the winter, it is a tad bit more challenging to get to. Access is only possible by ski, snowshoe, snowcat or snowmobile.

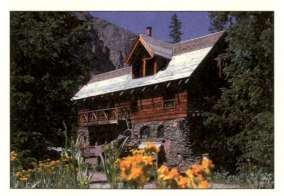

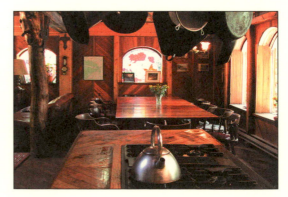

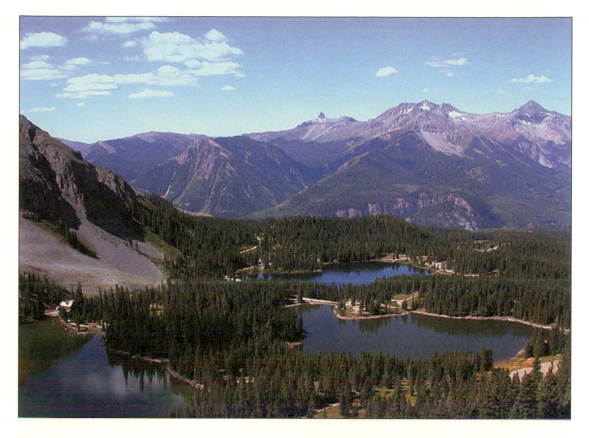

The lodge is a unique blend of old and new, handcrafted with wood and stone. A beautiful rock fireplace dominates the living room while an extra-deep hot tub and sauna stand at the ready to soothe those tired muscles. The lodge also has a fully-equipped kitchen, so remember to bring some food and your cooking skills.

Out the front door, you will find unlimited hiking, biking, canoeing, fishing and skiing. In addition, you can arrange horseback riding, Jeep tours and snowmobiling through local outfitters.

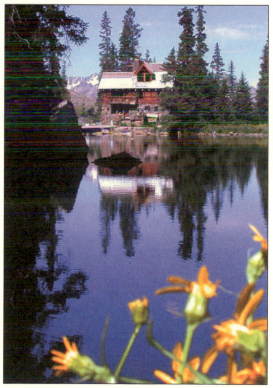

Colorado Cattle Company

New Raymer
Colorado, USA

ACTIVITIES: Horseback riding, cattle drives & real ranch work, such as gathering & sorting cattle

PHONE: 970-437-5345
WEB: www.ColoradoCattleCompany.com
CAPACITY: 20 adults: children under 18 are not allowed
OPEN: Mid April through October, 3 night minimum stay

RATES: Around $300 per person per day. Includes meals & all ranch activities. Pets & horses are allowed

LOCATION: 110 miles (2.5 hours) from Denver

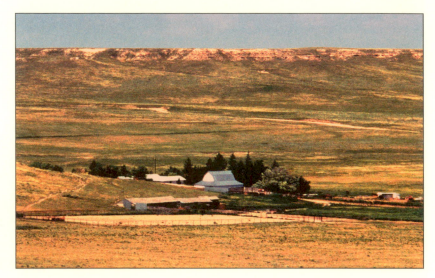

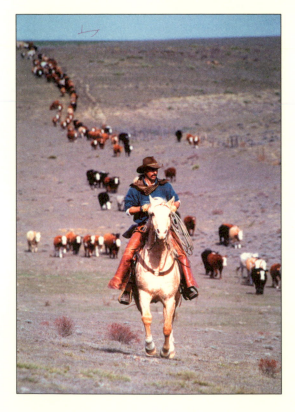

Not to be confused with a dude ranch, the *Colorado Cattle Company* is a real working cattle ranch with 8,000 acres of land and 700 head of cattle. You won't be riding nose to tail here: Instead, you might find yourself riding full throttle on the open range while chasing down a rogue cow. Additional ranch work that may need help getting done includes mending fences, gathering cattle, driving cattle, doctoring sicks, branding calves, or any of a million other things that can just come up out of the blue.

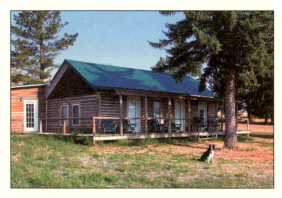

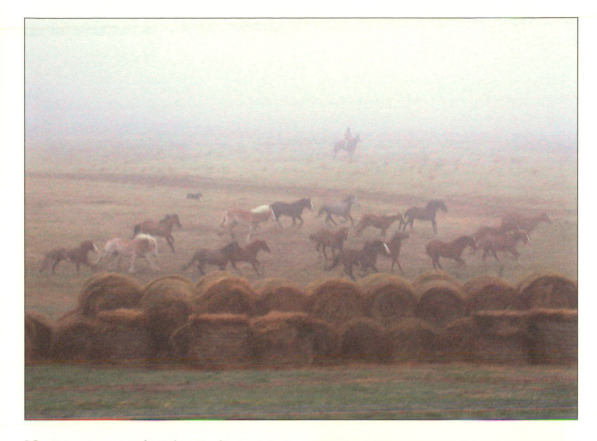

Not to worry, you don't have to be an expert rider to go to this ranch. In fact, they accept people that have never been on a horse before. Once you arrive, you choose the level of participation that you are comfortable with.

The accommodations are a big step up from a bunkhouse. They have five clean, comfortable and cozy cabins, all with private baths, front porches and fantastic views of the never-ending rolling hills. You may come as a guest, but you'll leave as a cowboy.

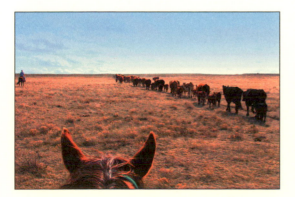

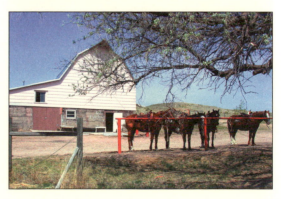

Coulter Lake Guest Ranch

Rifle
Colorado, USA

ACTIVITIES: Horseback riding, pack trips, fly-fishing, hiking, swimming, skiing & snowshoeing

PHONE: 800-858-3046 or 970-625-1473
WEB: www.CoulterLake.com
CAPACITY: 30 people; several log cabins
OPEN: Year-Round, 3 night minimum stay

RATES: Around $225 per person per day (less for kids). Includes meals & ranch activities

LOCATION: 21 miles northeast of Rifle, 62 miles from Grand Junction

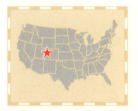

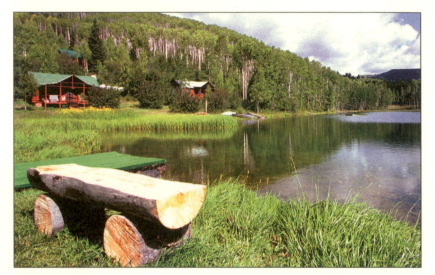

Nestled in the beautiful White River National Forest, *Coulter Lake Guest Ranch* offers some of Colorado's most spectacular mountain scenery. Crystal clear streams and meadows of wildflowers beyond description will make your stay absolutely unforgettable. At 8,000 feet, the days are warm while the nights are cool. Ideal temperatures for relaxing afternoon horseback rides or refreshing dips in the lake. The evenings are often filled with roasting marshmallows around a crackling campfire.

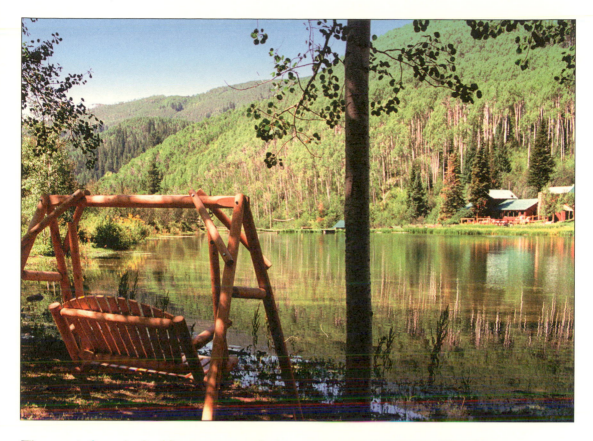

The scenic horseback rides are unmatched. Rugged mountain trails, overnight pack trips and evening dinner rides may just entice you to leave your job, head for the hills and become a real cowboy. For the kids, the ranch offers a great children's program. Your little cowpokes will be so busy doing all kinds of fun stuff that a return trip to the ranch is almost guaranteed. Other exciting activities include fly-fishing, swimming, snowmobiling, cross-country skiing and snowshoeing.

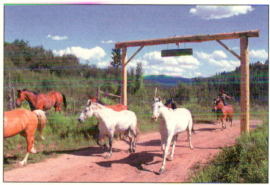

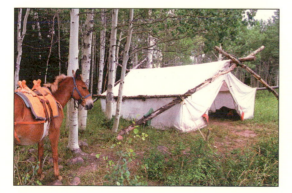

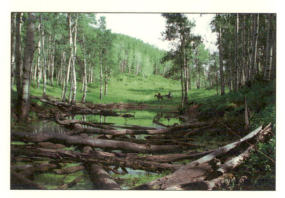

Dunton Hot Springs

Dolores
Colorado, USA

ACTIVITIES: Soaking in hot springs, massages, fly-fishing, hiking, heli-skiing & snowshoeing

PHONE: 970-882-4800
WEB: www.DuntonHotSprings.com
CAPACITY: 24 people: 11 cabins & 1 teepee
OPEN: Year-Round; minimum stays may be required

RATES: Around $275-$450 per person per day (kids are half price). Includes meals & use of hot springs

LOCATION: 32 miles (1.5 hours) from Telluride, 68 miles from Durango

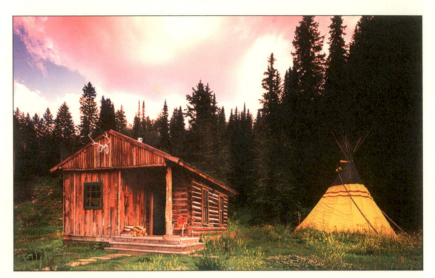

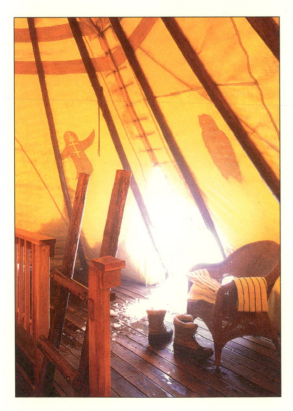

Located in Southwest Colorado's San Juan Mountains, *Dunton Hot Springs* is a spectacular 400-acre private town that is surrounded by two national forests. There are hundreds of miles of wilderness and over one thousand miles of trails. Guests can hike, snowshoe or heli-ski, but what really sets *Dunton* apart is its amazing hot springs and spa treatments. They have the best in holistic and therapeutic healing techniques, including Trager Therapy and hot rocks massage.

Dunton Hot Springs is truly one of the most beautiful rustic vacation getaways in the world. The stunning 19th Century hand-hewn log buildings are perfectly contrasted to the luxuriously rustic interiors. Each of the guest cabins has been restored by local and Native American craftsmen who specialize in traditional building techniques. No two are alike, and each bears an individual character and history. Adding to the uniqueness, one cabin even has a direct feed from the geothermal hot springs.

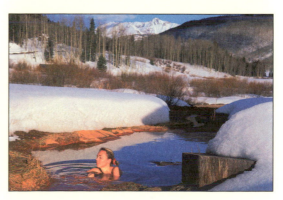

Hidden Treasure Yurts

Eagle
Colorado, USA

ACTIVITIES: Alpine hiking, mountain biking, wildlife viewing, backcountry skiing & snowshoeing

PHONE: 800-444-2813
WEB: www.Backcountry-Colorado-Yurt.com
CAPACITY: 16 people: 8 people in each of 2 yurts
OPEN: Year-Round, no minimum stay

RATES: Around $175-$200 per yurt per day

LOCATION: 1 hour's drive on a rough dirt road from Eagle. Winter: 6-mile ski or snowshoe trek from nearby Yeoman State Park

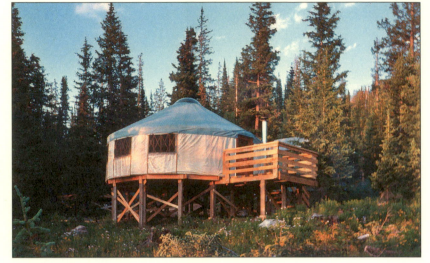

A yurt gives you all the fun of camping in a tent with all the conveniences of a cabin. A stay at *Hidden Treasure Yurts* will remind you of your days as a kid when you were at summer camp. You will love the simplicity and soon realize the excesses of life at home. There are two yurts, each of which can comfortably hold up to eight people. Be assured that your group, no matter what size, has exclusive use of your yurt during your stay. There are bunk beds, cooking facilities, and both a wood-burning and propane stove.

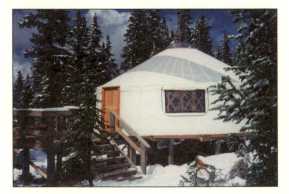

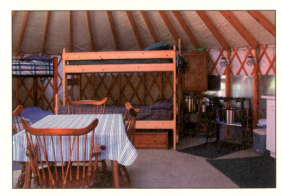

Getting to the yurts is an adventure in itself. In the summer, you can drive right to the door if you have the right vehicle. In the winter, however, you will need to ski or snowshoe in. Don't worry, there are well-marked trails, and the six-mile trip adds to the excitement.

At 11,200 feet, the yurts offer a treasure trove of activities in a serene, natural setting. Summer is great for alpine hiking and mountain biking, while the winter lends itself to backcountry skiing and snowshoeing.

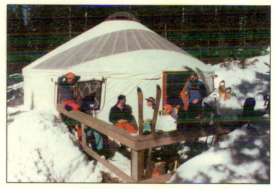

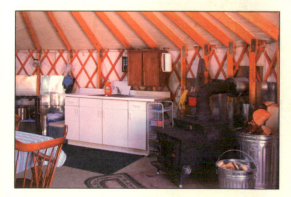

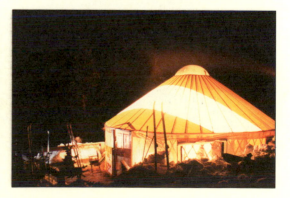

North Fork Ranch

Shawnee
Colorado, USA

ACTIVITIES: Horseback riding, overnight pack trips, whitewater rafting & fly-fishing

PHONE: 800-843-7895 or 303-838-9873
WEB: www.NorthForkRanch.com
CAPACITY: 35 people: 6 lodge rooms & 3 family cabins
OPEN: June through August; 3, 5 & 7 day packages

RATES: Around $300 per adult per day (less for kids 12 & under). Includes meals & all ranch activities

LOCATION: 52 miles (1 hour) southwest of Denver

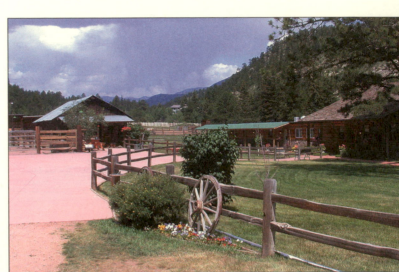

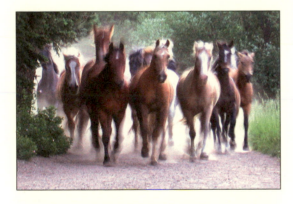

Imagine a place with beautiful log buildings, top-notch horses, professional wranglers, amazing food (really amazing food) and thick forests in every direction: that's the *North Fork Ranch*. Perfectly situated on the north fork of the South Platte River, the whole place is so darn scenic that it doesn't seem real. They have a fantastic covered porch off the back of the main lodge where you can relax with a cold drink, listen to country music and watch the river rush by.

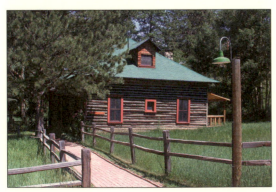

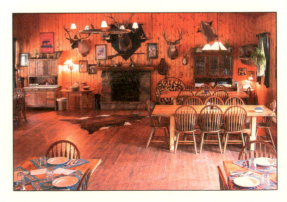

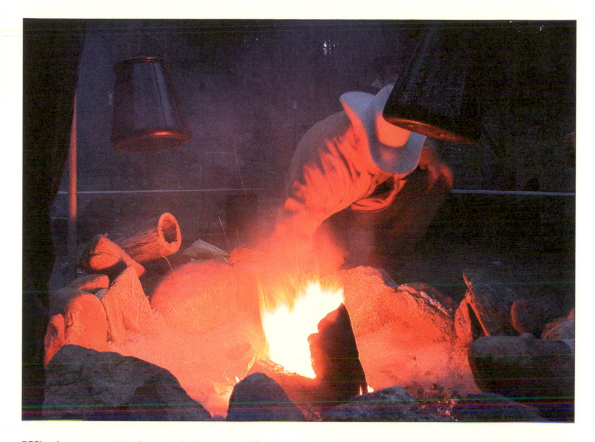

Whether you visit the ranch by yourself, as a couple, or with a large group, they have the facilities to accommodate every situation. In addition to three large family cabins, they offer six rooms in the main lodge, each with its own private bath.

The activities are absolutely fantastic. Between horseback riding, fly-fishing, whitewater rafting and overnight pack trips, you can't go wrong! The ranch also has a special family program for children of all ages, including infants.

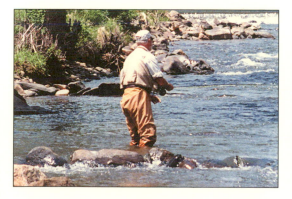

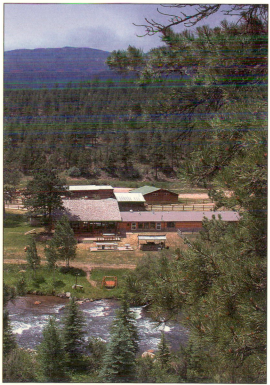

Smith Fork Ranch

Crawford
Colorado, USA

ACTIVITIES: Horseback riding, winery tours & fishing (private trout ponds & the Gunnison River)

PHONE: 970-921-3454
WEB: www.SmithForkRanch.com
CAPACITY: 26 people: 4 private cabins & a guest lodge
OPEN: Year-Round, 3 night minimum stay

RATES: Around $450 per person per day. Includes meals & all ranch-based activities

LOCATION: 55 miles from Montrose, 250 miles (5 hours) from Denver

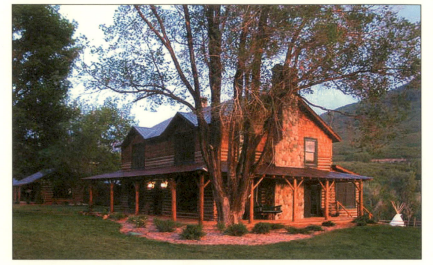

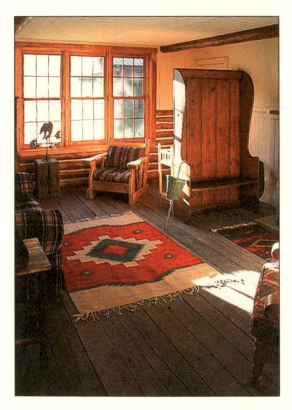

What is the ideal ranch vacation? Maybe it's sitting around a campfire watching the sun go down and listening to a story about how the West was won. Or, maybe it's seeing a herd of elk glide across a flower-filled meadow. Or, maybe it's both! Memories like these don't happen in the city, but they do happen at the *Smith Fork Ranch*. This spectacular ranch is located within the beautiful Gunnison National Forest and adjoins the wild, untamed West Elk Wilderness Area.

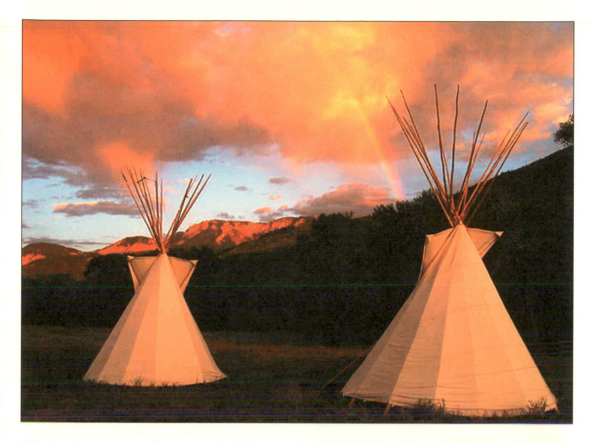

The ranch property and its surrounding areas are home to beautiful mountains, abundant rivers, high mountain lakes and breathtaking views. The ranch itself has nearly three miles of frontage along the Smith Fork of the Gunnison River, in addition to seven trout ponds.

All of the original buildings on *Smith Fork Ranch* were built by hand between 1890 and 1950. The guest lodge, private cabins, cookhouse and the old elk lodge have all been beautifully restored and refurbished.

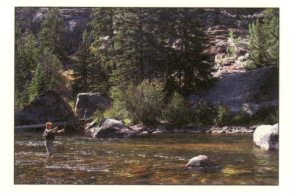

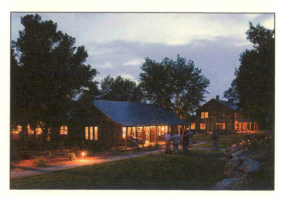

Tarryall River Ranch

Lake George
Colorado, USA

ACTIVITIES: Horseback riding, hiking, fishing, swimming, pack trips & river rafting

PHONE: 800-408-8407 or 719-748-1214
WEB: www.TarryallRiverRanch.com
CAPACITY: 36 people: private cabins or lodge rooms
OPEN: Mid May to mid September, 1 week minimum stay

RATES: Around $1,500 per person per week. Includes meals & all on-site ranch activities

LOCATION: 110 miles (2 hours) from Denver, 1 hour from Colorado Springs

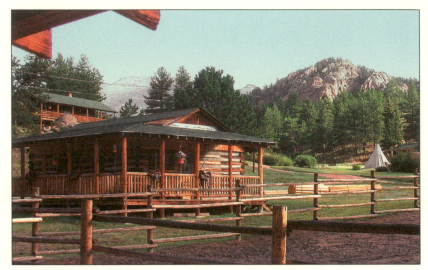

The rock formations are as stunning as the sunsets at the *Tarryall River Ranch*. At 8,600 feet, the days are comfortable and the nights are cool: perfect for campfires. The ranch adjoins the Lost Creek Wilderness Area, and Pikes Peak looms to the southeast. There is an abundance of aspen and ponderosa pine, and the vegetation is generally lush with wildflowers along the river that runs through the ranch. This region has plentiful wildlife, including bighorn sheep, elk, deer and bear.

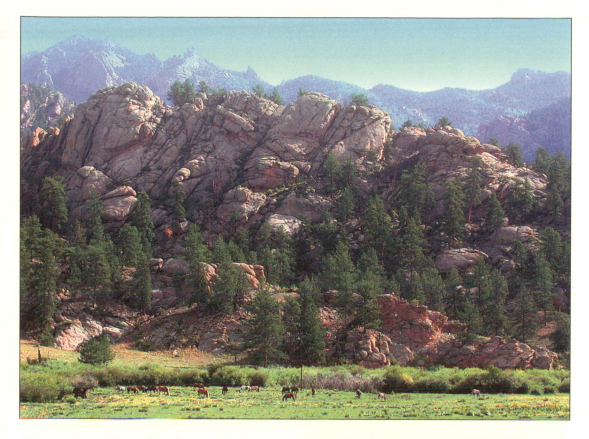

There's plenty of terrific riding at this family-run ranch, including all-day rides that will take you deep into the backcountry, oftentimes climbing above treeline. For the more adventurous, they offer exciting overnight pack trips. Other great activities include fishing, hiking, rafting and swimming (in a heated pool). There's also a hot tub for simply relaxing. No need to worry about your young'ns either. The ranch has a fantastic kids' program with all kinds of fun stuff to keep them busy.

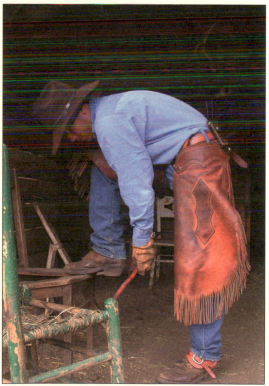

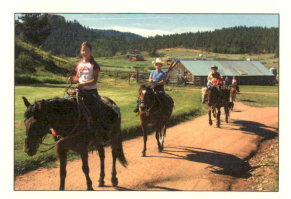

Wilderness Trails Ranch

Durango
Colorado, USA

ACTIVITIES: Horseback riding, hiking, fishing, waterskiing, four-wheel drive trips & river rafting

PHONE: 800-527-2624 or 970-247-0722
WEB: www.WildernessTrails.com
CAPACITY: 46 people: several private cabins
OPEN: Late May to October, 3 day minimum stay

RATES: Around $2,200 per adult per week (kids are less). Includes meals & all ranch activities

LOCATION: 340 miles (6 hours) from Denver, 220 miles from Albuquerque

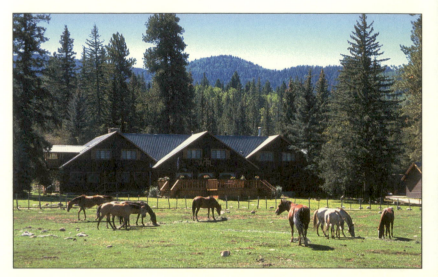

Blending the past and present, *Wilderness Trails Ranch* has been introducing guests to the cowboy lifestyle in their spectacular mountain valley hideaway since 1970. The ranch borders on the Piedra Wilderness Area, which includes secluded meadows, high mountain vistas and forests covering thousands of acres. In addition to a wide variety of scenic trail rides, they offer classes in natural horsemanship, fishing, rafting, waterskiing, four-wheel drive trips, and a tour of Mesa Verde's ancient cliff dwellings.

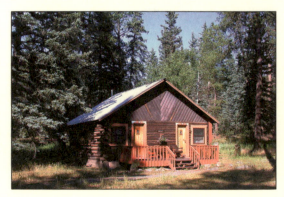

Given the ranch's convenient location just 35 miles from Durango, they can arrange an exciting ride on the famous Durango-Silverton Narrow Gauge Railroad. There are just a few of these old railways left, so make sure and take advantage of this unique opportunity.

Don't forget to bring the kids! They have an exceptional youth program for children of all ages. With horseback riding, hay rides, campfire sing-alongs, and a great swimming pool, everyone will have a blast!

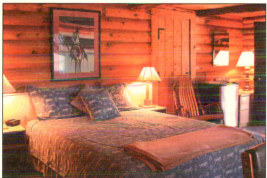

Wind River Guest Ranch

Estes Park
Colorado, USA

ACTIVITIES: Horseback riding, hiking, fishing, swimming, climbing & river rafting

PHONE: 800-523-4212 or 970-586-4212
WEB: www.WindRiverRanch.com
CAPACITY: 50 people: 14 private cabins & 1 chalet
OPEN: Summer only, 1 week minimum stay

RATES: Around $1,600 per adult per week & $1,200 per child per week. Includes meals & all ranch activities

LOCATION: 70 miles (2 hours) north of Denver

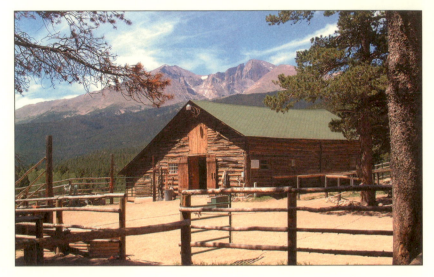

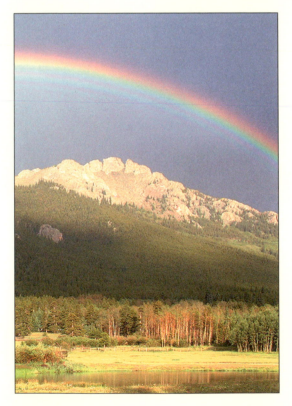

High in the Tahosa Valley lies one of the most magnificent places you will ever find, the *Wind River Guest Ranch*. While there are no telephones or televisions, what they do offer guests is time: the time to renew relationships with family and friends.

The ranch was established over a hundred years ago and became a guest ranch in the forties. The property is ideally situated across the road from Rocky Mountain National Park and Roosevelt National Forest.

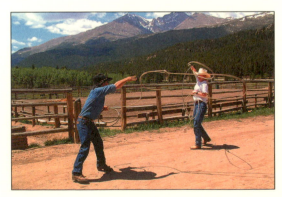

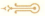

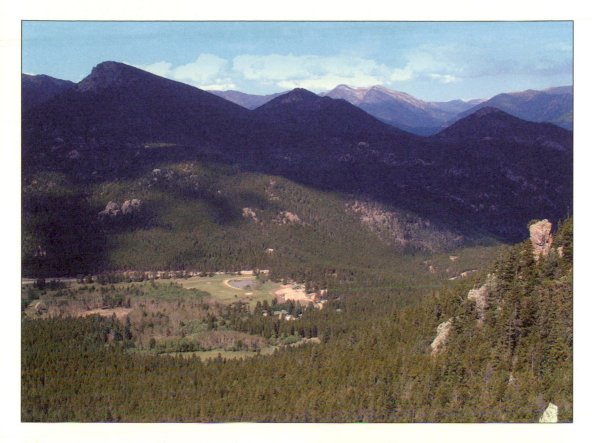

After an exciting day of horseback riding, you will enjoy sitting fireside each evening, roasting marshmallows and sipping hot chocolate. For the less adventurous, you may want to curl up with a good book from the library while resting in one of the many comfortable hammocks hidden in the aspens.

There are 15 log cabins scattered around the main lodge area. They all have decks with spectacular views and lovely cypress rocking chairs for relaxing.

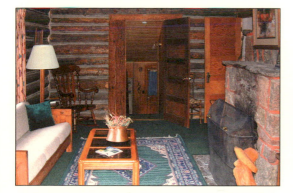

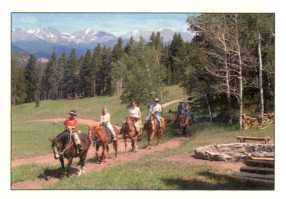

Wit's End Guest Ranch Resort

Durango
Colorado, USA

ACTIVITIES: Horseback riding, fishing, hiking, trapshooting, swimming & tennis

PHONE: 800-236-9483
WEB: www.WitsEndRanch.com
CAPACITY: 120 people: 32 (1-4 bedroom) cabins
OPEN: May through September, 1 week minimum stay

RATES: Around $2,800-$3,200 per person per week. Includes meals & all ranch activities

LOCATION: 24 miles northeast of Durango

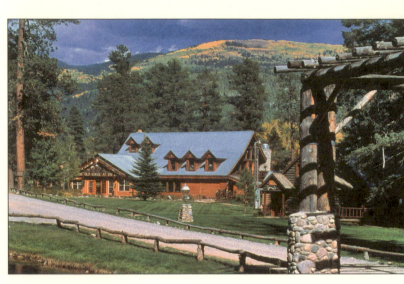

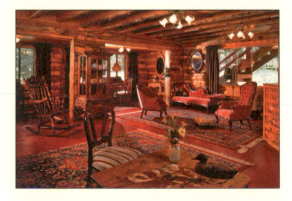

This is it! Look no further for the vacation you've always dreamed about in the Colorado Rockies. Surrounded by 12,000- to 14,000-foot peaks, *Wit's End Guest Ranch Resort* is a timeless place to participate in many outdoor activities or simply kick back and relax in the fresh air.

The fishing is excellent! Trophy cutthroats and rainbows are plentiful. You'll also have an opportunity to float or wade in premier fishing streams such as the San Juan and Animas.

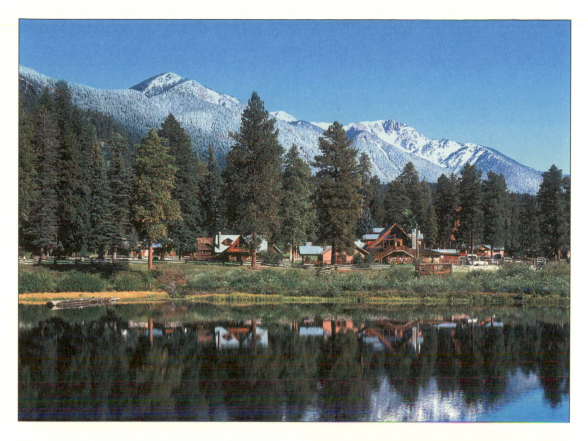

Wit's End also provides excellent opportunities for horseback riding. As a beginner or expert, their wranglers will find you just the right horse and just the right trail.

The luxurious log cabins are extremely plush. Immaculately maintained, they provide guests with all the trappings of a fully furnished home. Each cabin boasts a knotty pine interior, native stone fireplace, brass bed, down comforters, feather pillows, sofa bed, large deck and a fully equipped kitchen.

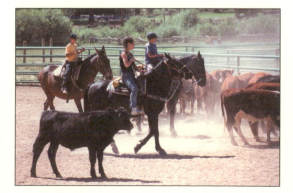

4D Longhorn Guest Ranch

Smith's Ferry
Idaho, USA

ACTIVITIES: Horseback riding, mountain biking, hiking, team building, roping & cattle drives

PHONE: 208-466-9527
WEB: www.4DRanches.com
CAPACITY: 20 people: several pioneer-style cabins
OPEN: May through October, 1 week minimum stay

RATES: Around $160 per person per day. Includes meals & ranch activities

LOCATION: 65 miles north of Boise, 20 miles south of Cascade

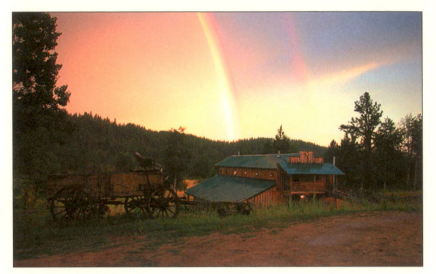

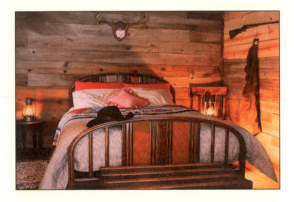

Whether you are a beginner or an experienced rider, you can't help but look and feel like a real cowboy while pushing a herd of Longhorn down the trail at the *4D*. You can even step it up a notch and try your hand at cutting and roping if the urge hits you. Or, if the closest you want to get to a horse is playing horseshoes, then that is an option, too. Whatever it is that you want to do, the sights and sounds of nature will be all around you at this stunning dude ranch. It is simply one of Idaho's best.

The ranch not only prides itself on creating a hearty appetite, they also do an excellent job of filling that belly back up. With delicious ranch-style, home-cooked meals, including outdoor Dutch oven cooking, it's not the place to go if you're sticking to a diet.

Each of their cozy cabins was built with the pioneer spirit in mind and has its own unique look inside and out. You will especially enjoy your own front porch for lazy summer days and nightly stargazing.

Indian Creek Guest Ranch

North Fork
Idaho, USA

ACTIVITIES: Horseback riding, fishing, float trips & sightseeing: natural history trail & mining camp

PHONE: 866-394-2126 or 208-394-2126
WEB: www.IndianCreekGuestRanch.com
CAPACITY: 15 people: 4 rustic cabins
OPEN: June through September, 5 night minimum stay

RATES: Around $250–$350 per person per day. Includes meals & all ranch activities

LOCATION: 36 miles from Salmon, 185 miles (3 hours) from Idaho Falls

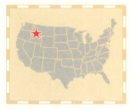

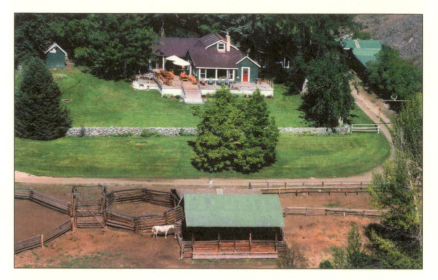

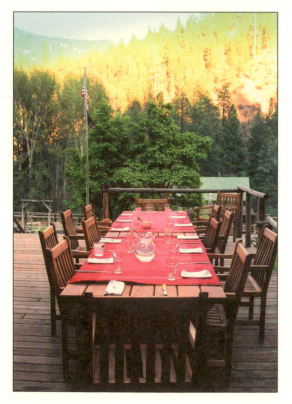

This ranch has history. Almost 200 years ago, Lewis and Clark explored Indian Creek while seeking a route to the Columbia River. A hundred years later, the Kitty Burton and Ulysses Mines were thriving gold camps on Indian Creek. Today, *Indian Creek* retains the same allure and magic of the past. The main lodge was built around the Red Onion Saloon that served many a thirsty gold miner, back in the day. When you stay at *Indian Creek Ranch*, you too, will become a part of its history.

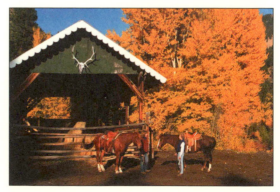

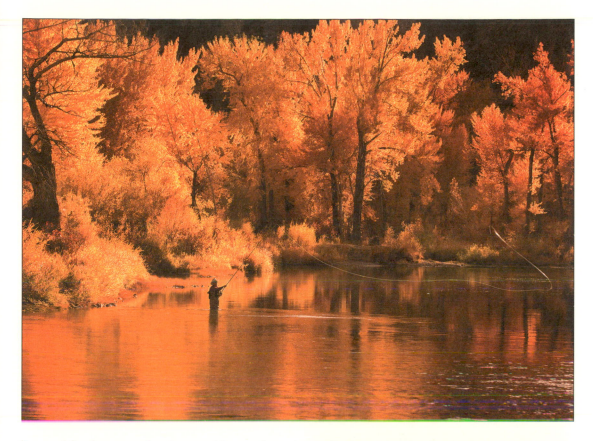

It would take several trips to this ranch to participate in all the activities they offer. Some of the best are fly-fishing in their private trout pond, taking a horseback ride to Lookout Ridge, hiking to the ghost town of Ulysses or bicycling along the Salmon River.

The cabins have fluffy down comforters, rustic wood furnishings and a warm glow from gas lamps. Fine dining has also been a long standing tradition at *Indian Creek*. Served family style, they offer gourmet western fare.

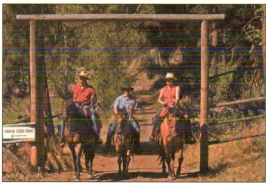

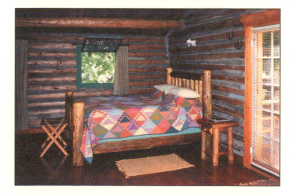

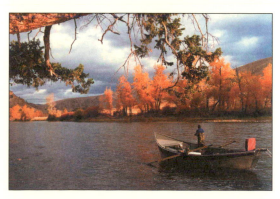

Sun Valley Trekking

Sun Valley
Idaho, USA

ACTIVITIES: Hiking, fishing, kayaking, wildlife viewing & backcountry skiing/snowboarding

PHONE: 208-788-1966
WEB: www.SVTrek.com
CAPACITY: 40 people: 5 huts/yurts (8-10 people in each)
OPEN: Year-Round, no minimum stay

RATES: Around $40 per person per day, with a minimum of $160 per night for an entire yurt

LOCATION: Sawtooth National Forest & Yellowstone National Park

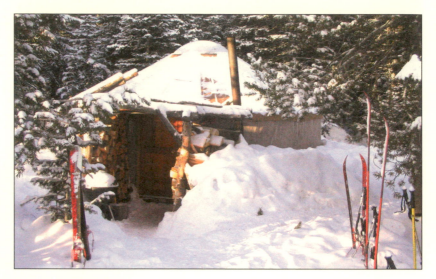

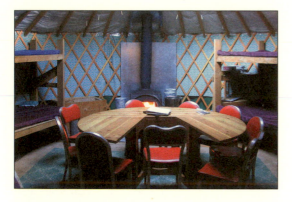

Rather than spending your day waiting in long lift lines at an overpriced/overcrowded ski resort where a burger costs ten bucks, why not get a bunch of friends together and rent a backcountry yurt for a fraction of the price and no lift lines? *Sun Valley Trekking* offers five backcountry wilderness huts/yurts that are available all winter for backcountry skiers, telemarkers, snowboarders and snowshoers who want a do-it-yourself snow-sport backcountry experience.

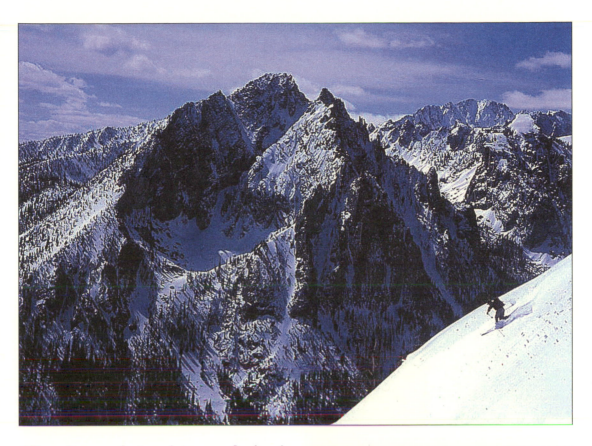

All you have to do is pack in your food and sleeping bag; everything else is provided once you arrive. If you think you might need a little help though, they do offer a snowmobile cargo service, pre-packaged food service and guiding.

In the summer, you can experience the tranquility of gliding across one of Yellowstone National Park's beautiful sub-alpine lakes in a sea kayak. Let civilization slip away as you paddle along the lakeshore at sunset while keeping a keen eye out for moose, elk or bison.

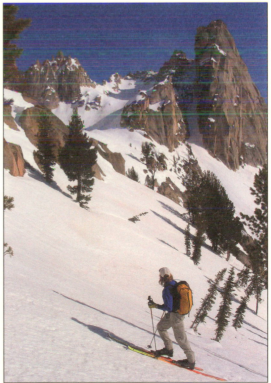

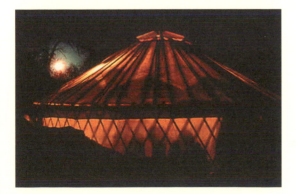

Twin Peaks Ranch

Salmon
Idaho, USA

ACTIVITIES: Horseback riding, herding cattle, river rafting, trapshooting, fishing & pack trips

PHONE: 800-659-4899 or 208-894-2290
WEB: www.TwinPeaksRanch.com
CAPACITY: 54 people: many rustic cabins
OPEN: Mid June to mid September, 3 night minimum stay

RATES: Around $2,000 per adult per week (less for kids). Includes meals, horseback riding, rafting & a pack trip

LOCATION: 3 hours south of Missoula, MT

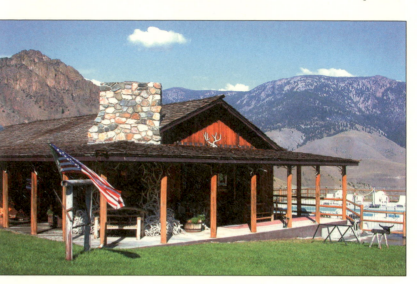

Make sure and remember to bring your energy to *Twin Peaks Ranch*, you're going to need it. Being located near Yellowstone National Park, Glacier National Park and Church Wilderness Area, there are far more activities than time. You can round up cattle one day, go whitewater rafting on the Salmon River the next or choose to take it easy by fly-fishing for rainbows all day. And then there's the fantastic overnight pack trip that takes you high up in the mountains to a backcountry wilderness tent camp.

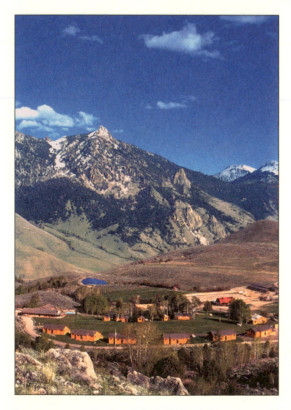

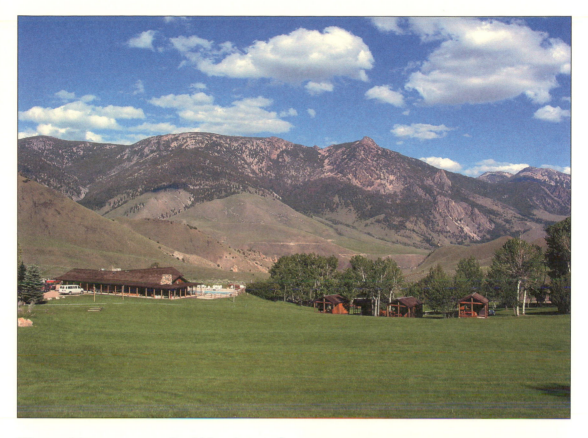

The ranch's 2,900 acres should be plenty of room for you to stretch out your legs while keeping an eye out for bighorn sheep: they are quite common in the area. And what summer day would be complete without a refreshing afternoon dip in the swimming pool?

Back at the ranch, you will have your choice of different cabin accommodations. The original cabins are one- and two-bedroom units with covered porches. The newer deluxe cabins are larger side-by-side units.

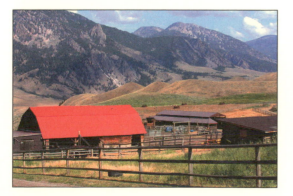

Birches Resort

ACTIVITIES: Whitewater rafting, kayaking, moose viewing cruises, skiing & snowmobiling

PHONE: 800-825-9453
WEB: www.Birches.com
CAPACITY: 80 people: cabins, tents, yurts & lodge rooms
OPEN: Year-Round, no minimum stay

RATES: Around $50-$250 per cabin per day. Meal plans are available. Pets are allowed

LOCATION: 300 miles (5 hours) from Boston

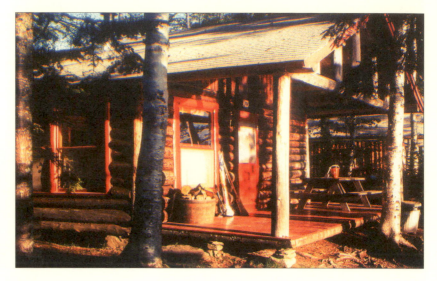

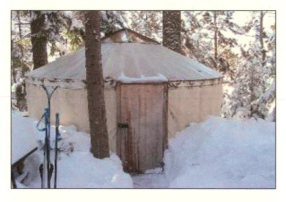

If you are looking for a fun, year-round destination in the Northeast with plenty of activities for the family, *Birches Resort* is just the place. Besides offering about any type of accommodation you could possibly imagine, their rates will fit any budget. The resort offers rustic waterfront cabins, exclusive private home rentals, cabin tents, wilderness yurts and rooms in their main lodge. In addition, there is a beach, hot tub, dry sauna and a new fitness center.

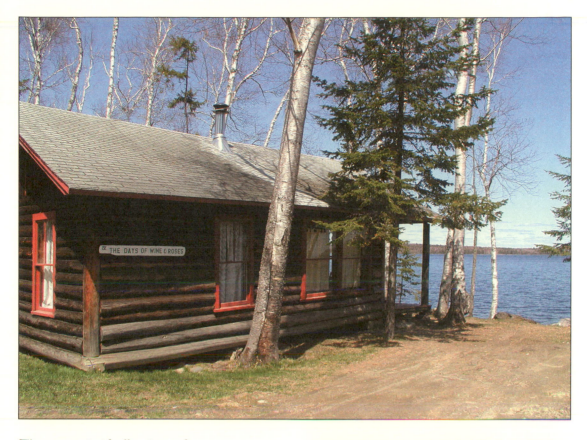

The resort is ideally situated on 11,000 acres of wilderness, which includes several gorgeous lakes and ponds. This amazing backcountry setting offers fantastic family activities such as whitewater rafting, fishing, kayaking and mountain biking, Jeep tours and the ever-popular moose cruises (guided pontoon boat outings on Moosehead Lake to view moose). In the winter, there's ice fishing, snowmobiling and miles and miles of well-groomed cross-country skiing trails.

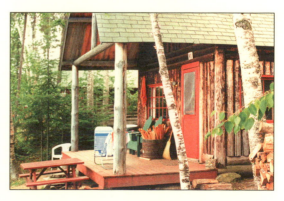

Bradford Camps

ACTIVITIES: Fishing, canoeing, kayaking, hiking, wildlife viewing, & porch sitting

PHONE: 207-746-7777
WEB: www.BradfordCamps.com
CAPACITY: 32 people: 8 private, waterfront log cabins
OPEN: May through November, no minimum stay

RATES: Around $150 per person per day. Includes meals

LOCATION: 60 miles (2 hours) from Ashland, or take a float-plane from Millinocket or Bangor

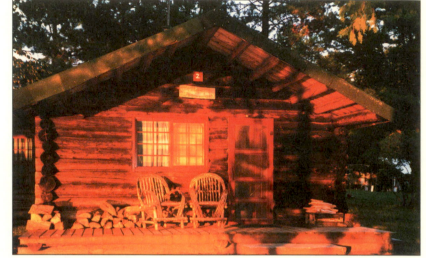

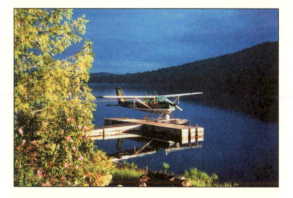

Flying into *Bradford Camps* is like going back in time 100 years. Your scenic runway, surrounded by towering pines, is Munsungan Lake, located in the heart of Maine's fabled North Woods. As your plane touches down on the smooth water, you are now officially on vacation. After unpacking, you may want to settle in with a cocktail on your porch while you await the supper bell. The drink is cooled with ice cut from the lake every winter, just as it has always been at *Bradford Camps*.

After dinner, you can meet with a guide to go over the prospects of tomorrow's fishing. The woods and waters around Munsungan are wild and deep. They are home to deer, bear, moose, beaver, coyote, bobcat, eagles and ospreys. Besides fishing, there's canoeing, kayaking, hiking or simply doing nothing at all.

Bradford Camps' vintage log cabins are the only buildings on the entire lake, and the grounds are talked about as the most scenic in Maine. This place is the stuff dreams are made of.

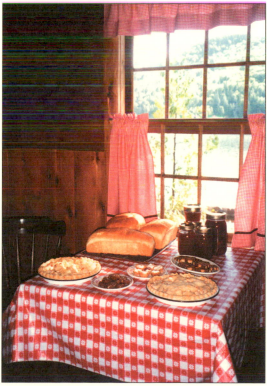

Double JJ Ranch Resort

Rothbury
Michigan, USA

ACTIVITIES: Horseback riding, golfing, cattle drives, swimming, snow tubing & snowmobiling

PHONE: 800-DOUBLE-JJ or 231-894-4444
WEB: www.DoubleJJ.com
CAPACITY: 250 people: log cabins, condos & bunkhouse
OPEN: Year-Round, minimum stay varies with season

RATES: Around $100-$200 per person per day. Includes meals & activities. Several packages are available. Pets are allowed

LOCATION: 20 miles north of Muskegon

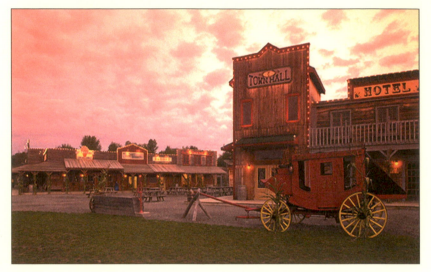

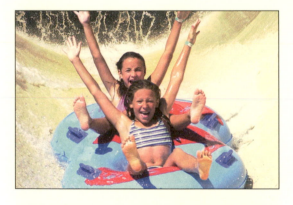

For over 60 years, the *Double JJ* has been a getaway for those seeking an adventure-packed vacation. Whether it's a week with the family or a weekend with the wife, there's something for everyone. So much, in fact, that it's almost guaranteed that you'll run out of energy before you run out of things to do. Year-round, fun-filled entertainment includes golf, horseback riding, rodeos, an indoor water park, archery, riflery, tennis, cross-country skiing, snow tubing, snowmobiling and dogsledding.

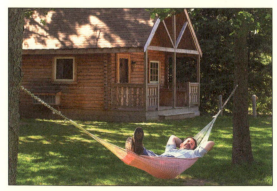

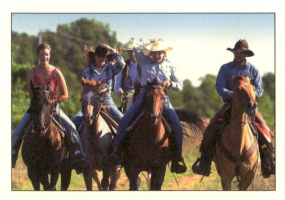

Surrounded by a 2,000-acre horse ranch and a championship golf course, the *Double JJ* is the ideal place to relax, unwind and enjoy the great outdoors. You can even drop the kids off at the 24-hour supervised kids' program. That's when the fun really begins!

Uniquely divided into three different sections based on what type of vacation you are looking for, they offer the Thoroughbred Golf Club for golfers, the Back Forty for families, and the Ranch for adult-only vacations.

Grand View Lodge

Nisswa
Minnesota, USA

ACTIVITIES: Swimming, canoeing, fishing, golfing, tennis, spa services & use of a fitness center

PHONE: 800-432-3788 or 218-963-2234
WEB: www.GrandViewLodge.com
CAPACITY: 240 people: 12 lodge rooms & 65 cottages
OPEN: Year-Round, 2 night minimum stay on weekends

RATES: Around $150–$350 per room per day. Includes breakfast & dinner

LOCATION: 90 miles (1.5 hours) south of Grand Rapids, 150 miles (3 hours) north of Minneapolis

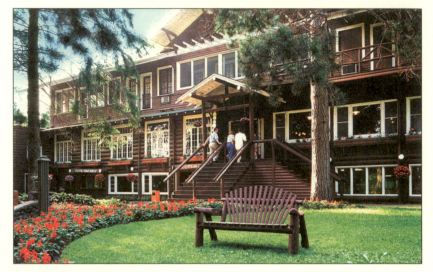

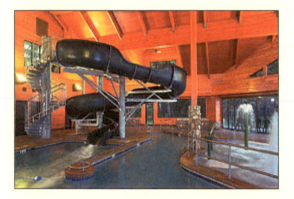

There was a time when style was as important to a great vacation as substance, when elegance was measured in terms of north-woods charm and attention to detail. That time lives on today at the *Grand View Lodge.* A year-round resort, the lodge specializes in family vacations, couples getaways, golf packages and spa vacations in the beauty and serenity of the woods and lakes of Minnesota. If you are looking for somewhere to start a family tradition, the *Grand View Lodge* is the perfect place.

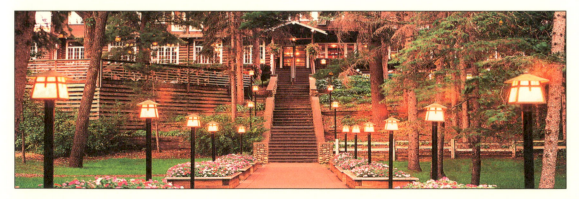

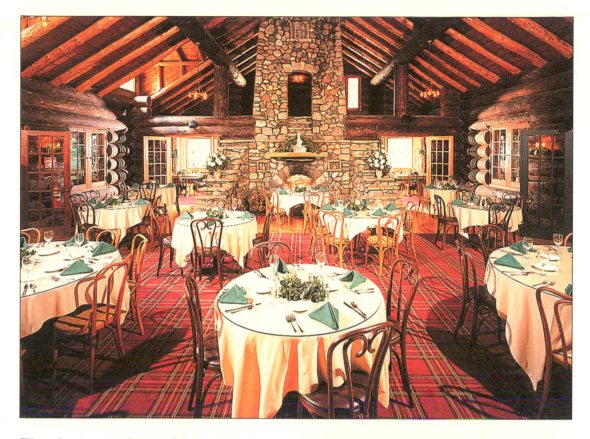

This destination boasts Minnesota's finest 1,500-foot natural sand beach on beautiful Gull Lake, providing endless fun swimming, canoeing, paddle boating and fishing. The kids will be in awe of the connecting indoor swimming pools with a 110-foot water slide, water guns and hot tubs. Then there's the golf. With four courses to choose from, finding a tee-time that fits into your schedule will be easier than making that 10-foot put. They also offer a fantastic supervised kids' program.

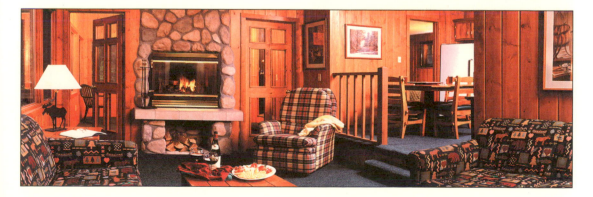

320 Guest Ranch

Big Sky
Montana, USA

ACTIVITIES: Horseback riding, hiking, fishing, hayrides, sleigh rides, skiing & snowmobiling

PHONE: 800-243-0320 or 406-995-4283
WEB: www.320ranch.com
CAPACITY: 166 people: 1, 2 & 3 bedroom log cabins
OPEN: Year-Round, no minimum stay

RATES: Around $125 per cabin per day, $225 per 2-room cabin per day. Pets are allowed

LOCATION: 52 miles south of Bozeman, 36 miles north of W. Yellowstone

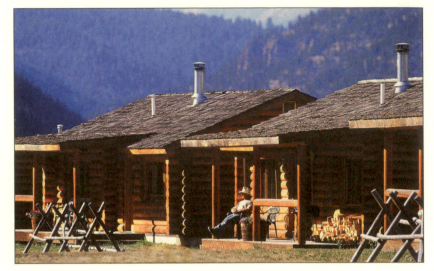

They call it "Big Sky" for a reason. No matter where you stand, you will be surrounded by a surreal sky with every shade of blue imaginable. It is an absolute treat to vacation in this part of the country and a must for everyone. A great place to stay to enjoy this heaven-on-earth is at the *320 Guest Ranch*. Unlike many ranches, there is no minimum stay here, so you can stop in for a couple days on your way to or from Yellowstone National Park, which is only a few minutes away. Activities and meals are available for an extra cost on an individual basis. They have a great restaurant and saloon right on the ranch along with a chuckwagon barbeque! And, for a small fee, you can bring your pet.

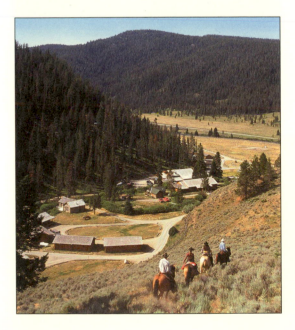

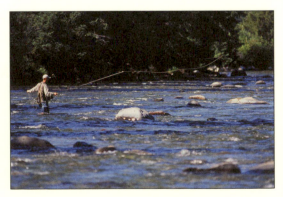

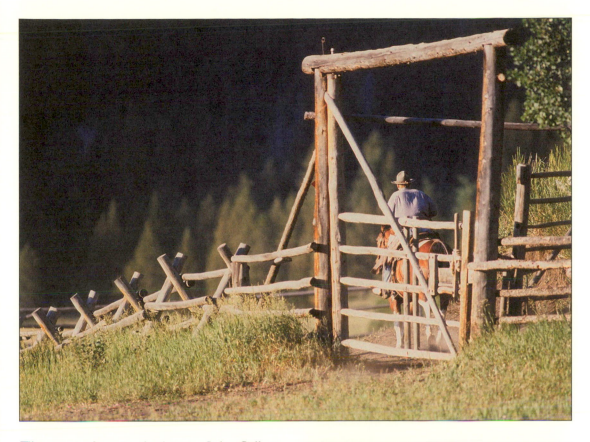

The *320* is deep in the heart of the Gallatin National Forest, with two miles of the renowned Gallatin River running through the property. This ideal location provides some of the world's best fishing just steps from your cabin door. Of course there's also horseback riding, hiking and tons of other outdoor activities to choose from. They offer several different types of cabins, sure to fit everyone's needs. There are deluxe one-room units, two-room cabins and three-room luxury log homes.

Abbott Valley Homestead

Martin City
Montana, USA

ACTIVITIES: Hiking, biking, canoeing, rafting, fishing, golfing, bear viewing, skiing & snowshoeing

PHONE: 888-307-4436
WEB: www.AbbottValley.com
CAPACITY: 28 people: 5 rustic cabins
OPEN: Year-Round, no minimum stay

RATES: Around $200-$250 per cabin per day. Pets are allowed for a small fee & prior approval

LOCATION: 30 miles from Kalispell, 10 miles from Glacier National Park

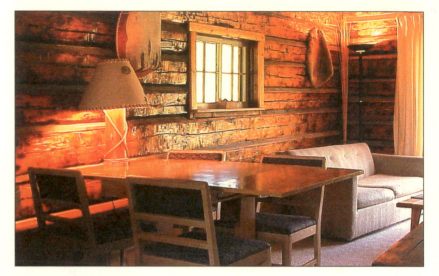

Located near Glacier National Park, the Bob Marshall Wilderness Area, and Flathead Lake (the largest freshwater lake in the West), *Abbott Valley* is the perfect place from which to plan a variety of awesome day trips. That is, if you can manage to pull yourself away from the gorgeous 260+ acres that make up the *Homestead*. Days can be spent walking through fields of wildflowers, wading through trout-filled streams, or watching deer, moose, elk, beaver, geese and ducks in their natural habitat.

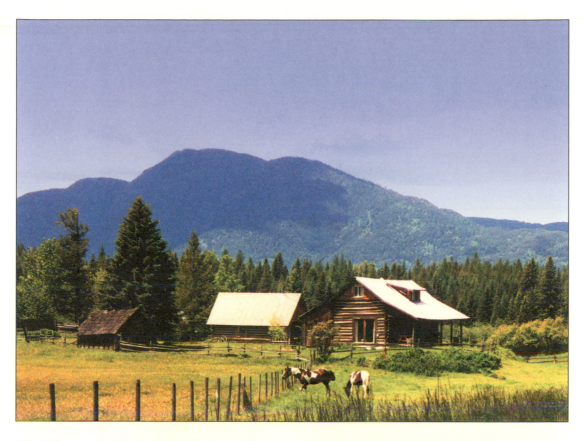

With five individual cabins to choose from, the *Homestead* is just as well suited for a romantic getaway as it is for a large family reunion. The rustic cabins provide an authentic old-time atmosphere, reminiscent of the early days when Montana settlers first came to the area. Happily though, they offer all the conveniences of modern day living. Each cabin comes complete with a fully appointed kitchen, full bath and wood stove. There's even a spacious yard with a picnic table and gas barbeque. Enjoy!

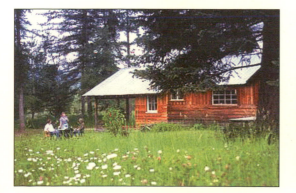

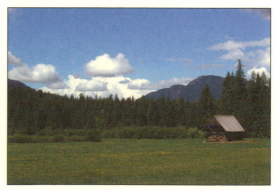

Averill's Flathead Lake Lodge

Bigfork
Montana, USA

ACTIVITIES: Horseback riding, fishing, canoeing, kayaking, lake cruises & campfires

PHONE: 406-837-4391
WEB: www.FlatheadLakeLodge.com
CAPACITY: 120 people: 17 cottages & several log lodges
OPEN: May to mid October, 1 week minimum stay

RATES: Around $2,700 per adult per week (less for kids). Includes meals & all ranch activities

LOCATION: 20 miles from Kalispell, 35 miles from Whitefish

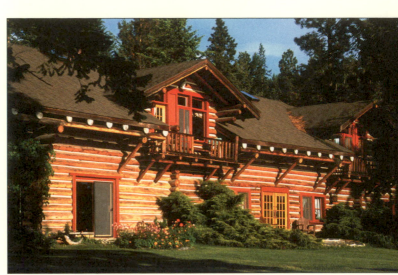

Just a few miles south of Glacier National Park on the largest body of fresh water west of the Great Lakes is one of the most amazing guest ranches in the country: *Averill's Flathead Lake Lodge*. This 2,000-acre ranch has all of the cozy ambience of historic log lodges of the past. Families can gather around a massive river rock fireplace or relax on buffalo hide couches. There are no telephones or televisions, so days can be enjoyed horseback riding or strolling around the lush, flower-filled grounds.

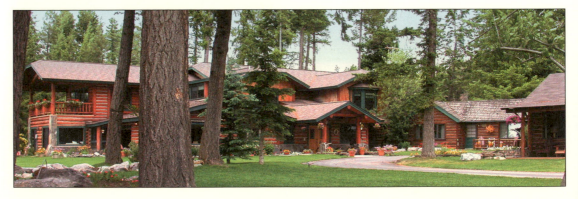

Although the ranch is a perfect romantic getaway for couples, it is also very family friendly. There is a separate horseback riding program for kids, which will turn your little ones into "junior wranglers." In addition to learning about saddling and grooming, they will also take a ride on the ranch's own old-school fire truck for a fun trip to the ice cream shop. You will be plenty busy, too. With all the horseback riding, fishing and boating, there will be tons of cherished memories to take home.

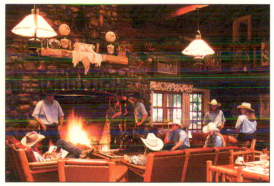

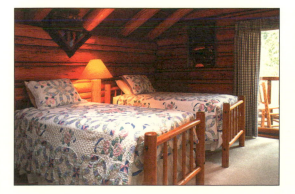

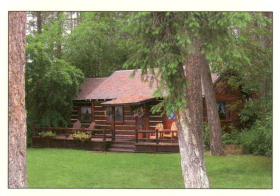

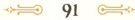

Elkhorn Ranch

Gallatin Gateway
Montana, USA

ACTIVITIES: Horseback riding, fishing, rafting & sightseeing: Grand Teton Park & Yellowstone N.P.

PHONE: 406-995-4291
WEB: www.ElkhornRanchMT.com
CAPACITY: 40 people: 15 log cabins (1-8 guests in each)
OPEN: Mid June through September, 1 week minimum stay

RATES: Around $200-$250 per person per day. Includes meals & all ranch activities

LOCATION: 33 miles north of West Yellowstone, 55 miles south of Bozeman

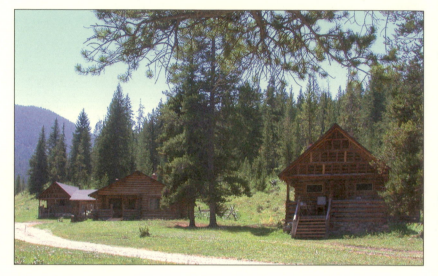

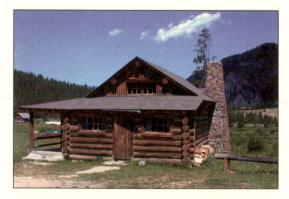

The *Elkhorn Ranch* is a family oriented guest ranch that provides an extraordinary kids' program. Upon arriving, if your children are between the ages of 6 to 12, they will become "Peanuts," under the watchful eye of the "Peanut Butter Mother," from breakfast until bedtime. Their days will be filled with riding, playing and eating together while making new friends. This program enables parents to relax while being assured that their children are happily safe and sound.

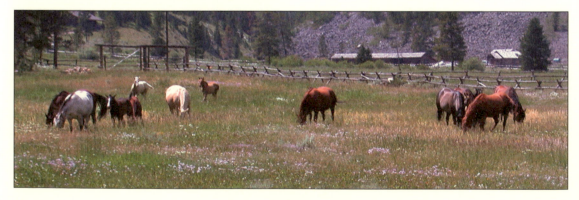

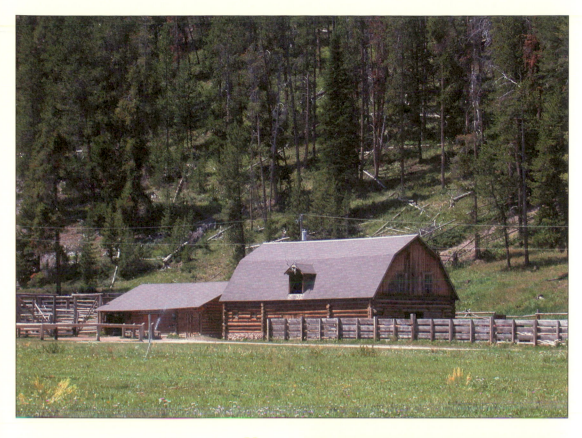

Scattered amongst the wildflowers are fifteen log cabins originally built in the thirties, each with its own delightful view of the peaceful ranch meadow. They vary in size, sleeping from one to eight people, and come with their own private bath, electric heat and spacious porch. Most of the porches are covered and offer a quiet spot to relax after a long day in the saddle. To ensure that every guest experiences solitude and tranquility, there are no phones or televisions in the cabins.

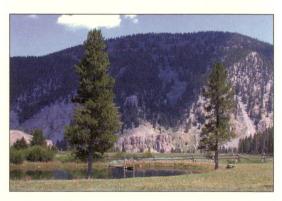

Papoose Creek Lodge

Cameron
Montana, USA

ACTIVITIES: Fly-fishing, hiking, horseback riding, wildlife viewing, canoeing & relaxing

PHONE: 888-674-3030
WEB: www.PapooseCreek.com
CAPACITY: 16 people: 5 lodge rooms & 3 cabins
OPEN: May through October, 3 night minimum stay

RATES: Around $450-$500 per person per day. Includes meals & all ranch activities

LOCATION: 65 miles (1.5 hours) from Bozeman, 45 minutes from Yellowstone

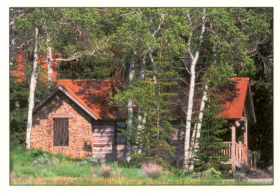

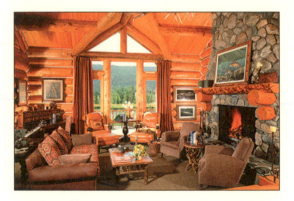

If amazing fly-fishing is what you are looking for, then pack your bags and head on out to *Papoose Creek Lodge*. They will introduce you to some of the world's best fly-fishing on the blue-ribbon waters of the Madison, Gallatin, Henry's Fork and Yellowstone Rivers. There's also plenty of great hiking, horseback riding and canoeing to keep you busy. And, if that's still not enough, the lodge is only 45 minutes from Yellowstone National Park. Area wildlife include wolf, antelope and bear.

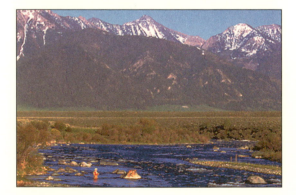

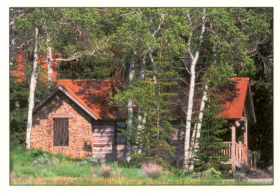

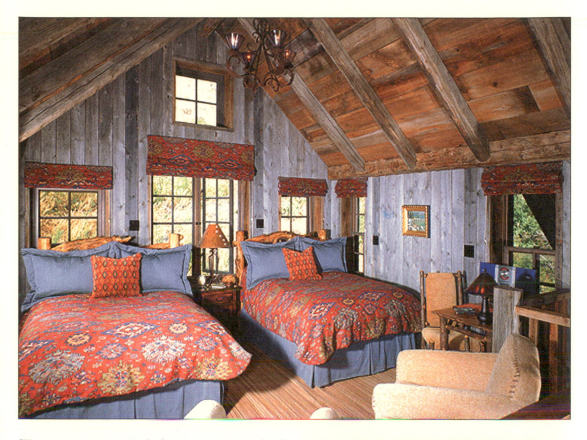

The property's main lodge is constructed of massive logs and boasts a huge living room with a dominating river rock fireplace. Just steps away, on the spacious deck, you will enjoy the view of Papoose Creek as it meanders lazily through the property. Lodging consists of five lodge guestrooms, along with three spacious pioneer-style cabins. They also have an outdoor hot tub, which is perfect for soothing any aching muscles. Get those cowboy boots and fly-rods ready for the experience of a lifetime.

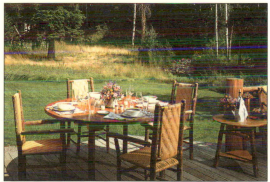

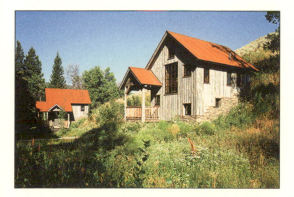

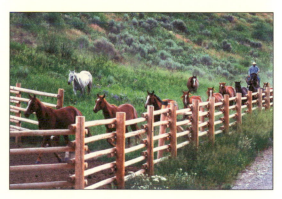

The Resort at Paws Up

Greenough
Montana, USA

ACTIVITIES: Horseback riding, fly-fishing, ATV trips, cross-country skiing & snowmobiling

PHONE: 800-473-0601 or 406-244-5200
WEB: www.PawsUp.com
CAPACITY: 80 people: private cabins/homes & tents
OPEN: Year-Round, 2 night minimum stay

RATES: Around $1,000-$3,000 per cabin/home per day. Includes meals for two & airport transfers

LOCATION: 35 miles (45 minutes) northeast of Missoula

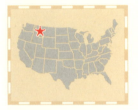

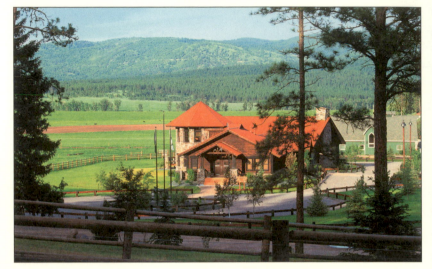

The Resort at Paws Up is simply rustic elegance at its finest. Nowhere else in the world will you find such extreme luxury combined with such extreme wilderness. In the same day you can go fly-fishing, horseback riding, trapshooting and take an **ATV** ride to an authentic ghost town, all before dinner. The meals are not your typical country fare either: they offer first-class dining in their restaurant. After dinner, you can catch the game on your massive flat-screen **TV** with satellite. Not a bad day.

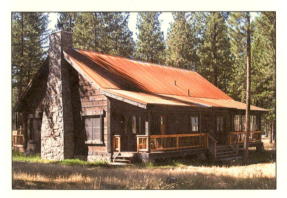

After staying the night in one of the perfectly appointed rustic cabins, it may cross your mind to ask if you can move in permanently. In fact, the accommodations are so amazingly deluxe, it may be difficult to ever return home.

Adding to the experience, Meriwether Lewis (of Lewis and Clark) traveled through the property on the Blackfoot River during his momentous journey. Treat yourself to an intimate and historical visit back to the Old West without sacrificing the finer things in life.

Rye Creek Lodge

Darby
Montana, USA

ACTIVITIES: Hiking, fishing, wildlife viewing, nature walks & relaxing on the porch

PHONE: 888-821-3366 or 406-821-3366
WEB: www.RyeCreekLodge.com
CAPACITY: 20 people: 5 log cabins
OPEN: Year-Round, no minimum stay

RATES: Around $250 per cabin per day. Cabins have a full kitchen, living room & big porch. Pets are allowed

LOCATION: 65 miles (1.5 hours) south of Missoula

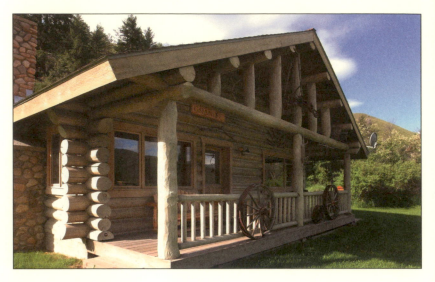

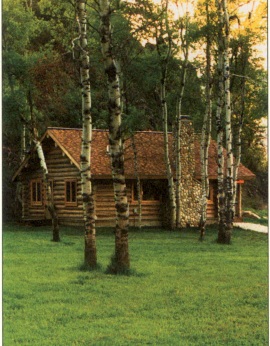

Perfect for family vacations, reunions or romantic getaways, *Rye Creek Lodge* is comprised of five rustic log cabins, all with gorgeous mountain views of the magnificent Trapper Peak. The area's enormous ponderosa pines and thick groves of aspen create a cozy atmosphere for the cabins. Rye Creek meanders through 120 acres of the scenic Bitterroot Valley, providing over a mile of riparian area for moose, elk and deer. There are also several excellent fishing ponds on the property.

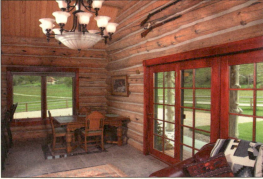

All the cabins are constructed of hand-hewn logs and come with a natural river rock fireplace, an individual telephone line, satellite TV and a completely furnished kitchen. They are decorated with old mining, Western and Indian artifacts that define the history of the valley. The beautiful Ponderosa cabin, for example, has log furniture, two bedrooms with queen-size beds, a large bath, Berber carpeting and a full-length covered porch. It overlooks a large pond stocked with rainbow trout.

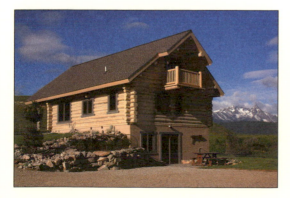

Sperry Chalet

West Glacier
Montana, USA

ACTIVITIES: Hiking & backpacking: winding trails, craggy peaks & cascading waterfalls

PHONE: 888-345-2649
WEB: www.SperryChalet.com
CAPACITY: 34 people: 17 rooms
OPEN: Mid July to mid September, no minimum stay

RATES: Around $175 per person per day. Includes meals

LOCATION: The trail to the chalet begins at the Lake McDonald Lodge parking lot. Hike takes 4-5 hours

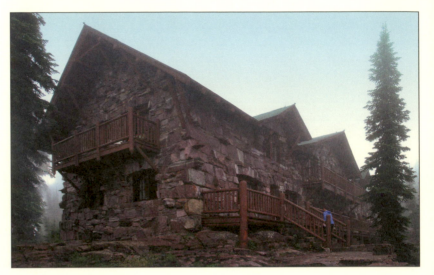

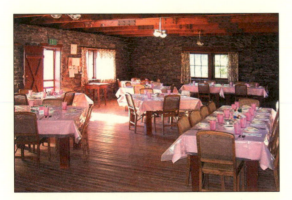

Do places like this really exist? Yes, *Sperry Chalet* is for real. This amazing hike-to or horseback-to alpine chalet is perched on a rocky mountain ledge in Glacier National Park. With an average hiking time of five hours, the 6.7 mile trail, with its 3,300-foot vertical rise, can be a challenge to many hikers. It is recommended that you bring comfortable hiking shoes, warm rain gear, hat, sunscreen, flashlight, full water bottle, insect repellent and bandages (for possible blisters).

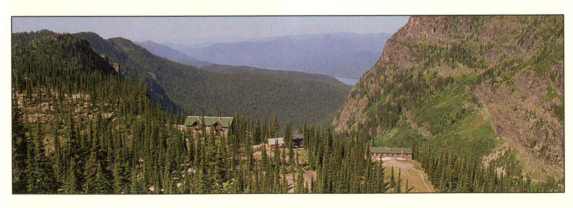

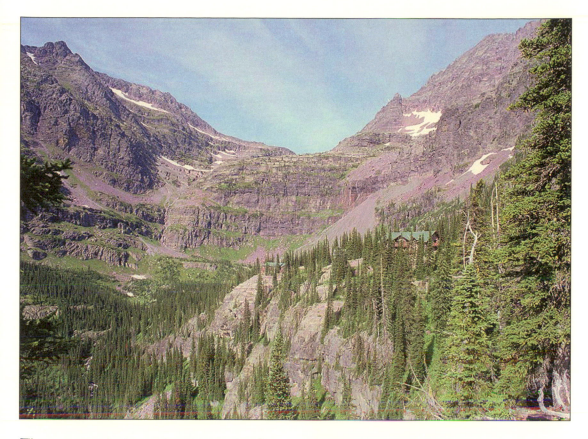

There are 17 private guest rooms ranging from single occupancy to rooms for five. Linens, blankets and towels are provided. There is a restroom facility outside with sinks for washing up, but there is no electricity, bath, heat or hot water. The dining room has propane lights for evening use. No candles or fueled lights are allowed in the rooms, so flashlights are highly recommended. Reservations are required, so make sure and call before hiking all the way up there.

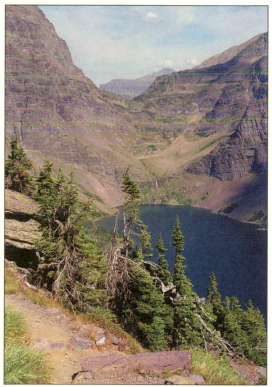

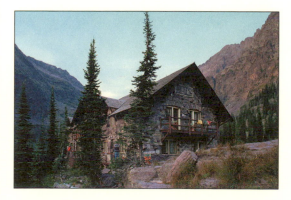

Cow Creek Ranch

Pecos
New Mexico, USA

ACTIVITIES: Fly-fishing, archery, horseback riding, pack trips, trapshooting & spa treatments

PHONE: 505-757-2107 or 505-471-9120
WEB: www.CowCreekRanch.com
CAPACITY: 20 people: several lodge rooms
OPEN: June through September, 3 night minimum

RATES: Around $250 per person per day. Includes meals & all ranch activities

LOCATION: 27 miles southeast of Santa Fe

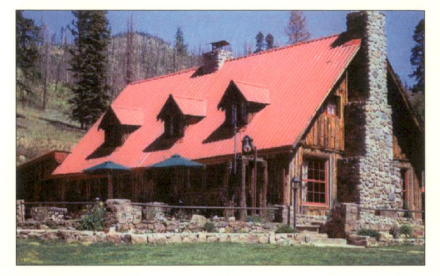

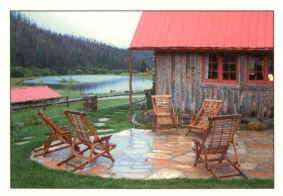

Cow Creek Ranch is an historic fly-fishing guest ranch that offers a wide variety of outdoor activities including fishing, horseback riding, spa treatments and much more. For over 70 years, the ranch has served as a relaxing escape for families and couples alike. Hidden deep in the wilderness of the Santa Fe National Forest within one of the many valleys of the Sangre de Cristo Mountains, this very special ranch has distinguished itself by offering fine cuisine and warm Southwestern hospitality.

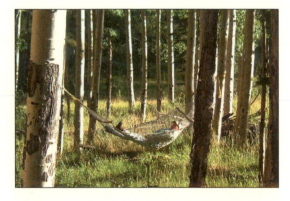

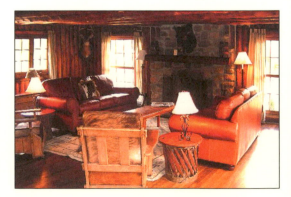

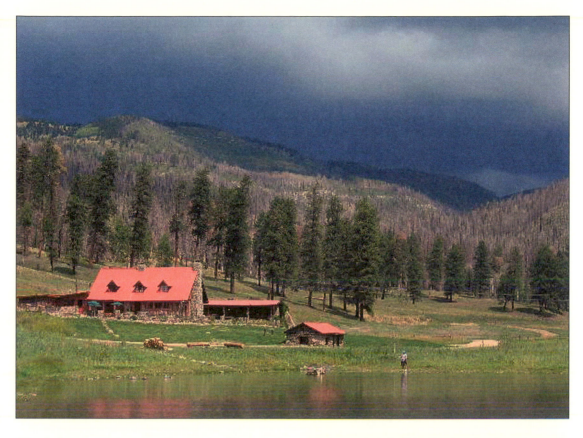

The lodge, with its open-beamed ceilings and fireplaces, provides the ideal atmosphere for dining and visiting with friends. It also serves as a gathering place where adventures are relived and memories are made over the embers of a crackling fire. All of the buildings on the ranch were built from pine and aspen harvested from the property. The charming rooms, each of which opens onto a large porch, come complete with a fireplace and private bath. They combine luxury with traditional western ambience.

Hacienda del Cerezo

Santa Fe
New Mexico, USA

ACTIVITIES: Horseback riding, swimming, tennis, reading, relaxing & hiking in the desert

PHONE: 888-982-8001 or 505-982-8000
WEB: www.HaciendaDelCerezo.com
CAPACITY: 20 people: 10 suites
OPEN: Year-Round, 2 night minimum stay

RATES: Around $600-$750 per couple per day ($100 less for singles). Includes meals & beverages

LOCATION: 12 miles northwest of Santa Fe

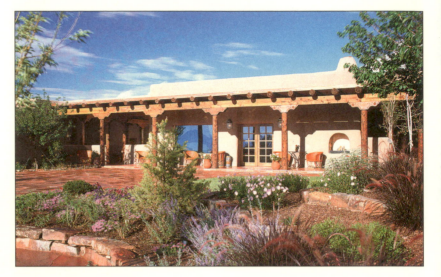

If you would like to experience one of the most secluded and intimate high-desert guest ranches in the world, then pack your bags and head to New Mexico. For it is here that you will find the legendary *Hacienda del Cerezo*. The ranch sits on 336 brush-covered acres that border the Tesuque Indian Reservation, which means that you will have unlimited access to over 150,000 additional acres of open land. That should be enough room for you to run free on horseback or hike to your heart's content.

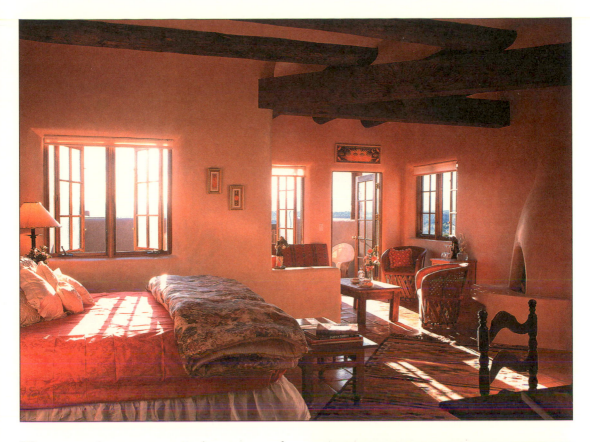

The rooms have an amazingly warm and inviting feel to them. Decorated with just the right touch of southwestern color, you will immediately feel relaxed. Each room has its own private patio, fireplace, sitting area, king-size bed, separate shower and oversized bath with Jacuzzi tub.

Of course, the meals are another reason everyone keeps returning. Their renowned candlelit dinners served up each evening by their four-star chef are spectacular.

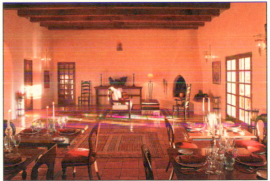

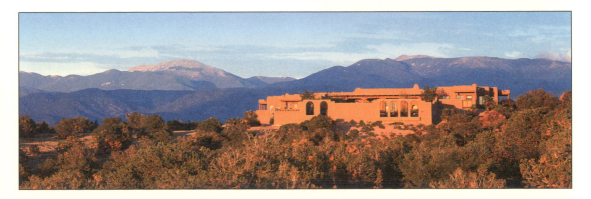

N Bar Ranch

ACTIVITIES: Horseback riding & real ranch work: branding & spreading cattle over 80,000 acres

PHONE: 800-616-0434 or 505-533-6253
WEB: www.NBarRanch.com
CAPACITY: 10 people: cabins & wood-paneled tents
OPEN: Year-Round, 1 week minimum stay

RATES: Around $1,000 per person per week. Includes meals, horseback riding & airport transfers to/from Albuquerque

LOCATION: 220 miles (4.5 hours) from Albuquerque

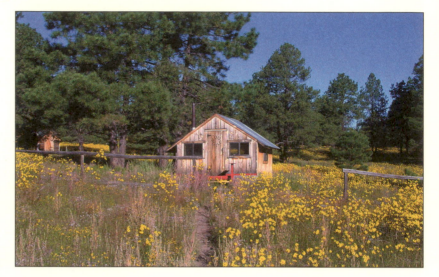

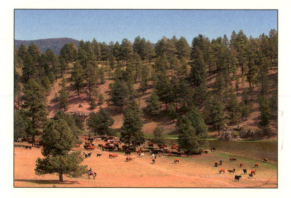

The *N Bar Ranch* is a working cattle ranch. There is no set daily itinerary because each day is dictated by the weather and the cattle. Everything is done from the back of a horse, the way cowboying used to be. By June, most of the herd has been moved up into the mountains to the summer range. Early summer is spent spreading them out over some 80,000 acres; mid-summer is a time for gathering calves and bringing them in for branding; and late summer is filled with moving them to new pasture.

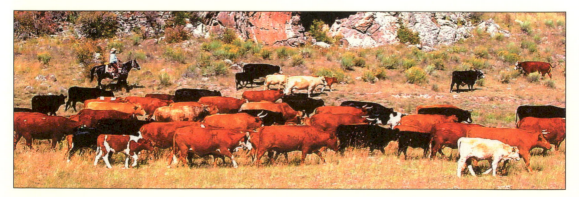

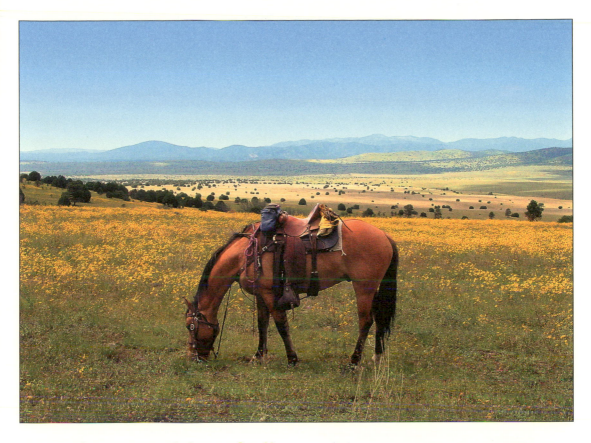

Accommodations are simple but comfortable. They consist of rustic cabins or wood-paneled wall tents. Each is watertight and roomy and has two beds, a table with a kerosene lamp, and wool rugs for that first chilly step in the morning. Some out-of-date reading material, a small wood stove, and a few old western knick knacks will make it feel like home and make you feel like a real ranch hand. If they're pitching camp for the night, a chuck wagon will be your kitchen, serving up tasty grub.

Catskills Retreat Cabin

Franklin
New York, USA

ACTIVITIES: Long walks on dirt roads, relaxing in a hammock & bike rides through covered bridges

PHONE: 718-858-0093
WEB: www.CatskillsRetreatCabin.com
CAPACITY: 6 people: 2 bedrooms & a loft
OPEN: Year-Round, 2 night minimum stay

RATES: Around $450 per weekend or $900 per week for the entire cabin. Pets are allowed

LOCATION: 180 miles (3.5 hours) northwest of New York City

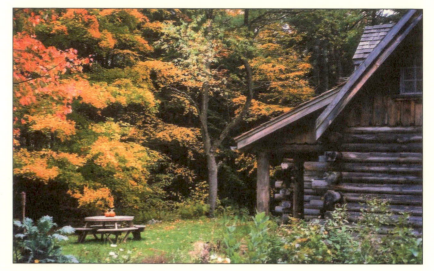

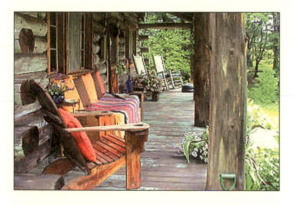

Just three-and-a-half hours from New York City is one of the most refreshing country cabins in the Northeast. At the edge of the Catskill State Park in the historic village of Franklin, *Catskills Retreat Cabin* will take you back in time to when things happened at a slower pace and relaxing was an essential part of everyday life. A hawthorn grove, flower garden and apple orchard surround this little slice of heaven. There's even a little creek that wanders through the backyard.

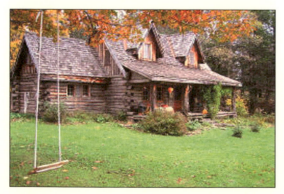

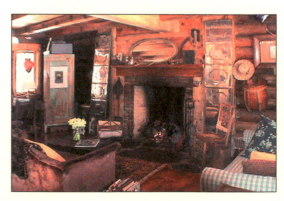

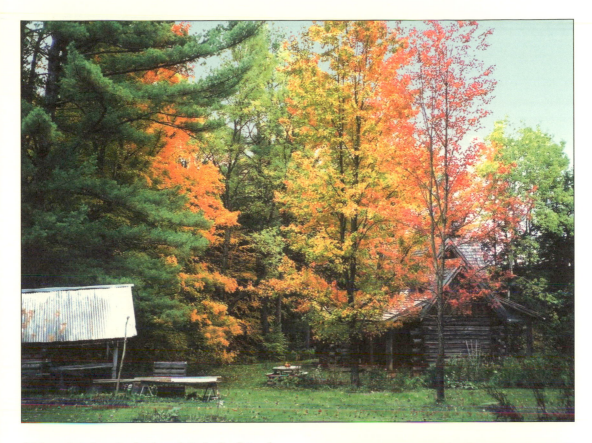

Although it has the look and feel of a Lincoln-era cabin, it still offers all the modern amenities that we are now accustomed to. There are two full bedrooms, a cozy loft bedroom, country kitchen with wood-burning stove, and a wood-burning fireplace in the dining and living area.

There's no need to push yourself here. It's all about relaxation. Read a book or take a nap in the hammock, stroll along the dirt roads looking for squirrels, or dust off the sticks for a round of golf at the local course.

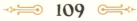

Dry Island

ACTIVITIES: Hiking, biking, fishing, canoeing, sailing, water skiing, swimming, golf & tennis

PHONE: 518-359-9494
WEB: www.AdkDryIsland.com
CAPACITY: 10 people: main lodge rooms & cabins
OPEN: Year-Round, 3 night minimum stay

RATES: Around $4,000 per night for the entire lodge & island. Includes all meals & owner's staff

LOCATION: 300 miles (5 hours) north of New York City

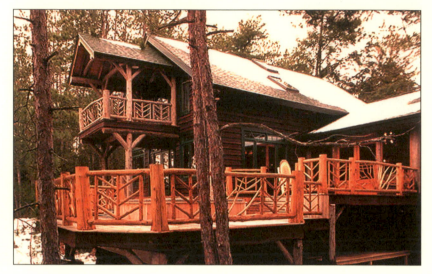

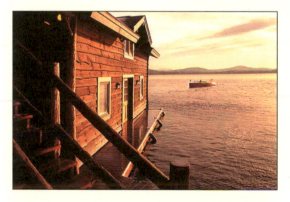

Of the 100 places in this book, *Dry Island* is probably the most exclusive of them all. If money is no object and you would like to rent an entire island (complete with a very luxurious, but still rustic, Adirondack retreat), then look no further. Rates include the owner's staff of a boatman, chef and housekeeper, carte blanche use of the facility, three meals per day, afternoon tea, sports equipment, water sports, and unlimited wine, liquor and snacks. Not too shabby.

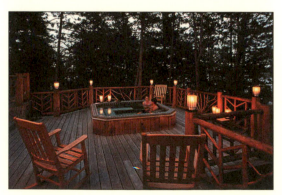

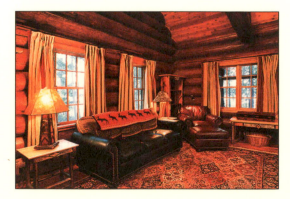

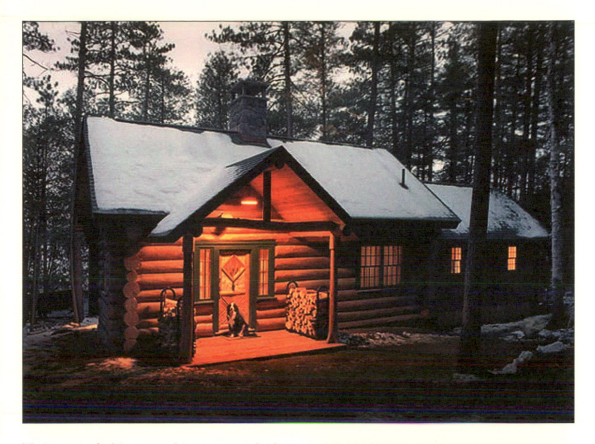

If this sounds like something you might be interested in (and who wouldn't be), they will start you off in style. You will be greeted with champagne and hors d'oeuvres during your short ten-minute boat ride to the island. From there, it just gets better: gourmet meals, afternoon tea, sailing and extreme pampering. Of course, what private island retreat would be complete without an outdoor hot tub to soothe those aching croquet muscles? What are you waiting for? Live it up!

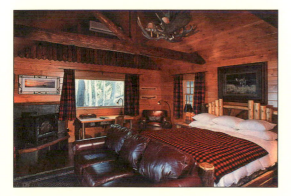

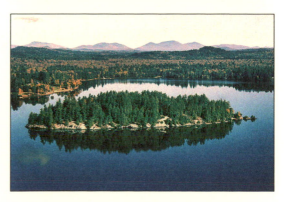

Elk Lake Lodge

North Hudson
New York, USA

ACTIVITIES: Hiking, fishing, canoeing, wildlife viewing, swimming, picnicking & relaxing

PHONE: 518-532-7616
WEB: www.ElkLakeLodge.com
CAPACITY: 54 people: 6 lodge rooms & 8 cottages
OPEN: May to mid October, 2 night minimum stay

RATES: Around $125-$175 per person per day. Includes meals

LOCATION: 240 miles (4 hours) north of New York City, 120 miles (2 hours) south of Montreal

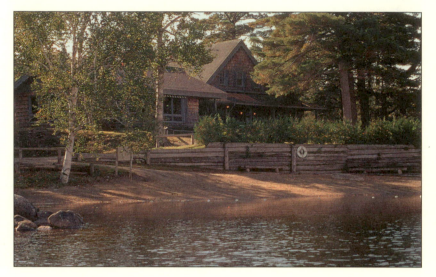

Elk Lake Lodge is an Adirondack hideaway that is just what the doctor ordered. Whether it is a romantic weekend or a family vacation that you are interested in, everyone in your party will leave refreshed and revived from the peaceful surroundings. Located on a 12,000-acre, privately owned forest preserve, your only neighbors will be the resident birds and squirrels. The views are stunning, with several peaks to fix your gaze upon. Keep an eye out for these natural high rises: Colvin, Dix, Macomb and Nippletop Mountains. The lodge provides use of its many rowboats and canoes to cruise around the 600-acre lake looking for that perfect picnic spot or a place to throw in a line.

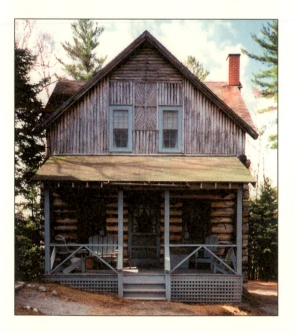

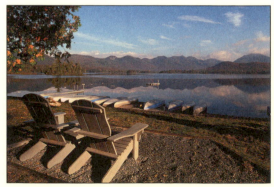

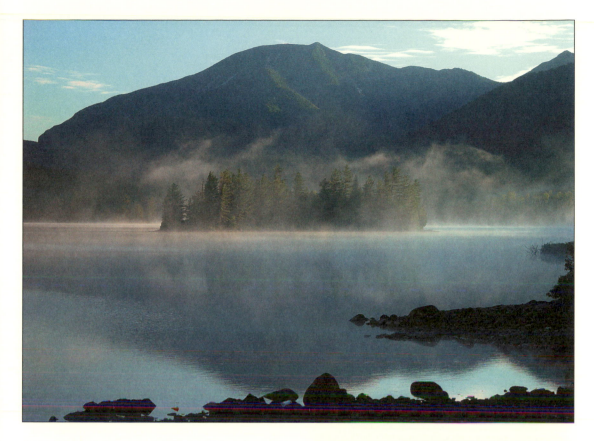

Aside from boating and fishing, there are over 40 miles of well-maintained hiking trails to choose from, and several of the trailheads are conveniently located close to the lodge.

The main lodge was built over a hundred years ago and features a large fieldstone fireplace framed by lovely Adirondack furniture. There are six comfortable rooms in the lodge, each with twin beds and a private bath. There are also eight private cottages, all with mountain and lake views.

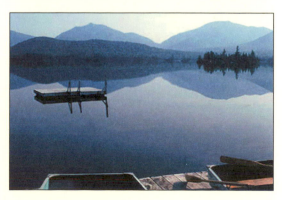

Lake Placid Lodge

ACTIVITIES: Guided hiking, horseback riding, boat tours, fishing, waterskiing, snowshoeing & skiing

PHONE: 877-523-2700 or 518-523-2700
WEB: www.LakePlacidLodge.com
CAPACITY: 86 adults: children under 14 are not allowed
OPEN: Year-Round, no minimum stay

RATES: Around $400–$1,300 per room per day. Includes breakfast & afternoon tea

LOCATION: 300 miles (5 hours) north of New York City

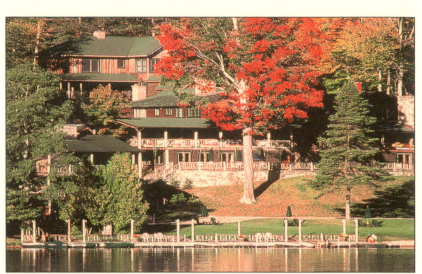

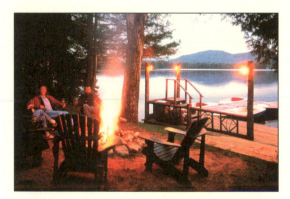

Twig, hickory and birch bark furnishings set the tone for the sophisticated vacationer at this magnificent Adirondack getaway. Set in the oldest mountain range in North America, *Lake Placid Lodge* boasts the best of the past and present on the shores of Upper Saranac Lake. Rustic elegance defines the exquisite decor. Each room, suite and cabin has a stone wood-burning fireplace, king or queen featherbed, deep soaking tub and original Adirondack artwork.

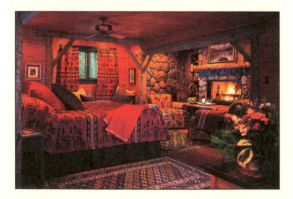

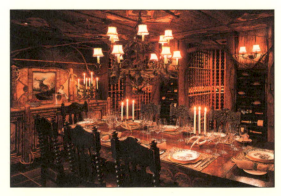

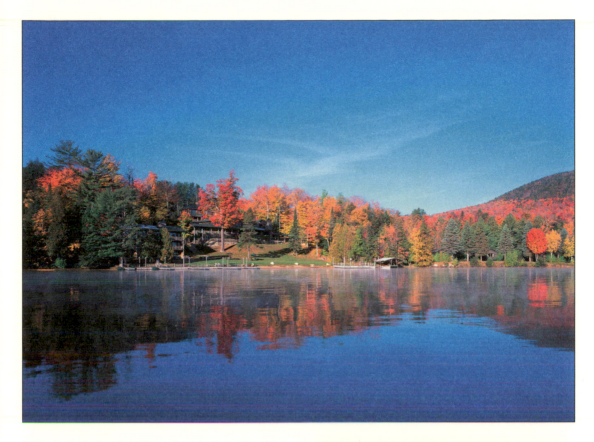

The main lodge buildings house two fireplace sitting rooms, a cozy pub, romantic twig-laced dining room, wraparound lakefront porch with an outdoor fireplace, and a private wine cellar dining room.

The lodge's highly acclaimed restaurant has sweeping views of Lake Placid and Whiteface Mountain. The chef prepares New American cuisine composed with classical French techniques using local organic products. Simply put, *Lake Placid Lodge* is outstanding in every way!

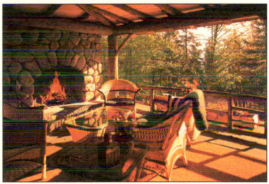

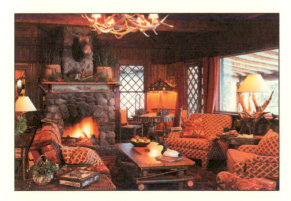

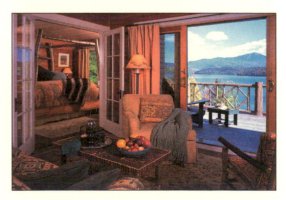

Timberlock

ACTIVITIES: Swimming, horseback riding, archery, badminton, ping-pong, volleyball & basketball

PHONE: 518-648-5494 or 802-453-2540
WEB: www.Timberlock.com
CAPACITY: 70 people: many cabins
OPEN: Late June to mid September, no minimum stay

RATES: Around $100-$200 per person per day. Includes meals

LOCATION: 110 miles (2 hours) north of Albany, 265 miles (5 hours) north of New York City

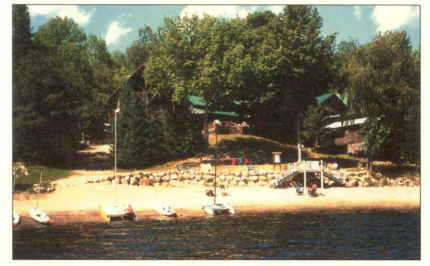

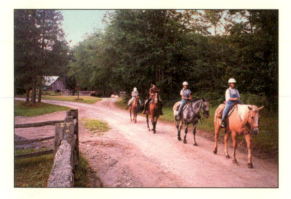

At *Timberlock*, it's all about the family. Not only is it one of the oldest Adirondack resorts, it's one of the best! Surrounded by miles of forest preserve and mountain views, the spectacular lakeside location is the ideal setting for strengthening family relationships. Keep in mind that *Timberlock* is not a luxury resort, they have elected to remain rustic and informal while retaining the original camp traditions. They still split wood, light the cabins with gas lamps and walk the same 100-year-old paths.

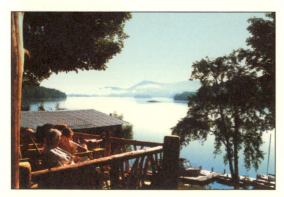

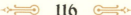

Sounds pretty rustic doesn't it? Well, yes, the cabins don't have electricity, but that seems to be one of the things that people like most about the resort. Simple but comfortable, the cabins are nestled along the shores of beautiful Indian Lake. Propane lights give off a warm, cheery light, while the wood stove takes the chill away on cold nights. Some cabins have bathrooms, while others share a community bathroom. Three hearty meals are served daily on the lodge's covered porch. You'll love it!

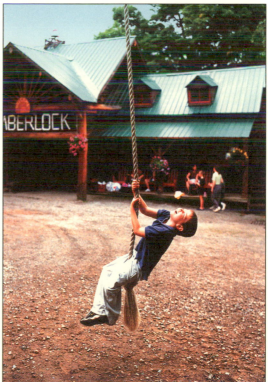

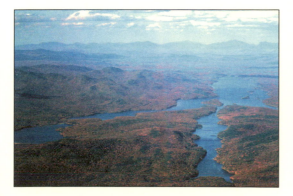

Turnstone Log Cabins

ACTIVITIES: Fishing, canoeing, kayaking, antiquing & hiking the Appalachian Trail

E-MAIL: info@TurnstoneCabins.com
WEB: www.TurnstoneCabins.com
CAPACITY: 18 people: 4 Appalachian log cabins
OPEN: Year-Round, 2 night minimum stay

RATES: Around $100-$150 per couple per day

LOCATION: 80 miles (1.5 hours) southwest of Asheville, 120 miles northeast of Atlanta, GA

Enjoy the best the mountains of North Carolina and Georgia have to offer by visiting *Turnstone*. Located on the border of the two states and nestled alongside the 24,500-acre Nantahala Wilderness Area and Standing Indian Wildlife Reserve, here you will find more clean mountain air than you ever thought existed. Whether you are looking for an active or relaxed vacation, there is something for everyone. Activities range all the way from hiking the Appalachian Trail to just relaxing on the front porch.

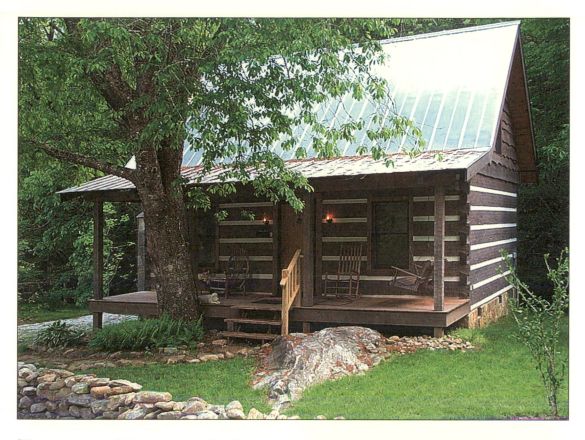

The rustic turn-of-the-century-style cabins rest peacefully in the trees on Betty's Creek and offer a long list of modern conveniences, including a full kitchen and beautiful rock fireplace. Your senses will be overwhelmed with the sweet scent of wildflowers and the soothing sound of the stream while barbequing on the back porch with friends or family. Keep an eye out for wild turkeys, which often gather around the pond in the mornings. Every season is special, but the fall colors are truly spectacular!

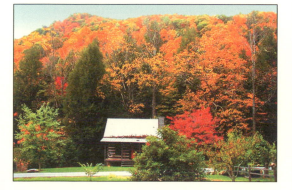

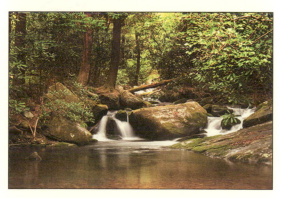

Heartland Country Resort

Fredericktown / Chesterville
Ohio, USA

ACTIVITIES: Horseback riding, feeding the farm animals & spending time with your family

PHONE: 800-230-7030 or 419-768-9300
WEB: www.HeartlandCountryResort.com
CAPACITY: 21 people: 3 suites in a large log cabin
OPEN: Year-Round, no minimum stay

RATES: Around $100-$200 per suite per day. Includes breakfast. Pets & horses are allowed

LOCATION: 60 miles (1 hour) northeast of Columbus

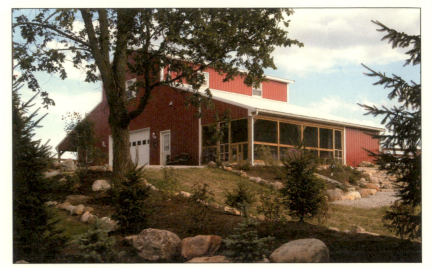

Heartland Country Resort is a Midwestern dream come true. Located in a serene and tranquil country setting of rolling hills, pastures, fields, and woodlands, this resort offers fun and relaxation for couples and families alike. Recreation includes horseback riding on wooded trails, feeding and grooming the horses and other farm animals, or just sitting on the porch, listening to the birds sing. If you don't know how to ride a horse, they offer English and Western riding lessons.

Lodging consists of three suites in a large log home located on a wooded hillside at the north edge of the resort's 100+ acres. You will enjoy the lovely cathedral ceilings, fireplaces, Jacuzzi tubs, porch swings and scenic views.

Area attractions include Amish country, Malabar Farm and Mohican State Park. They have a welcoming pet policy that includes horses. Just let them know, and they will prepare a stall for your steed. They also offer a Horse Lovers Camp for youth in the summer.

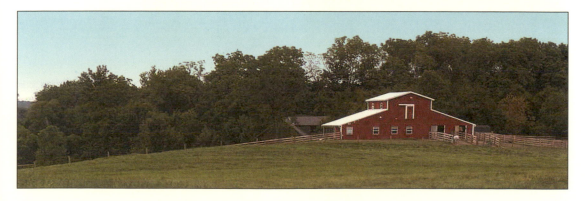

The Inn at Cedar Falls

Hocking Hills / Logan
Ohio, USA

ACTIVITIES: Hiking, antiquing, relaxing & exploring: caves, forests & waterfalls

PHONE: 800-65-FALLS or 740-385-7489
WEB: www.InnAtCedarFalls.com
CAPACITY: 50 people: cabins, cottages & inn rooms
OPEN: Year-Round, no minimum stay

RATES: Around $100–$250 per room or cabin per day. Includes breakfast

LOCATION: 60 miles (1 hour) from Columbus, 3 hours from Cincinnati

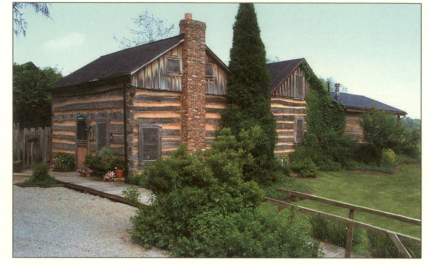

Surrounded by state parks on three sides, there is a long list of fantastic outdoor activity options at *Cedar Falls*. You can explore hidden caves, photograph beautiful waterfalls or climb huge rock formations. Other less strenuous options include browsing little antique shops and touring old abandoned iron furnaces. And, of course, you must visit the famous Hocking Hills Flea Market. To satisfy the hearty appetite you will most definitely develop, *Cedar Falls* has their own excellent on-site restaurant.

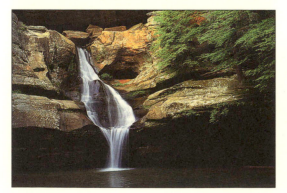

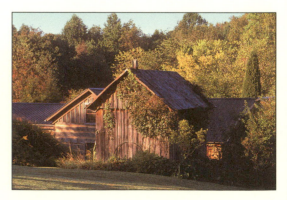

The inn offers nine antique-filled bed and breakfast rooms, each furnished with two twin beds or a queen-size bed, small writing desk, comfortable sitting chair and a private bath. There are also six renovated pioneer-era log cabins. Each has its own cooking facilities, gas log stove, whirlpool tub and a deck with a porch swing that looks out onto a wooded lot. The cottages feature a two-person whirlpool tub, separate shower, gas log stove and small refrigerator. Fresh-baked cookies are waiting!

Rebel Hill Ranch

Antlers
Oklahoma, USA

ACTIVITIES: Horseback riding, canoeing, fishing, campfires, wagon rides & wildlife viewing

PHONE: 580-298-2851
WEB: www.RebelHillRanch.com
CAPACITY: 40 people: cabins, covered wagon & train car
OPEN: Year-Round, 2 night minimum stay on weekends

RATES: Around $100-$150 per cabin per day

LOCATION: 150 miles (2.5 hours) south of Tulsa, 160 miles (3 hours) northeast of Dallas, TX

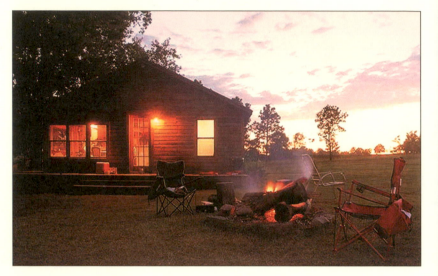

Home to over 100 horses, *Rebel Hill* is a third generation working horse ranch that offers non-stop activities combined with cozy relaxing accommodations. With the ranch's 15-acre lake and six ponds, it's also home to plenty of wildlife, including squirrels, raccoons and deer. Interested in seeing more wildlife? From your deck, you can watch the beavers building all kinds of things while the ducks and geese look on. The ranch even has their own wildlife park with elk, deer, llamas, wild hogs and goats.

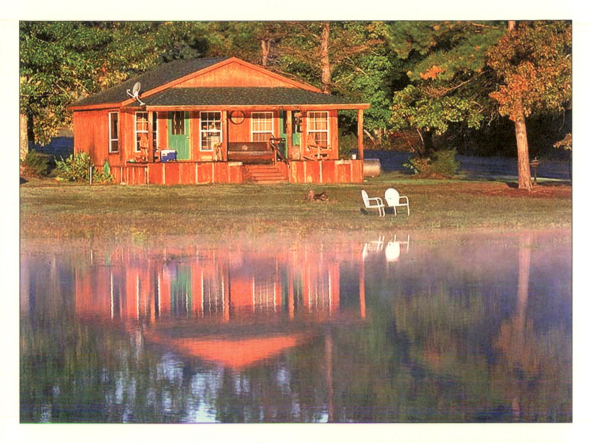

The charming lakeside cabins have everything you will need for a great vacation. They come with dishes, utensils, barbeque pits, picnic tables and firewood. For a more unique accommodation option, they also offer a covered wagon and an 80-foot Victorian passenger train.

The horseback riding is fabulous. So be sure to dig out those dusty old cowboy boots hidden somewhere up in the attic before heading out to the ranch. Don't worry though, if you can't find 'em, you can still go fishing!

Lake of the Woods Resort

Klamath Falls
Oregon, USA

ACTIVITIES: Waterskiing, fishing, sailing, hiking, canoeing, cross-country skiing & snowmobiling

PHONE: 866-201-4194 or 541-949-8300
WEB: www.LakeOfTheWoodsResort.com
CAPACITY: 120 people: 26 (1 & 2 bedroom) cabins
OPEN: May 15th to Sept. 30th & mid Dec. to March

RATES: Around $100-$300 per cabin per day. Meals can be purchased in the main lodge. Pets allowed

LOCATION: 36 miles from Ashland, 36 miles from Medford

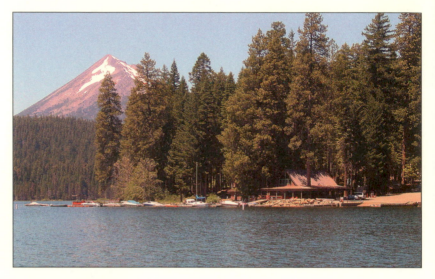

Lake of the Woods Resort offers excellent hiking and wildlife viewing opportunities. Towering forests with cascading streams and wildflowers are the norm here. Don't be surprised if a deer, rabbit, beaver or raccoon introduces itself to you along the trail. Must-see sights include the famous Crater Lake and the upper Klamath Lake, which is a nationally known feeding spot for migrating ducks and geese. If that's still not enough to keep you busy, the incredibly scenic Pacific Crest Trail is just 20 minutes away.

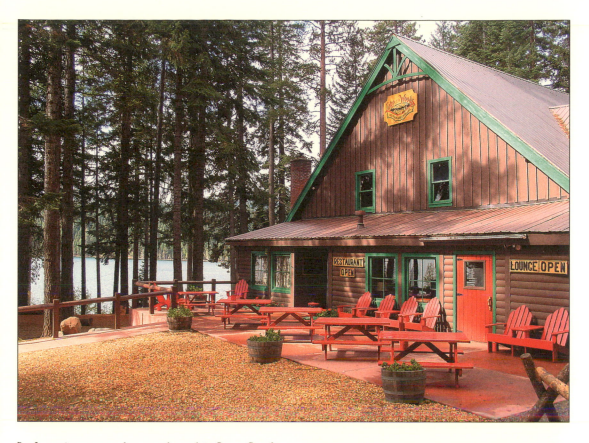

It doesn't get any better than this for a family vacation. There is no way that you could possibly run out of things to do here. And you can rent everything imaginable right from the resort's marina. They have great equipment, including canoes, paddle boats, patio boats, motorboats and fishing gear. In the winter, you can rent ice skates, cross-country skis and snowshoes. Pack up the kids and head out to an authentic and historic 1925 old-fashioned resort in the Oregon Cascades!

Olallie Lake Resort

Mt. Hood National Forest
Oregon, USA

ACTIVITIES: Fishing, boating, swimming, hiking, biking, horseback riding & berry picking

PHONE: 541-504-1010
WEB: www.OlallieLake.com
CAPACITY: 73 people: cabins, yurts & a campground
OPEN: July through Oct., minimum stay on weekends

RATES: Around $75-$150 per cabin per day. Pets are allowed

LOCATION: 92 miles (2.5 hours) southeast of Portland, 80 miles (2 hours) east of Salem

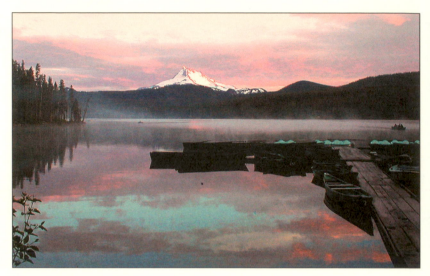

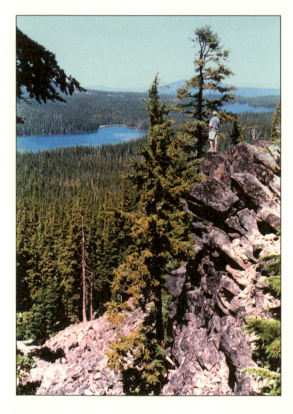

Since 1933, *Olallie Lake Resort* has catered to families, anglers and outdoor enthusiasts in a friendly and relaxed atmosphere. The area's scenery is simply stunning, with the majestic Mount Jefferson dominating the landscape. You will also find crystal clear waters and magnificent meadows ablaze with wildflowers. The evenings can be just as special, with an endless sea of stars blanketing the sky. Geological buffs will love the area's unique rock formations, created by ancient lava flows.

The remote location of *Olallie Lake* adds to the overall allure of the destination. This will quickly become apparent on the final stages of your drive to the resort. The last seven miles are on a long tree-lined gravel road.

Hidden among the pines are wilderness yurts, wooden cabins and campground sites. The lakefront cabins have remained in their original rustic fashion from the days of early settlers, with wood stoves for heat and front porches for visiting with neighbors.

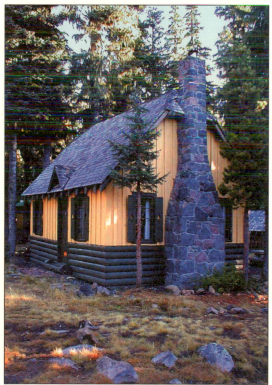

Out 'n' About Treesort

Cave Junction
Oregon, USA

ACTIVITIES: Tree climbing, rappelling, horseback riding, hiking, biking, swimming & crafts classes

RATES: Around $100-$200 per treehouse per day. Includes breakfast

LOCATION: 30 miles southwest of Grants Pass, 60 miles from Medford

PHONE: 541-592-2208
WEB: www.TreeHouses.com
CAPACITY: 36 people: 18 different treehouses
OPEN: Year-Round, 2 night minimum stay (May-Oct.)

What could possibly be more uniquely rustic than sleeping in a treehouse? Sounds like fun, doesn't it? These treehouses are not like the ones you had when you were a kid: unless you were an extremely lucky kid. These are unbelievably deluxe, with 18 different kinds of treehouses ranging in elevation from eight to 52 feet off the ground, along with six really neat swinging bridges. Some of the more interesting names for the treehouses are the Swiss Family, the Cavaltree, the Treeloon, the TreePee and the Serendipitree. How luxurious are some of these treehouses? The two-story luxury cabin treehouse has a queen bed upstairs, in addition to a double futon and single rollaway downstairs. It also has a bathroom with a shower and kitchenette.

To get you in the swing of things, they offer a basic tree climbing/rappelling course. There's plenty to do on the ground, too. They have a swimming pool, campfire site, and barbeques. You can also take one of their fun crafts classes.

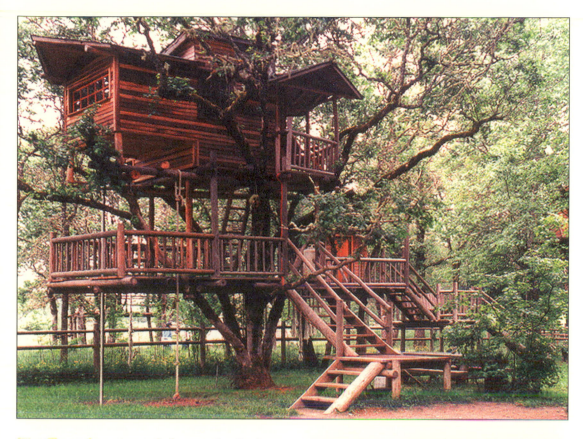

The *Treesort* has 36 wooded acres that back up to the national forest. This gives you plenty of room to roam around, along with their 13 horses, eight chickens, three dogs and two cats.

Of course there are other adventurous vacation sites in Oregon, but only one where you can lit-treely go out on a limb while you're there. If you have kids, they will absolutely love the idea of staying in a treehouse! Branch out and try something different, it might just be your favorite vacation ever!

Weasku Inn

Grants Pass
Oregon, USA

ACTIVITIES: Antiquing, canoeing, kayaking, golf, fishing, hiking, shopping & visiting museums

PHONE: 800-493-2758 or 541-471-8000
WEB: www.Weasku.com
CAPACITY: 34 people: 5 lodge rooms, 12 river cabins
OPEN: Year-Round, no minimum stay

RATES: Around $200-$300 per room or cabin per day. Includes breakfast

LOCATION: 140 miles (2.5 hours) north of Eugene, 250 miles (4 hours) south of Portland

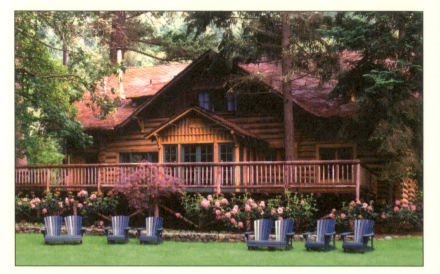

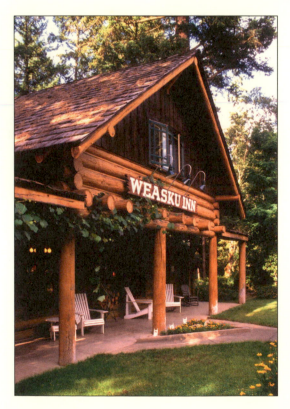

Built as a secluded fishing lodge, the historic *Weasku Inn* once hosted the likes of President Herbert Hoover, Zane Grey, Walt Disney, Clark Gable and Carole Lombard. A complete renovation has returned the inn to its former glory. Situated on the banks of the dramatic Rogue River and surrounded by dense forest, this romantic hideaway awaits anyone who enjoys the fragrant scent of towering pines. In the evenings, guests are treated to a relaxing wine and cheese gathering.

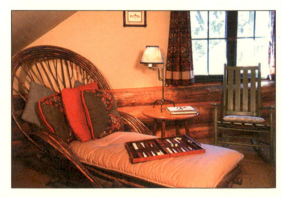

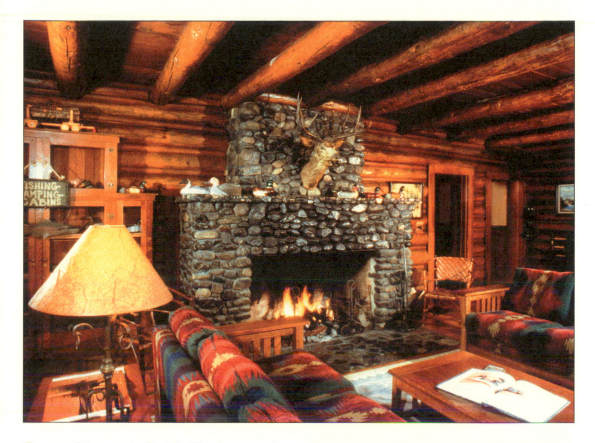

Decorated in a rustic, Pacific Northwest-style, soothing colors and warm accents make the rooms extremely inviting. Most of the accommodations offer a whirlpool tub, river rock fireplace and views of the river. Prepare yourself for a deep, restful sleep at the *Weasku*.

There's great antiquing, live theater and winery tours in the area. Or, if you are looking for more adventure, the inn's staff can help you plan additional activities, including wilderness fishing and whitewater rafting trips.

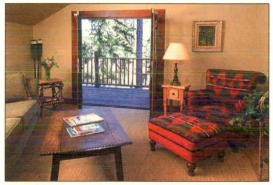

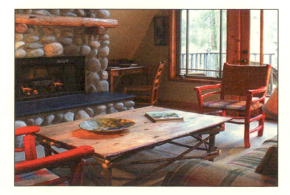

Weatherbury Farm

Avella
Pennsylvania, USA

ACTIVITIES: Picnicking, relaxing on the porch, napping in a hammock & catching fireflies

PHONE: 724-587-3763
WEB: www.WeatherburyFarm.com
CAPACITY: 26 people: in restored historic farm buildings
OPEN: Year-Round, no minimum stay

RATES: Around $150 per room per day. Includes breakfast

LOCATION: 35 miles (50 minutes) southwest of Pittsburgh

The beauty of visiting a farm (as opposed to living there) is that when the rooster crows at dawn, you don't have to get up. Instead, you can stay in bed until you smell the sausage cooking. You will awaken each morning to the aroma of a farm-fresh breakfast, which includes family favorites such as apple-cinnamon pancakes or creamy peach-filled French toast. Steeped in tradition, this farm oozes old-school ways of living and relaxing. Your days will be filled with helping out with farm chores or, if you prefer, just sitting on the porch drinking lemonade. Other options include having a picnic in a meadow under the shade of a giant oak or taking a dip in the swimming pool on a hot summer day.

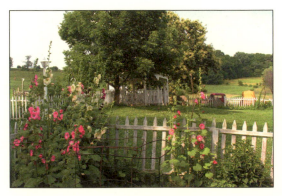

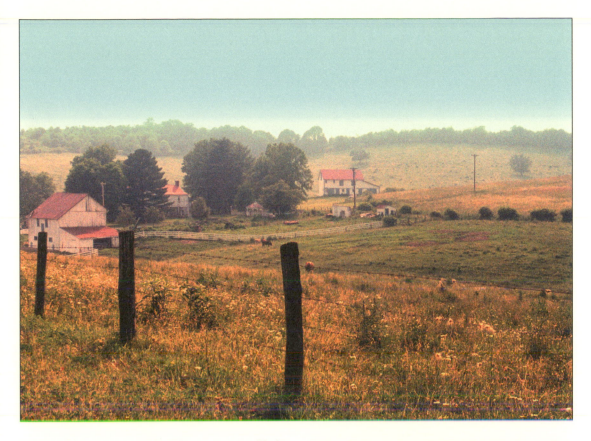

Weatherbury is a great family vacation. Kids often see animals at the zoo, but that doesn't compare to the thrill of actually living with them. Children of all ages will enjoy getting acquainted with the goats, rabbits, ducks, chickens, geese, sheep and cows.

This place is indeed a paradise for nature lovers, artists and photographers. In the evening, you can sit on the porch swing and watch the fireflies dance around or gather in the music room and enjoy the player piano.

Lajitas, The Ultimate Hideout

Lajitas
Texas, USA

ACTIVITIES: Horseback riding, swimming, golf, tennis, spa treatments & shopping

PHONE: 877-525-4827 or 432-424-5000
WEB: www.Lajitas.com
CAPACITY: 200 people: 92 rooms
OPEN: Year-Round, no minimum stay

RATES: Around $250-$750 per room per day (kids under 12 stay free). Includes some activities. Pets are allowed

LOCATION: 250 miles (5 hours) south of Midland

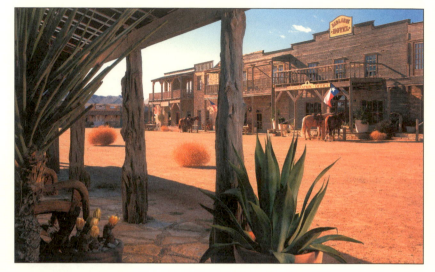

Imagine a place where the Comanche Indians once roamed, Pancho Villa led raids across the Rio Grande, and cowboys sat around an open campfire: Welcome to *Lajitas*. Formerly the ultimate hideout for bandits running from the law, today *Lajitas* is the ultimate hideout for sophisticated travelers who want a respite from the stresses of corporate life. Create your own history at this exquisite 25,000-acre private resort, which is tucked between Big Bend National Park and Big Bend State Park.

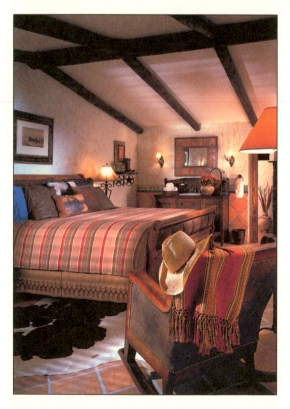

Plush accommodations will make your western experience more than comfortable. Try the cowboy chic of their Cavalry Post rooms or the rustic elegance of their Officers' Quarters suites. Don't forget to leave your robe and slippers at home, as they provide both.

Relaxing trail rides, naps by the pool, treatments at the Agavita Spa, or golfing at the Ambush Golf Course are all options for the day. You can also casually ask that famously proper question, "Tennis, anyone?"

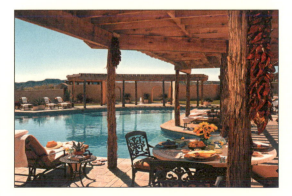

Pipe Creek Ranch

Pipe Creek (near Bandera)
Texas, USA

ACTIVITIES: Fishing, canoeing, hiking & mountain biking: several miles of excellent trails

PHONE: 214-369-8703
WEB: www.PipeCreekRanch.com
CAPACITY: 6 people: 3 lodge bedrooms
OPEN: Year-Round, 2 night minimum stay

RATES: Around $300-$400 per couple per day. Discounted rates for longer stays

LOCATION: 45 miles (1 hour) northwest of San Antonio, 110 miles south of Austin

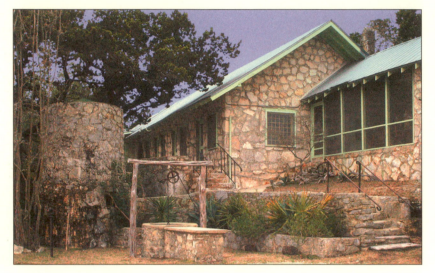

Pristine landscapes, scenic valleys and ancient canyons are what you will find when you visit *Pipe Creek Ranch*. Secluded from the outside world and fully self-contained, you have to look close to find it. Once you do, however, you will feel like an adventurer who just discovered a hidden treasure. Deep in the heart of the Texas Hill Country, this amazing 5,000-acre ranch will transform you. It is the perfect place to relax, rejuvenate and restore.

The lodge is situated on the side of one of the highest hills on the ranch. Built at the turn of the last century from stones rolled down from the ridge, it offers simplistic country charm coupled with all the modern conveniences one would expect to find in a lovely Texan home.

There are seven beautiful spring-fed lakes on the property, all with fantastic catch-and-release fishing, canoeing, swimming and paddle boating. You must take an early evening boat ride: They are magical.

The Lodge at Red River Ranch

Teasdale
Utah, USA

ACTIVITIES: Fly-fishing, trapshooting, horseback riding, mountain biking, ATV & Jeep rentals

PHONE: 800-205-6343 or 435-425-3322
WEB: www.RedRiverRanch.com
CAPACITY: 40 people: 15 guest rooms
OPEN: Year-Round, no minimum stay

RATES: Around $150-$250 per room per day

LOCATION: 215 miles (3.5 hours) from Salt Lake City, 5.5 hours from Las Vegas

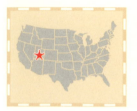

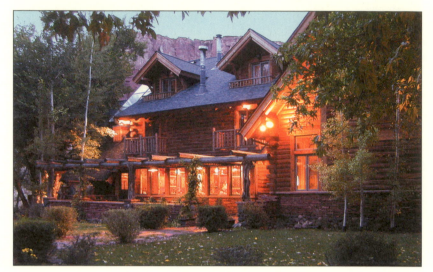

The thought of a "rustic vacation" likely conjures up a picture in your mind. The classic image is usually of a big log lodge with high ceilings, a large fireplace and a variety of wild animal heads hanging on the walls. *The Lodge at Red River Ranch* fits that image to a tee. Built on the grand scale of the great western lodges with open-beam construction and a massive floor-to-ceiling Anasazi-style fireplace, you will feel the power that it possesses. The lodge features a piano, game nook and furniture arranged for intimate conversation, along with a reading alcove with plenty of books and magazines. During your stay, make sure and save some time to visit the magnificent towering red rocks of the Capitol Reef National Park, one of the true treasures of Utah.

An especially scenic area, *Red River Ranch* is comprised of over 2,000 acres of grass and sage pastures, alfalfa fields and river bottoms. They offer fantastic fly-fishing on six private miles of the Fremont River, so don't forget to bring your gear!

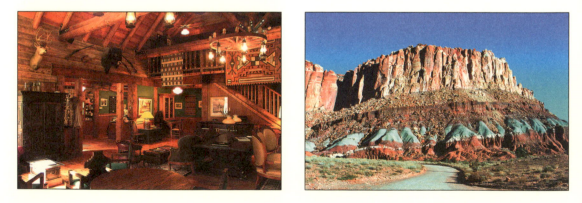

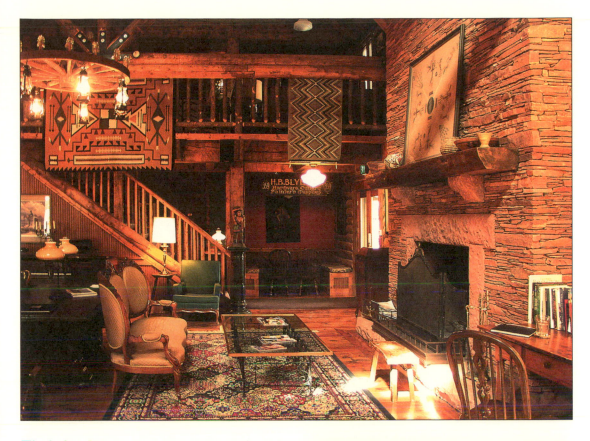

The lodge features 15 guestrooms, each with its own fireplace, step-out balcony and in-room music. Additionally, each room is tastefully decorated with antique furnishings and rustic artifacts. The lodge also has a few more luxurious rooms that can comfortably accommodate additional guests; they feature added amenities such as loveseats, sofas and desks. And, as if all of this isn't already enough, they also offer a lovely recreation room and home theater.

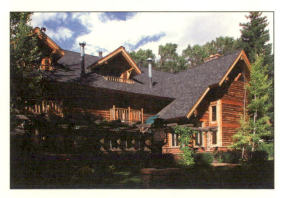

Sorrel River Ranch Resort

Moab
Utah, USA

ACTIVITIES: Horseback riding, hiking, mountain biking, golfing, fishing, river rafting & Jeep tours

PHONE: 877-359-2715 or 435-259-4642
WEB: www.SorrelRiver.com
CAPACITY: 140 people: riverfront rooms & family suites
OPEN: Year-Round, 2 night minimum stay

RATES: Around $200-$400 per room per day

LOCATION: 120 miles (2 hours) west of Grand Junction, Colorado, 240 miles (4 hours) southeast of Salt Lake City

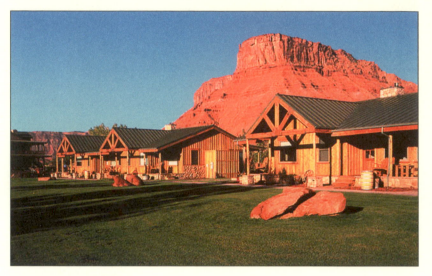

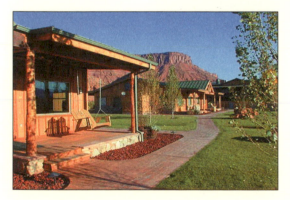

You haven't lived until you've seen the majestic red rock formations around Moab, Utah. The area offers visits to the renowned Arches National Park and Canyonlands National Park, two of the country's most visited preserves. These sights are a photographer's dream (especially at sunrise and sunset, when the warm colors intensify the deep red-orange of the rock). This slightly cooler time of day is perfect for taking a hike along the river while basking in the magical glow of the mountains.

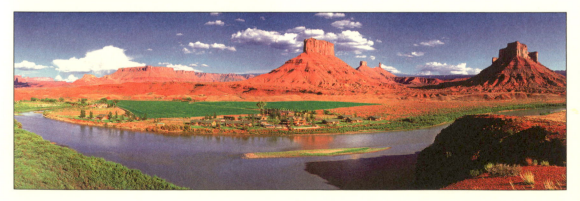

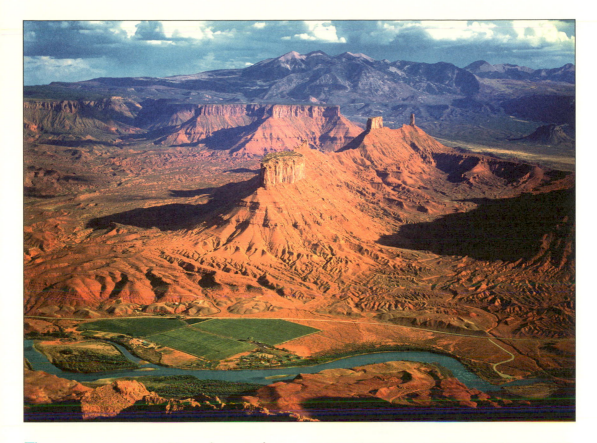

There are numerous activities to keep you busy while at the ranch. There's a swimming pool, hot tub and fitness center along with a fantastic spa, which offers traditional massage as well as hot rock massage and aromatherapy treatments.

Sorrel River's lodging options are almost as varied as their activities. You'll have the option of choosing from spacious river-view deluxe suites to mountain-view rooms with red rock vistas. Every room has a kitchenette, porch swing and handcrafted western decor.

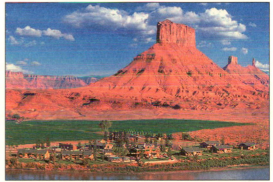

Moose Meadow Lodge

Waterbury
Vermont, USA

ACTIVITIES: Hiking, biking, fishing, antiquing, cross-country skiing, snow-shoeing & snowmobiling

PHONE: 802-244-5378
WEB: www.MooseMeadowLodge.com
CAPACITY: 8 people: 4 lodge rooms
OPEN: Year-Round, 2 night minimum stay

RATES: Around $150-$200 per room per day. Includes breakfast

LOCATION: 30 miles from Burlington, 120 miles (2 hours) from Montreal, 150 miles from Manchester

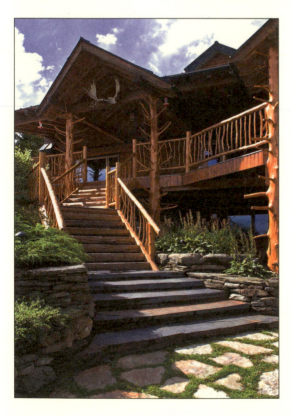

Quietly nestled in the lush Green Mountains on a private 86-acre estate, *Moose Meadow Lodge* is indeed one of Vermont's best kept secrets. From the moment you arrive, the long tree-lined driveway will slowly ease you into a feeling of peace. Continuing the tradition of the great camps of the Adirondack Mountains, you will feel like a part of the family. Surrounded by maple, spruce and birch trees, the 4,000-square-foot lodge provides the ultimate escape for anyone looking to just get away and relax.

Decorated with antler lamps, fishing rods and Amish twig rocking chairs, the living room exudes a warm, rustic charm. Days can easily be filled sitting by the fire, reading a book and sipping tea. For the more active or adventurous person, the options are quite lengthy. You can spend the afternoon hiking, biking, fishing, cross-country skiing or snowshoeing. For antique hounds, there are several great shops nearby. Whatever your pleasure, *Moose Meadow* is the perfect place to do everything or nothing at all.

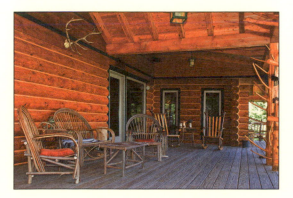

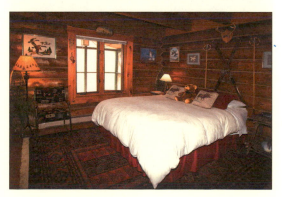

Three Sisters Log Cabin

Montebello
Virginia, USA

ACTIVITIES: Hiking the Appalachian Trail, fishing, horseback riding, relaxing, antiquing & skiing

PHONE: 540-377-9945
WEB: www.3-Sisters-Log-Cabin.com
CAPACITY: 8 people: 1 queen bed, 2 twins & a loft
OPEN: Year-Round, 2 night minimum stay

RATES: Around $150-$200 per day for the entire cabin. Includes firewood & fishing poles

LOCATION: 55 miles west of Charlottesville, 120 miles from Richmond

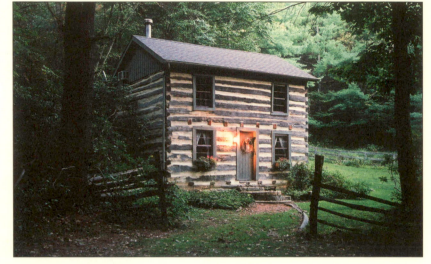

If you are looking to go back in time and sleep in the same type of cabin as our early settlers, then this is the place for you. *Three Sisters* is one of only a few surviving two-story log cabins along Virginia's scenic, world-renowned Blue Ridge Parkway. Although the cabin has retained all of its original charm and ambience, it has been fully restored and carefully modernized for your comfort. Complete with linens, firewood and fishing poles, you will be able to enjoy the cabin's solitude to the utmost.

If you decide to leave your cozy retreat and do some exploring, you are right in the center of many noted recreational and historical sites. There are endless Shenandoah Valley towns and attractions to visit nearby, and antiquing in this area is on a professional level. Or, if you are interested in a more active vacation, just beyond the cabin's split-rail fence are miles of hiking trails, including the famous Appalachian Trail. Other nearby activity options include horseback riding, trout fishing and skiing.

Guest House Log Cottages

ACTIVITIES: Relaxing, reading, golfing, scuba diving, kayaking, boating & mountain biking

PHONE: 800-997-3115 or 360-678-3115
WEB: www.GuestHouseLogCottages.com
CAPACITY: 12 people: 1 log home & 5 cottages
OPEN: Year-Round, no minimum stay

RATES: Around $200-$350 per cottage per day. Includes breakfast

LOCATION: 46 miles (1.5 hours) north of Seattle, 110 miles north of Olympia

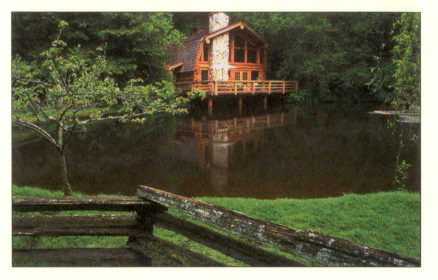

Guest House Log Cottages is exceptional. Situated on 25 wooded acres and bordered by forest and fruit trees, you will find five lovely cottages along with one very exceptional log home. If you are fortunate enough to reserve the log home, which overlooks a serene wildlife pond, it will be yours alone. Here, you can soak in the jetted tub or in the large bedroom Jacuzzi while watching the stars through a ceiling of glass. For even more romance, there's a large stone fireplace that's perfect for cuddling by.

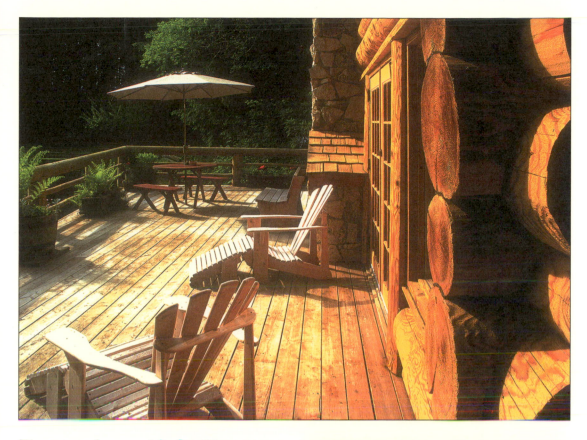

The cottages do a great job of sparking romance, and they all come complete with personal Jacuzzi tubs, fireplaces, fully equipped kitchens and plenty of reading material. They are individually decorated with quaint country antiques, adding warmth to the rooms.

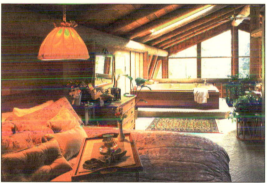

You can choose to spend most of your time hidden away in your room, watching movies from the giant, complimentary movie library, or, if you prefer, strolling the property's lush, flower-filled grounds. Romance awaits you!

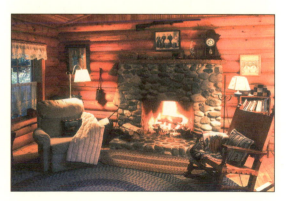

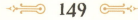

Mountain Springs Lodge

Leavenworth
Washington, USA

ACTIVITIES: Horseback riding, fishing, wagon rides, snowmobiling & sleigh rides

PHONE: 800-858-2276 or 509-763-2713
WEB: www.MtSprings.com
CAPACITY: 100 people: lodge rooms & private cabins
OPEN: Year-Round, 2 night minimum stay

RATES: Around $200-$300 per room or cabin per day

LOCATION: 120 miles (2.5 hours) east of Seattle, 200 miles (3.5 hours) west of Spokane

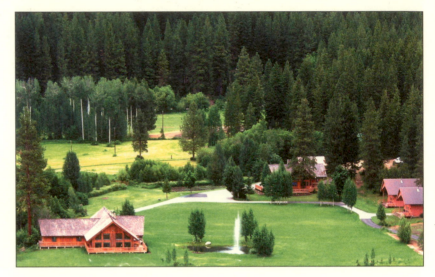

The pristine Beaver Valley, with its seemingly endless rolling meadows, bubbling creeks, trout-filled ponds, towering ponderosa pine trees and snow-capped Cascade Mountains, is where you will find *Mountain Springs Lodge*. Here, the simple pleasures in life are promoted, such as being able to look up in the sky and see the stars at night, going fishing with your kids or just relaxing on the porch. The lodge offers plenty of fun family activities. Summer is a great time for horseback riding, wagon rides, whitewater rafting, golf, fishing, mountain biking, canoeing, kayaking, hiking and barbeques. In the winter, choose between dogsledding, snowshoeing, cross-country skiing, sledding and snowmobile tours. They even offer wonderful old-time sleigh rides! Just imagine the thrill of hearing sleigh bells ring and feeling the crisp mountain air on your face as you glide across feathery meadows, beneath towering mountains and through aspens and evergreens. Sounds like fun, doesn't it?

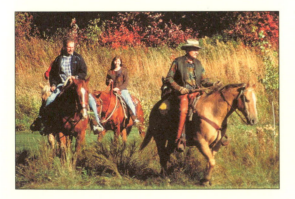

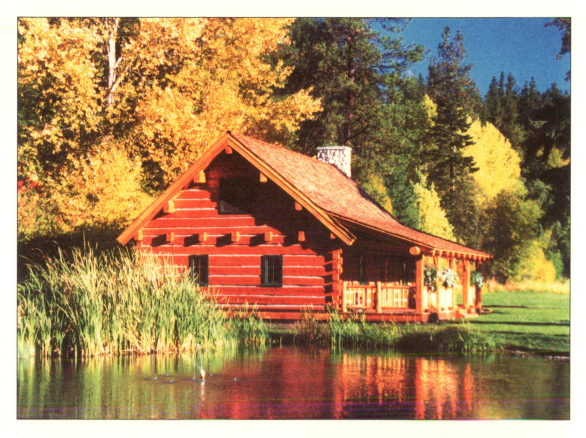

Constructed of native fir and pine, the cabins boast cathedral ceilings, river rock fireplaces, wraparound decks, rustic furnishings and plenty of room for comfort. For sightseeing and shopping, the quaint Bavarian town of Leavenworth is only 20 minutes away. There are also museums, movie theaters and festivals to keep you busy.

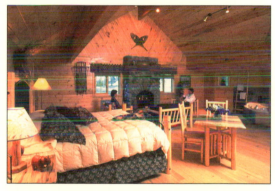

The lodge has been expertly created as a destination where guests can come to relax, unwind and rejuvenate. Here, you can sip hot spiced cider in front of a crackling fire while your kids brag about the snowman they made earlier that day. Dining is also very special, as *Mountain Springs Lodge* prepares delicious Northwest selections. For example, one night's meal might be prime rib, fresh-smoked fillet of salmon, seasonal vegetables, potatoes du jour, salad of wild greens, fresh-baked bread and homemade dessert. Vegetarian selections are also available. *Mountain Springs Lodge* is the perfect vacation spot to spend quality time with friends and family.

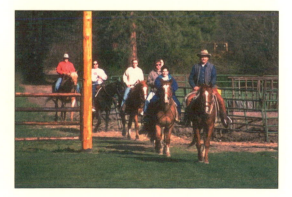

Justin Trails Resort

Sparta
Wisconsin, USA

ACTIVITIES: Bird watching, hiking, disc golf (18 basket course), cross-country skiing & snowshoeing

PHONE: 800-488-4521 or 608-269-4522
WEB: www.JustinTrails.com
CAPACITY: 18 people: farmhouse rooms & cabins
OPEN: Year-Round, minimum stay on weekends/holidays

RATES: Around $150–$350 per room per day. Includes breakfast. Pets allowed with prior approval

LOCATION: 190 miles (3.5 hours) from Milwaukee, 5 hours from Chicago

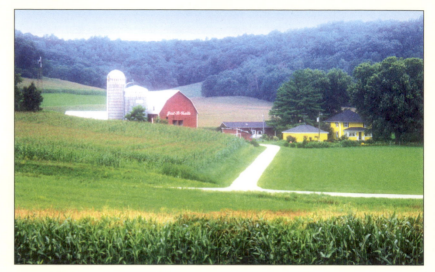

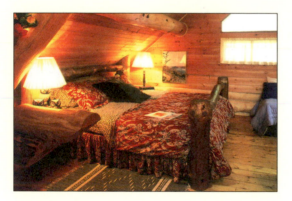

You've probably driven by them a thousand times, or maybe you've just seen pictures. Either way, everyone has at least wondered what it would be like to live on a farm. Here's your chance to finally see for yourself. Farms hold a very special place in American history, and taking a family vacation to one is a great opportunity to show yourself and your kids what America was built around. There used to be tons of family farms, but there's not that many left anymore (especially ones that allow guests).

Believe it or not, there's plenty of fun things to do on a farm, and on this farm in particular. They have an impressive 18-basket disc golf course that will keep you entertained for hours, if not days. Other less strenuous activities include watching squirrels gather nuts, relaxing in a rocking chair or counting the stars.

Justin Trails is an excellent example of a traditional Midwestern farm, and the nice folks there will take good care of you. Don't forget to enjoy the soothing sound of the crickets.

Flying A Ranch

Pinedale
Wyoming, USA

ACTIVITIES: Horseback riding, trapshooting, hiking & fishing (private ponds & nearby rivers)

PHONE: 888-833-3348 or 307-367-2385
WEB: www.FlyingA.com
CAPACITY: 14 adults: children are not allowed
OPEN: June through September, 1 week minimum stay

RATES: Around $1,500 per person per week. Includes meals & all ranch activities

LOCATION: 50 miles south of Jackson, 27 miles north of Pinedale

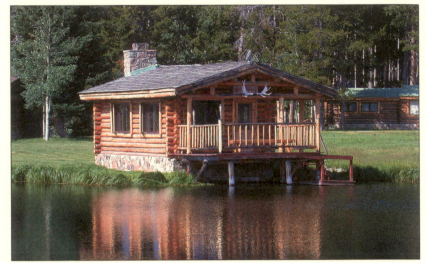

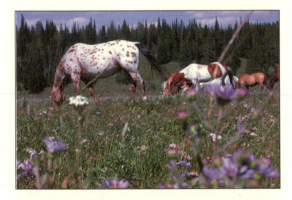

The *Flying A* is quite possibly the most beautiful guest ranch in the West. Tucked back in its own little valley, this ranch has it all: picture-perfect log cabins, incredible views, and a chef that could work at any of New York City's finest restaurants. Staying at the *Flying A* is roughing it without the rough part. At an elevation of 8,200 feet, the days are comfortable and the nights are crisp. And with access to more than 36,000 acres of the Bridger-Teton National Forest, the riding's phenomenal.

Built in the thirties, the 360-acre spread provides adults with an authentic western vacation, complete with scenic rides through groves of aspen and pine along with fishing in one of its two stream-fed ponds. The ranch can also arrange for expert guides to take you to nearby mountain lakes, streams and rivers.

All the cabins have private bathrooms, kitchenettes and wood-burning stoves or fireplaces, along with private porches for relaxing and enjoying the sunset over the mountains.

The Hideout at Flitner Ranch

Shell
Wyoming, USA

ACTIVITIES: Horseback riding, cattle drives, fly-fishing, trapshooting & real ranch work

PHONE: 800-354-8637
WEB: www.TheHideout.com
CAPACITY: 30 people: cabins, casitas & lodge rooms
OPEN: April through October, 4 night minimum stay

RATES: Around $300-$400 per person per day. Includes meals & all ranch activities

LOCATION: 6 miles from Greybull, 70 miles from Cody

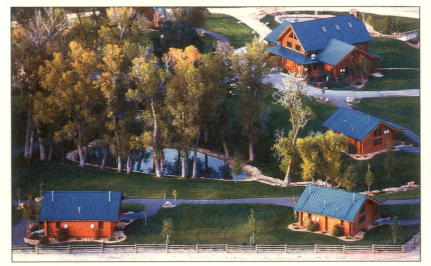

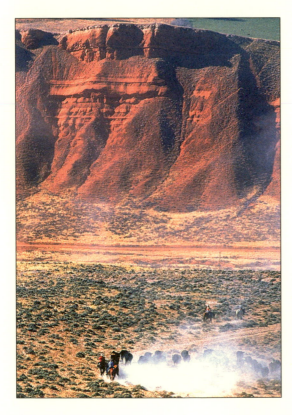

At the foot of the Big Horn Mountains in northern Wyoming, the historic *Flitner Ranch* is home to *The Hideout,* which has been owned by the same family for five generations. As a guest, you will get to work side by side with real cowboys and wranglers, helping them with real ranch work.

The ranch boasts a massive 5,000-square-foot log lodge complete with a great room, wood-burning fireplace, relaxation loft and cozy family room. It is impressive, in every aspect.

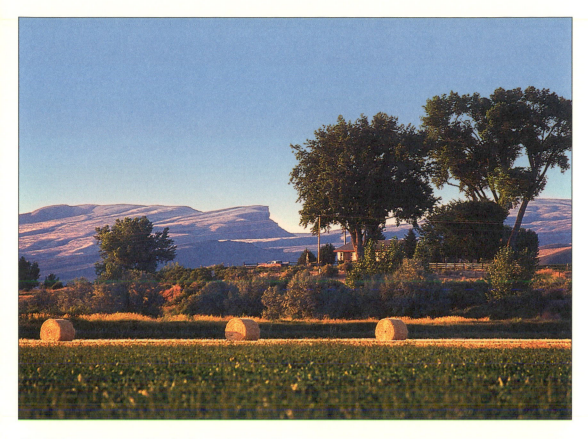

The Hideout is a unique blend of a working cattle ranch and an upscale guest ranch. Normally, you would have to choose between the two. At a working ranch, you often sacrifice a little luxury on the accommodations but gain a much more rewarding riding experience. At a guest ranch, you usually have special amenities and good meals but don't get the opportunity to participate in real ranch activities. At *The Hideout*, you get the best of both worlds: amazing accommodations *and* riding! Make it a tradition.

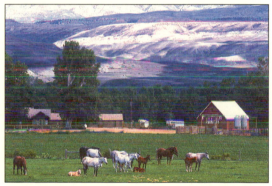

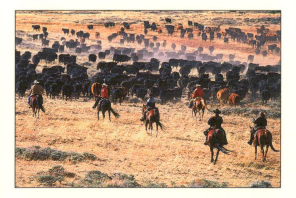

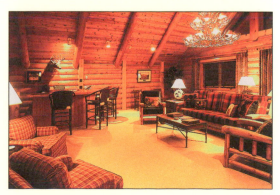

Lazy L & B Ranch

ACTIVITIES: Horseback riding, fishing, hayrides, barbeques & listening to cowboy poetry & songs

PHONE: 800-453-9488 or 307-455-2839
WEB: www.LazyLB.com
CAPACITY: 34 people: several cabins
OPEN: June to mid September, 1 week minimum stay

RATES: Around $1,300 per person per week (less for kids). Includes meals & ranch activities

LOCATION: 22 miles northeast of Dubois, 88 miles from Jackson Hole

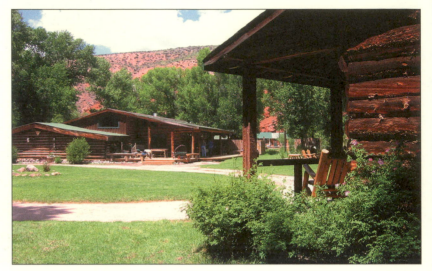

Back in the day, the *Lazy L & B* used to be an old sheep and cattle ranch that was originally settled by Scottish homesteaders. The area has since become known as "Scotch Valley." The ranch sits at 7,200 cool feet above sea level. The cabins are tucked in the cottonwood trees and arranged around a central courtyard beside a river. The lodge has a cozy fireplace, library and sitting area where you can enjoy evening entertainment filled with cowboy poetry and songs.

Surrounded by the Wind River, the Absaroka and the Owl Creek Mountains, the horseback riding is superb at the *Lazy L & B*. Amazing scenic vistas and endless trails will keep you in awe, and the fishing is equally incredible. There are several stocked ponds and rivers, including the famous Wind River. After a long day of activities, you will welcome the hearty ranch-style dinners with homemade breads and delicious desserts. Make sure and bring your appetite.

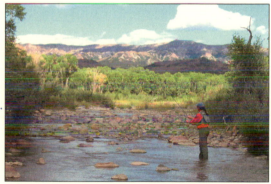

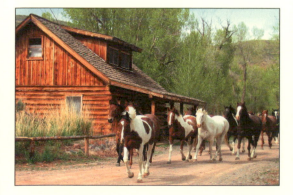

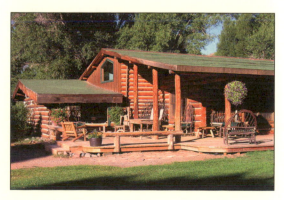

Trail Creek Ranch B&B

Wilson / Jackson Hole
Wyoming, USA

ACTIVITIES: Horseback riding, swimming, hiking fly-fishing & sightseeing: Jackson Hole & area

PHONE: 307-733-2610
WEB: www.JacksonHoleTrailCreekRanch.com
CAPACITY: 20 people: several cabins
OPEN: June through September & February to mid March

RATES: Around $200-$400 per room or cabin per day. Includes breakfast. Horseback riding is only available in the summer

LOCATION: 15 minutes from Jackson Hole

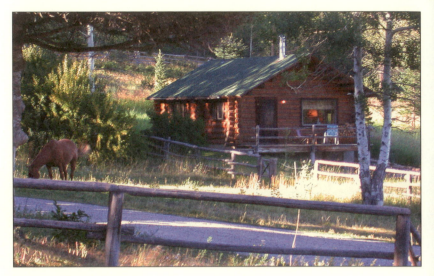

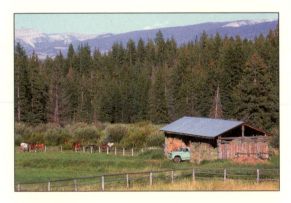

Some rustic vacation spots can be very remote and a real pain to get to. This is not the case with *Trail Creek Ranch*. It feels secluded and hidden, but it is actually just a short drive from the bustling resort town of Jackson Hole. This is a convenience that is not found at many other places. The ranch's location allows you to hang out on your porch, watching the horses playing in the meadow as the sun goes down, and still have plenty of time to go into town for cocktails and a nice dinner.

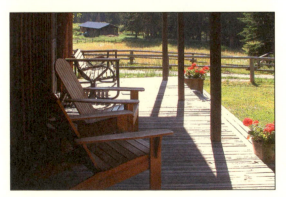

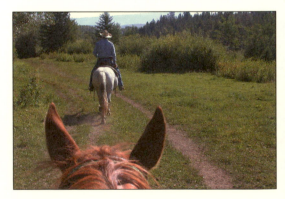

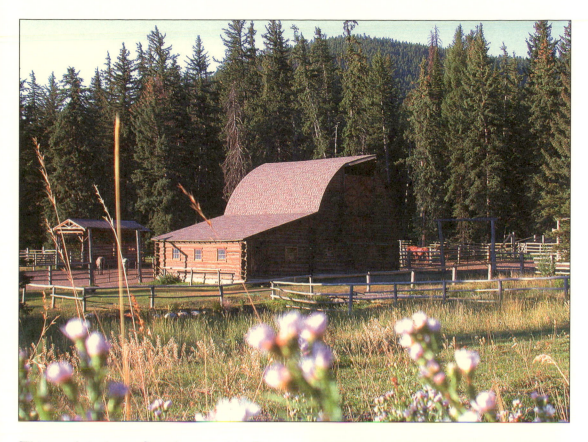

This ranch is the perfect place to visit if you have been considering a dude ranch vacation, but you just aren't sure you are up for that much horseback riding and that much isolation.

All of the accommodations are set amongst beautiful aspen trees and have porches with stunning views. Rest assured that you won't get tired of gazing out upon fields of brilliant wildflowers or the famous Sleeping Indian, which has been naturally carved out of the Gros Ventre mountain range.

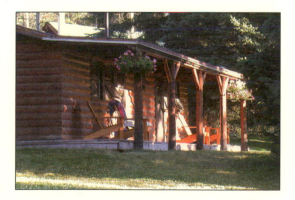

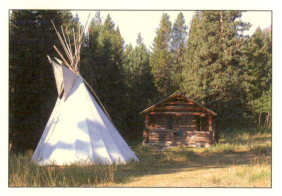

CANADA

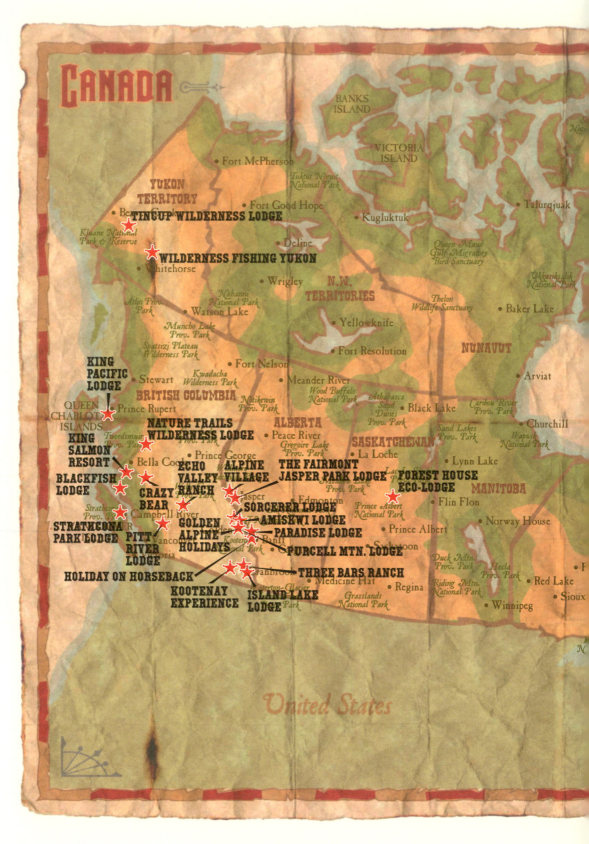

CANADA

BANKS ISLAND

VICTORIA ISLAND

• Fort McPherson

Tuktut Nogait National Park

• Talurqjuak

YUKON TERRITORY

• Fort Good Hope

• Kugluktuk

TINCUP WILDERNESS LODGE

Kluane National Park & Reserve

• Deline

Queen Maud Gulf Migratory Bird Sanctuary

Okkusiksalik National Park

WILDERNESS FISHING YUKON

• Whitehorse

• Wrigley

N.W. TERRITORIES

Atlin Prov. Park

Nahanni National Park

• Watson Lake

• Yellowknife

Thelon Wildlife Sanctuary

• Baker Lake

Muncho Lake Prov. Park

Spatsizi Plateau Wilderness Park

Kwadacha Wilderness Park

• Fort Resolution

NUNAVUT

• Stewart

Notikewin Prov. Park

• Fort Nelson

• Meander River

Wood Buffalo National Park

Athabasca Sand Dunes Prov. Park

• Black Lake

Caribou River Prov. Park

• Arviat

KING PACIFIC LODGE

BRITISH COLUMBIA

QUEEN CHARLOTTE ISLANDS

• Prince Rupert

ALBERTA

Sand Lakes Prov. Park

• Churchill

Wapusk National Park

NATURE TRAILS WILDERNESS LODGE

Tweedsmuir Prov. Park

• Peace River

Gregoire Lake Prov. Park

SASKATCHEWAN

• La Loche

FOREST HOUSE ECO-LODGE

• Lynn Lake

MANITOBA

KING SALMON RESORT

• Bella Coola

• Prince George

ECHO VALLEY RANCH

ALPINE VILLAGE

THE FAIRMONT JASPER PARK LODGE

Meadow Lake Prov. Park

• Flin Flon

BLACKFISH LODGE

CRAZY BEAR

• Jasper

SORCERER LODGE

• Edmonton

Prince Albert National Park

• Norway House

Strathcona Prov. Park

• Campbell River

AMISKWI LODGE

• Prince Albert

STRATHCONA PARK LODGE

GOLDEN ALPINE HOLIDAYS

PARADISE LODGE

• Saskatoon

Duck Mtn. Prov. Park

Hecla Prov. Park

• Red Lake

PITT RIVER LODGE

• Vancouver

• Victoria

Kootenay National Park

• Banff

PURCELL MTN. LODGE

Riding Mtn. National Park

• Winnipeg

• Sioux

HOLIDAY ON HORSEBACK

THREE BARS RANCH

• Medicine Hat

• Regina

KOOTENAY EXPERIENCE

ISLAND LAKE LODGE

Waterton-Glacier Park

Grasslands National Park

United States

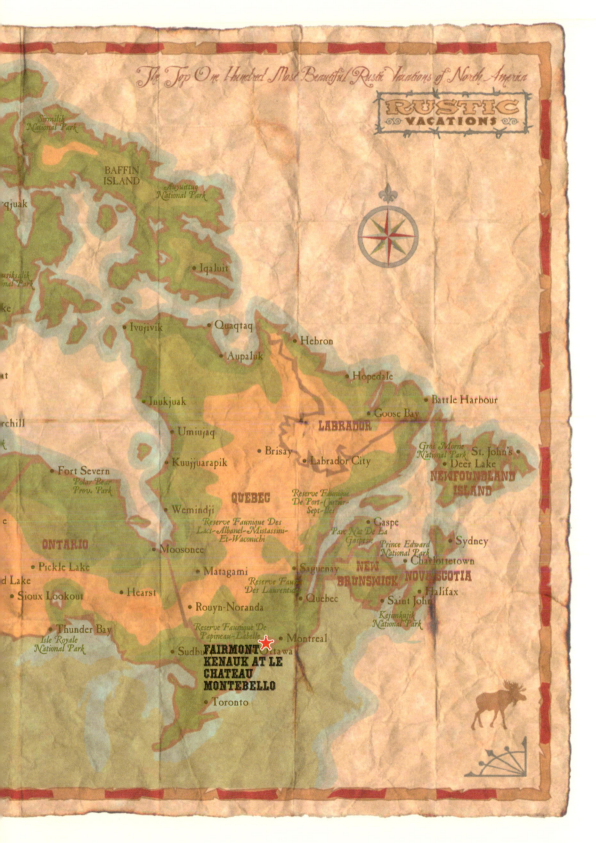

The Top One Hundred Most Beautiful Rustic Vacations of North America

RUSTIC
VACATIONS

BAFFIN
ISLAND

Sirmilik
National Park

Auyuittuq
National Park

...qjuak

...usiksalik
...nal Park

Iqaluit

Ivujivik

Quaqtaq

Hebron

Aupaluk

Hopedale

Inukjuak

Battle Harbour

Umiujaq

Goose Bay

...orchill

LABRADOR

...at

Brisay

Gros Morne
National Park

St. John's

Kuujjuarapik

Labrador City

Deer Lake

Fort Severn

NEWFOUNDLAND
ISLAND

Polar Bear
Prov. Park

QUEBEC

Reserve Faunique
De Port-Cartier-
Sept-Iles

Wemindji

Reserve Faunique Des
Lacs-Albanel-Mistassini-
Et-Waconichi

Gaspe

ONTARIO

Moosonee

Parc Nat De La
Gaspesie

Prince Edward
National Park

Sydney

Pickle Lake

Matagami

Saguenay

Charlottetown

...d Lake

Reserve Faun...
Des Laurentid...

NEW
BRUNSWICK

NOVA SCOTIA

Sioux Lookout

Hearst

Quebec

Halifax

Rouyn-Noranda

Saint John

Thunder Bay

Reserve Faunique De
Papineau-Labelle

Montreal

Kejimkujik
National Park

Isle Royale
National Park

Sudb... ...tawa

FAIRMONT
KENAUK AT LE
CHATEAU
MONTEBELLO

Toronto

Alpine Village

ACTIVITIES: Hiking, kayaking, whitewater rafting, canoeing, fishing & golfing

PHONE: 780-852-3285
WEB: www.AlpineVillageJasper.com
CAPACITY: 160 people: 40 cabins
OPEN: May to mid Oct., 3 night minimum stay (seasonal)

RATES: Around $150-$300 USD per cabin per day

LOCATION: 225 miles (4 hours) from Edmonton, 260 miles (5 hours) from Calgary

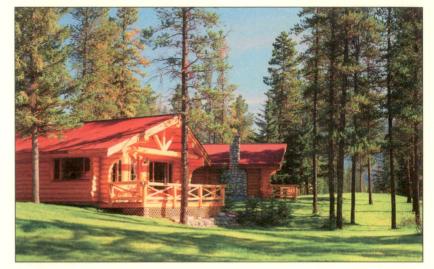

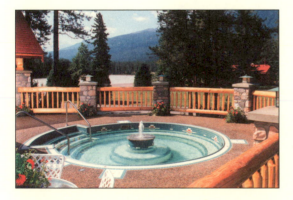

It's hard to beat the Canadian Rockies for sheer beauty. And it's even harder to beat being located on a gorgeous aqua-blue river in the middle of the Canadian Rockies! This is exactly what you will get if you stay at *Alpine Village*. Situated about a mile south of Jasper in Jasper National Park, the possibilities for activities are mind boggling. Besides all of the amazing hiking, fishing, whitewater rafting and more, you also get the convenience of great shopping just minutes away.

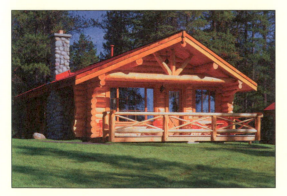

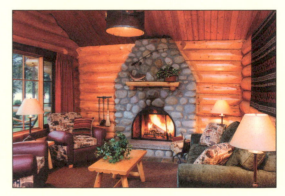

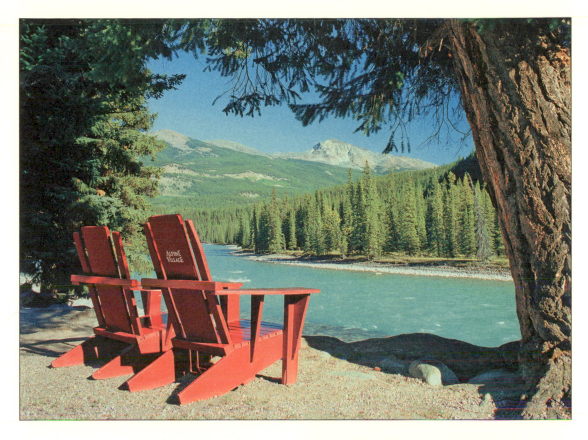

At over 4,000 square miles, Jasper National Park is the largest park in the Canadian Rocky Mountains. It is home to thousands of roaming elk, deer, sheep, moose, caribou, bears and wolves. So be sure to bring your camera!

Alpine Village has 40 log cabins set in the forest across from the Athabasca River, with stunning views of Mt. Edith Cavell towering nearby. You can choose from several deluxe or heritage-style cabins, most with well equipped kitchens and wood-burning fireplaces.

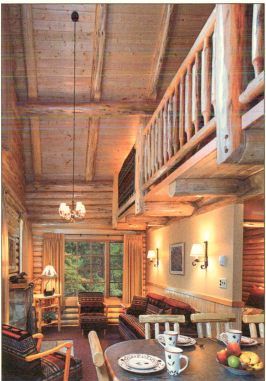

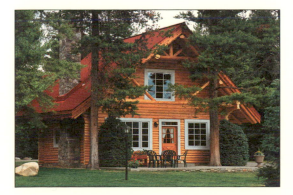

The Fairmont Jasper Park Lodge

Jasper
Alberta, CANADA

ACTIVITIES: Golfing, hiking, biking, canoeing, tennis, cross-country skiing & snowshoeing

PHONE: 800-441-1414 or 780-852-3301
WEB: www.Fairmont.com
CAPACITY: Around 1,200 people: 446 guest rooms
OPEN: Year-Round, no minimum stay

RATES: Around $200-$900 USD per room per day

LOCATION: 225 miles (4 hours) from Edmonton, 260 miles (5 hours) from Calgary

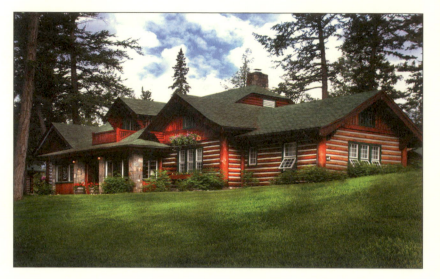

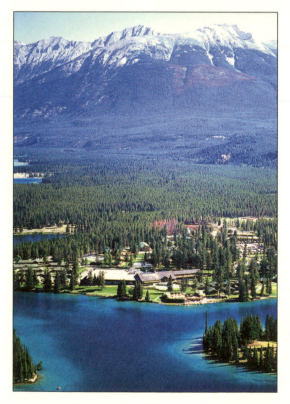

Offering unbelievable canoeing, kayaking, rafting, fishing, swimming, horseback riding and spa services, along with one of Canada's top-rated golf courses, *The Fairmont Jasper Park Lodge* has it all. And that's just in the summer. The winter holds an entirely different set of amazing activities. You can enjoy great skiing, ice skating, dogsledding, snowmobiling, snowshoeing, and even take an old-fashioned sleigh ride. Or, if you prefer, you can choose to do nothing at all. Sometimes that's even better.

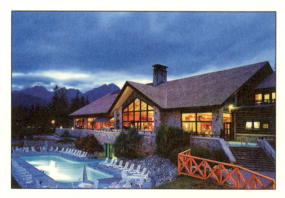

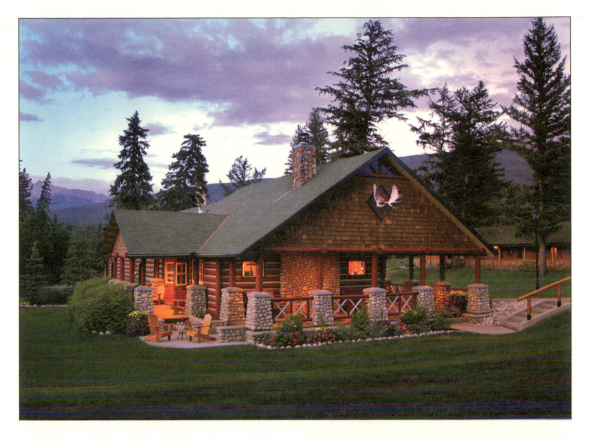

There are a variety of excellent accommodations to choose from. They have lodge rooms, cedar chalets and log cabins connected by picturesque paths. The views you will experience from your room are breathtaking. Jasper features the most extraordinary surroundings, including emerald-green alpine lakes, mountain glaciers and majestic forests. Everywhere you look resembles a postcard. A stroll in the village at dusk will likely give you the opportunity of crossing paths with an elk or deer.

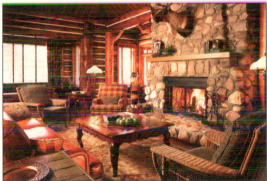

Holiday on Horseback

ACTIVITIES: Horseback riding, pack trips, hiking, wildlife viewing, fishing & nature photography

PHONE: 800-661-8352 or 403-762-4551
WEB: www.Horseback.com
CAPACITY: 20 people per trip: tenting or lodge rooms
OPEN: June through September, 2–6 day trips

RATES: Around $150–$200 USD per person per day. Includes meals & a horse

LOCATION: Depart on horseback from Banff into Banff National Park

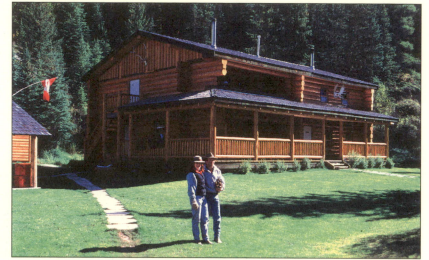

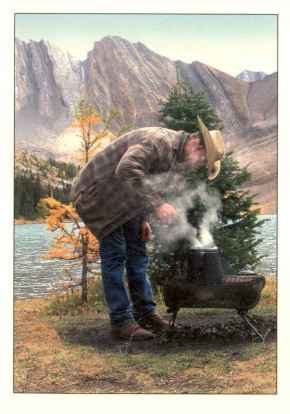

If you really want to experience unspoiled wilderness at the highest level, then packing in on horseback is the way to go. The folks at *Holiday on Horseback* are absolute professionals and offer an experience that simply can't be equaled anywhere else. They will take you deep into Banff National Park, one of the most beautiful places on earth, where the wildlife runs free. The horses walk at a nice easy pace, so you don't even need any previous riding experience.

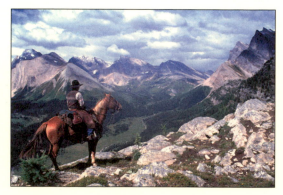

Depending on the type of package you choose, your accommodations will either be a large (two-man) canvas tent with wooden floors or one of their rustic backcountry lodges. If you decide on the tent trip, you will ride from camp to camp, sleeping in a different place each night. Along the way, you will see a variety of wild animals, remote mountain lakes and millions of wildflowers. At each camp, there is a large socializing tent for meals and chatting with new friends.

Paradise Lodge & Bungalows

Lake Louise
Alberta, CANADA

ACTIVITIES: Hiking, mountain biking, wildlife viewing, horseback riding, canoeing & river rafting

PHONE: 403-522-3595
WEB: www.ParadiseLodge.com
CAPACITY: 150 people: lodge rooms & private cabins
OPEN: Mid May to mid October, no minimum stay

RATES: Around $200-$300 USD per cabin per day

LOCATION: Less than one mile from Lake Louise, 40 miles (50 minutes) from Banff, 145 miles (3 hours) from Jasper

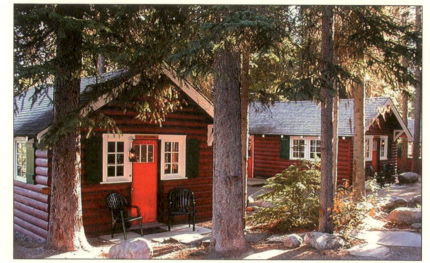

For an absolutely fantastic family vacation that is reasonably priced and located in one of the most stunning parts of the world, *Paradise Lodge & Bungalows* is an ideal choice. Situated less than one mile from Lake Louise, you will be able to experience a true wilderness vacation without any of the inconveniences that an overly secluded location often has. Upon arrival, you will be overwhelmed with the spectacular scenery, variety of hiking trails and numerous sightseeing spots.

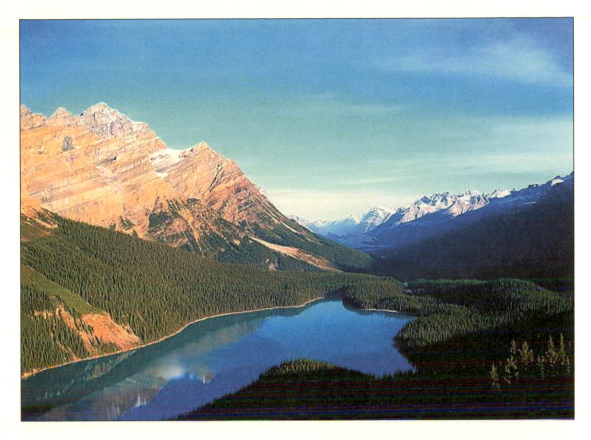

There are two beautiful accommodation types to choose from. You can stay in one of the many rustic wooded cabins that offer private access, or you can opt for the slightly more modern interiors of the spacious lodge suites. Both are excellent choices and include unlimited fresh mountain air, along with the use of a centrally located gas barbeque. There's also a fantastic children's playground, which is guaranteed to keep your little ones busy all day long. It is an outdoor paradise, just waiting for you.

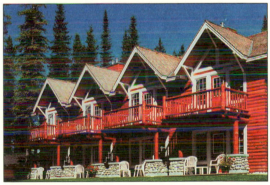

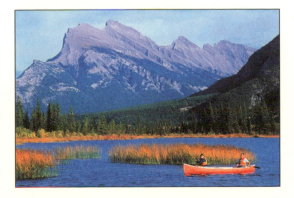

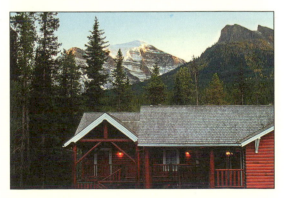

Amiskwi Lodge

ACTIVITIES: Hiking, climbing, backpacking, swimming, snowshoeing, skiing & alpine touring

PHONE: 403-678-1800
WEB: www.Amiskwi.com
CAPACITY: 16 people: several lodge rooms
OPEN: July to Oct. & Dec. to May, 1 week min. in winter

RATES: Around $50 USD per person per day, $650 USD per person per week in the winter

LOCATION: 2 hour drive or 20 minute helicopter ride from Golden

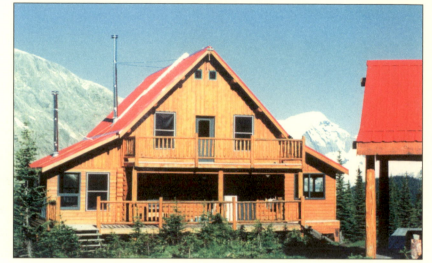

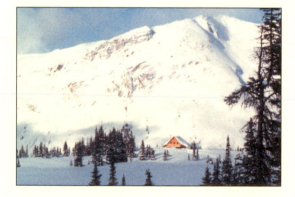

If you are looking for a remote cabin up in the mountains where civilization is far, far away, then look no further than *Amiskwi Lodge*. At 7,000 feet on the western edge of Yoho National Park, you will experience amazing views of the Wapta and Freshfield Icefields, the Mummery group, and Des Poilus and Arete Peaks. During the summer you can get to the lodge with a four-wheel drive vehicle and a short hike, but in the winter, the only way to get there is in a helicopter (included in winter rate).

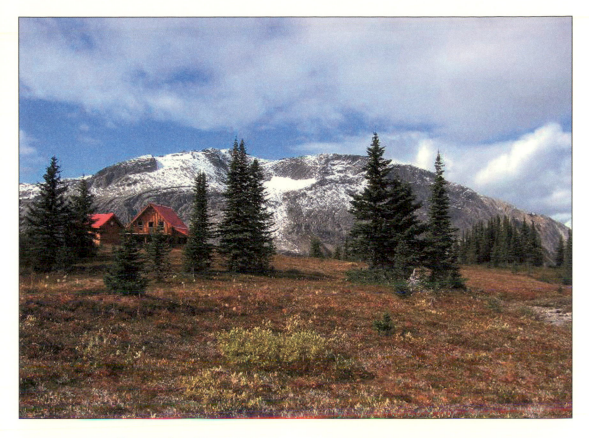

The lodge is self-guided and self-catered, which means you will be on your own; so don't forget to bring plenty of food and warm bedding. There are separate bedrooms, and a fully equipped kitchen with refrigerator, stove and freezer. There are also composting toilets, a shower house, two wood-burning fireplaces and a wood-burning sauna. There is a satellite telephone for emergencies. *Amiskwi Lodge* is the perfect place for a family vacation or a getaway with a group of good friends.

Blackfish Lodge

ACTIVITIES: Wildlife viewing & fishing (fresh & saltwater) for salmon, halibut, trout & steelhead

PHONE: 206-789-1224
WEB: www.BlackfishLodge.com
CAPACITY: 6 adults: several lodge rooms
OPEN: April through October, 2 night minimum stay

RATES: Around $550 USD per person per day. Includes meals, guided fishing & float-plane ride from Seattle to the lodge

LOCATION: 35 miles from Port McNeill

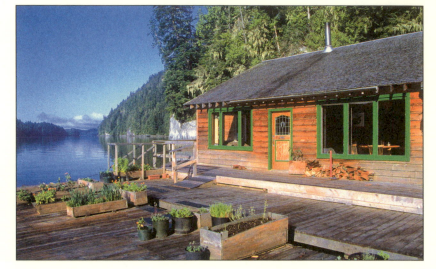

If half the fun is getting there, then get ready for a good time! Accessible only by float-plane or boat, *Blackfish Lodge* is really off the map, tucked away in a little cove on Baker Island. Never heard of Baker Island before? That's good, because that means nobody else has, either. The lodge features a hybrid combination of freshwater and saltwater fishing. Fly-fishing, spincasting and trolling techniques are all utilized. There are no pre-set fishing hours, so the more, the better!

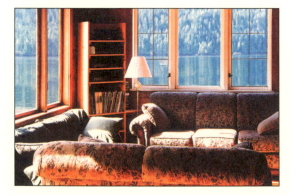

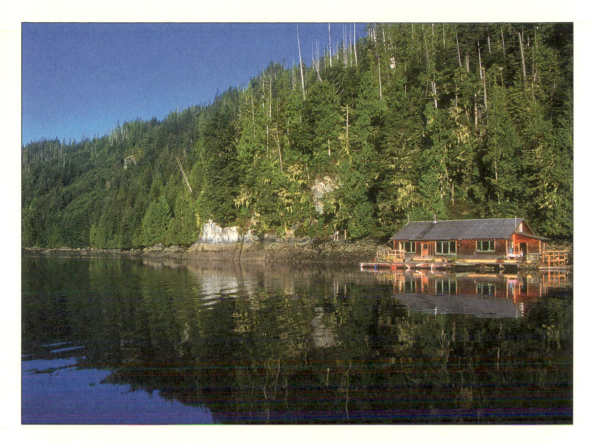

The lodge was handcrafted with yellow and red cedar from nearby forests. It is heated by a wood stove and has a generator to provide electricity. The generator is turned off in the evenings for sleeping. Each room has two beds and a bathroom with a shower. The modest living and dining room areas have spectacular views. In addition, there's a great selection of music, plus an upright piano for those who want live entertainment during their stay. The lodge is also wheelchair accessible.

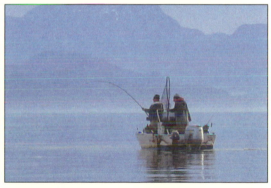

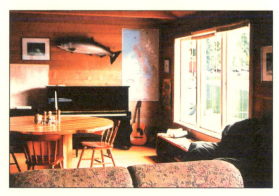

Crazy Bear Lake Lodge

Crazy Bear Lake
British Columbia, CANADA

ACTIVITIES: Fishing, hiking, canoeing, camping, backpacking, wildlife viewing & photography

PHONE: 800-974-8824 or 604-739-0789
WEB: www.CrazyBearLodge.com
CAPACITY: 24 people: 4 log cottages & a teepee
OPEN: June to mid September, 6 day minimum stay

RATES: Around $1,700 USD per person for 6 days. Includes meals & float-plane ride. Pets allowed

LOCATION: 20 min. float-plane ride to Crazy Bear Lake from Nimpo Lake

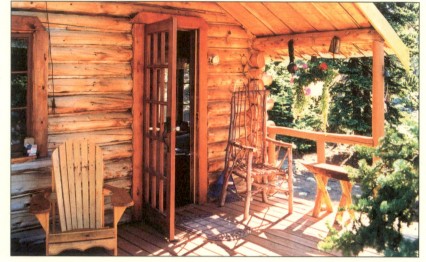

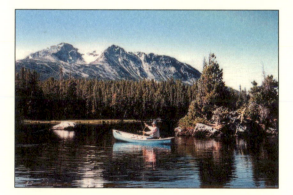

Accessible by float-plane only, *Crazy Bear Lake Lodge* caters to those who want unspoiled wilderness along with some of the finest wild rainbow trout fishing British Columbia has to offer. The few buildings that make up the property are the only structures on the lake.

No expensive fly-outs are necessary. The lodge is already so remote that there is absolutely no need to go anywhere else. There are more fish right outside your cabin door than you could possibly catch in several lifetimes.

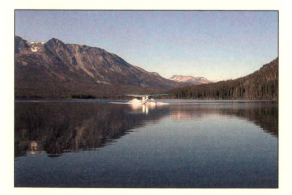

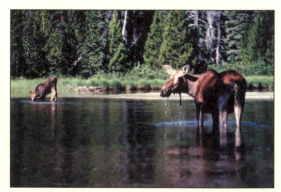

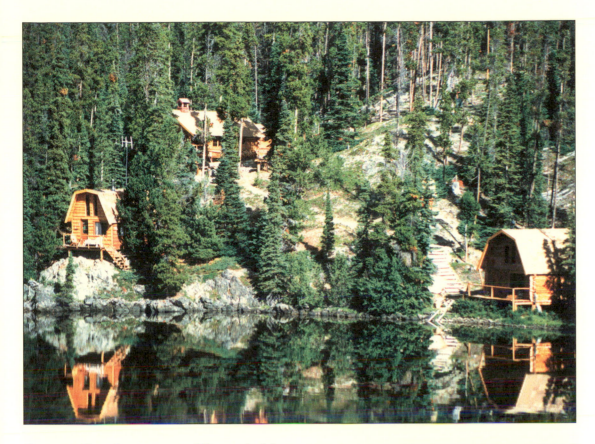

At 4,200 feet, the snow runoff keeps the lakes cool, so the fishing is always great. In addition to fishing, you can also take a relaxing canoe ride around the lake or get steamy in an authentic Indian sweat lodge.

There are four log cottages that each hold one to six guests. They come complete with fresh linens, hot showers and a fridge. Or you can try sleeping in a teepee. Meals are served in the dining lodge, and complimentary wine to celebrate the day's catch is offered with dinner.

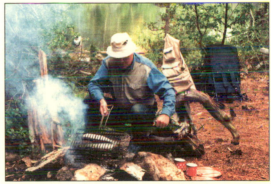

Echo Valley Ranch & Spa

Clinton / Jesmond
British Columbia, CANADA

ACTIVITIES: Horseback riding, hiking, mountain biking, fly-fishing, 4x4 trips & spa treatments

PHONE: 800-253-8831 or 250-459-2386
WEB: www.EVranch.com
CAPACITY: 40 people: private lodges & cabins
OPEN: Year-Round, 3 night minimum stay

RATES: Around $250-$300 USD per person per day. Includes meals & all ranch activities

LOCATION: 80 miles (2 hours) from Kamloops, 5 hours from Vancouver

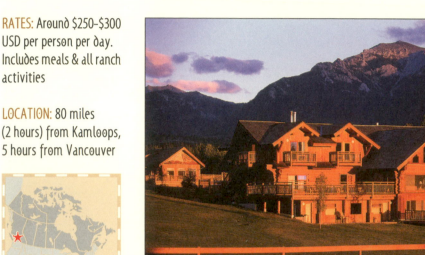

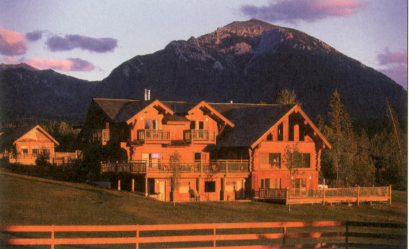

What makes *Echo Valley Ranch* so spectacular is how they have seamlessly combined the authentic western adventure of horseback riding, fly-fishing, and more with a top-notch spa. It is the perfect choice for those who love the outdoors but also enjoy a little pampering.

The ranch is located in a prime spot, with amazing vistas in every direction. To the east is the Marble Mountain Range, to the west are grasslands, to the south is Fraser Canyon, and to the north are countless lakes and marshlands.

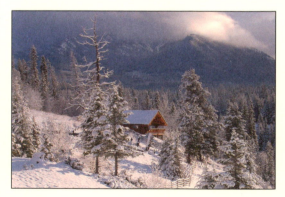

In this remote location, the air is unbelievably clean and clear: a definite perk awaiting every lucky guest. This clean air is especially nice when participating in outdoor recreation. Of the many activities offered, they are particularly proud of their horseback riding program. Guests get the rare privilege of riding Tennessee Walking Horses, which are world famous for their ultra-smooth gait. For hikers, there are several scenic and challenging trails that enable them to explore the area alone or with a guide.

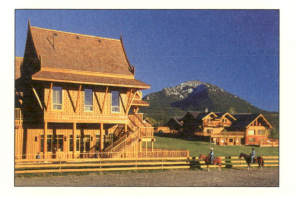

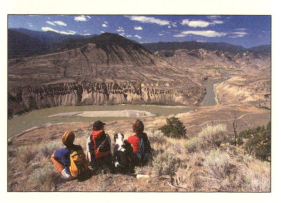

Golden Alpine Holidays

ACTIVITIES: Hiking, backpacking, wildlife viewing, backcountry skiing & snowboarding

PHONE: 250-344-7273
WEB: www.GAH.ca
CAPACITY: 36 people: 3 lodges (up to 12 guests in each)
OPEN: Year-Round, 3 night minimum stay

RATES: Around $250-$350 USD per person per day. Includes meals & helicopter to/from lodge

LOCATION: 10 minute helicopter ride to the lodge from Golden

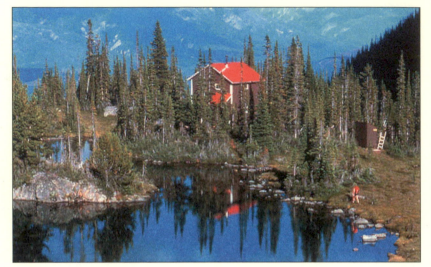

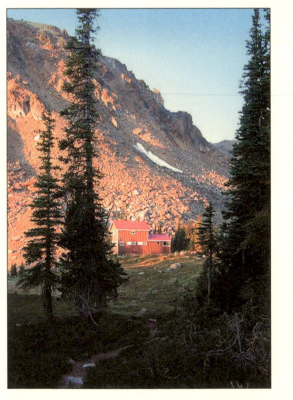

Golden Alpine Holidays welcomes you to the ultimate trio of backcountry lodges: Sunrise, Meadow and Vista. All three are located at treeline on the backbone of the famous Esplanade Range. Accommodations come complete with a fully loaded kitchen, sauna, two outhouses and an indoor chemical toilet for night use. The bedrooms have mattresses and bedding, so luckily you don't need to bring a sleeping bag. The lodges run on propane, so leave your hair dryers at home. You won't care how you look, anyway!

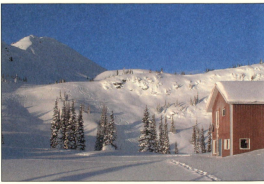

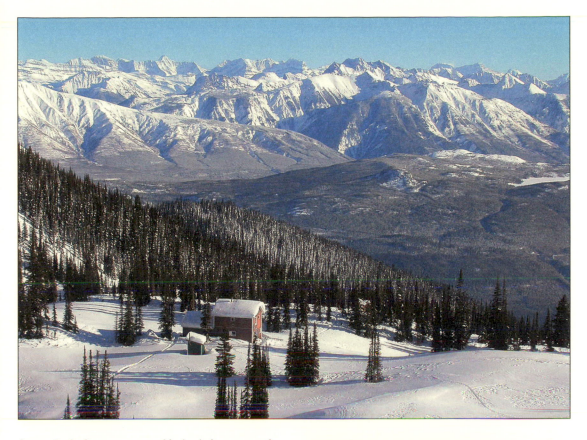

Since the lodges are accessible by helicopter only, getting there is part of the fun. Once you arrive at your mountain-top hideaway, you will have access to unlimited backcountry hiking and skiing.

When booking a trip, you can choose to be in one lodge for your entire stay or hike from lodge to lodge. As far as meals go, you have the option of self-catered (you cook your own food) or catered (a chef cooks for you). Also, you can join a trip that is already up and running or book an entire lodge with a group of friends.

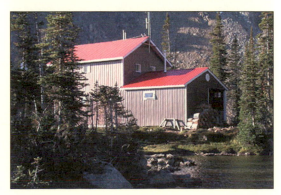

Island Lake Lodge

ACTIVITIES: Guided alpine hiking, rock climbing, fly-fishing, mountaineering & spa treatments

PHONE: 888-422-8754 or 250-423-3700
WEB: www.IslandLakeResorts.com
CAPACITY: 52 people: 26 rooms in 3 separate lodges
OPEN: Year-Round, 2 night minimum stay

RATES: Around $100-$150 USD per adult per day (less for kids). Includes breakfast

LOCATION: 60 miles (1.5 hours) from Cranbrook, 4 hours from Calgary, AB

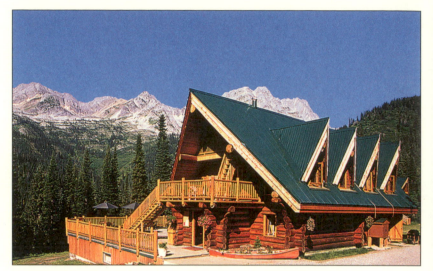

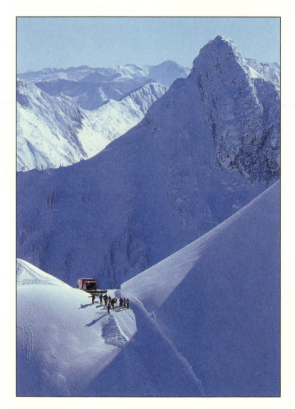

Just because you are staying at a log lodge in the middle of the Canadian wilderness doesn't mean you should rule out the chance to be pampered. After all, it only seems fair that if you spend the afternoon hiking up and down all kinds of demanding mountain trails, a soothing massage should be your just reward. Good news: The spa at *Island Lake Lodge* delivers the ultimate in relaxation and rejuvenation, with five treatment rooms, two outdoor hot tubs, a eucalyptus sauna and a fresh natural rain shower.

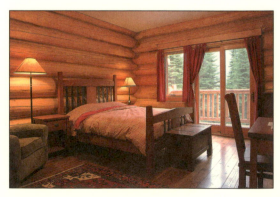

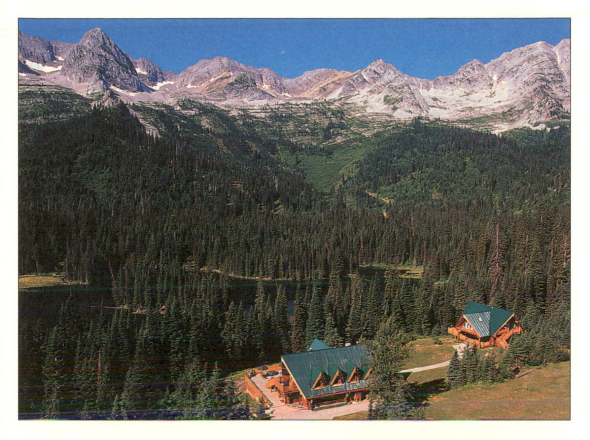

An a la carte menu of independent or guided activities will be presented to you upon arrival. Choices range from hidden stream fly-fishing to interpretive hikes through ancient fir and cedar forests to rock climbing. They even have a special kids' wilderness camp program.

The meals are also a huge highlight of the trip. You will experience everything from hearty breakfasts and fresh hot pastries to gourmet three-course meals complemented by a fine selection of beer and wine. Cheers!

King Pacific Lodge

ACTIVITIES: Guided ocean fishing, fly-fishing, sea kayaking, whale watching, heli-hiking & spa services

PHONE: 888-592-5464 or 604-987-5452
WEB: www.KingPacificLodge.com
CAPACITY: 28 people: 17 luxury rooms & suites
OPEN: May through September, 3 night minimum stay

RATES: Around $1,200 USD per peson per day. Includes meals, activities & float-plane ride

LOCATION: 56 miles south of Prince Rupert

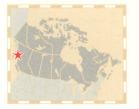

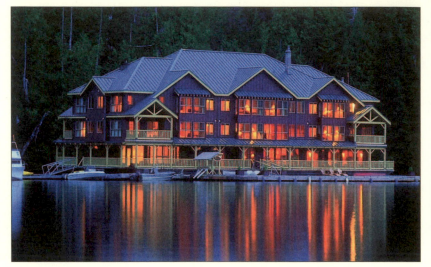

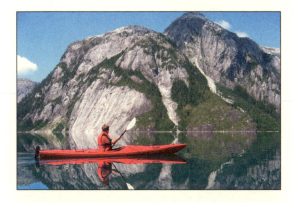

Chances are, you have never seen anything quite like the *King Pacific Lodge*. This ultra-luxurious floating wilderness lodge sits quietly and safely in a secluded harbor on Princess Royal Island. Its remarkable isolation does not limit the amount of amenities or activities that one can enjoy here. On the contrary, there is a lengthy list of superb activities, one of which is exceptional wildlife viewing. Princess Royal and a few of the surrounding islands are the only known homes of the elusive Spirit Bear.

The lodge features 17 rooms and suites, each with a stunning view of the ocean or forest. They are quite spacious, with a large king-size bed, fluffy down duvets, slate-lined bathroom, and relaxing, deep soaker-tub.

To get to this incredibly remote lodge, guests must first happily endure a privately chartered plane ride from Vancouver to Bella Bella. From there, it's off to the lodge via float-plane. There's nothing like touching down on the water in the wilderness to begin a vacation.

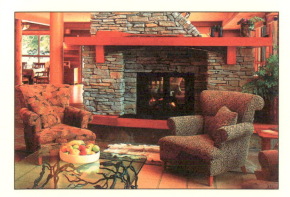

King Salmon Resort

ACTIVITIES: Self-guided salmon fishing, hiking, wildlife viewing & nature photography

PHONE: 800-663-7090 or 250-598-3366
WEB: www.KingSalmonResort.com
CAPACITY: 26 people: several cabins
OPEN: July to mid September, 3 night minimum stay

RATES: Around $2,500 USD per person for a 4 day/3 night stay. Includes meals, boat, tackle & Vancouver airport transfers

LOCATION: Transfers from Vancouver Int'l airport

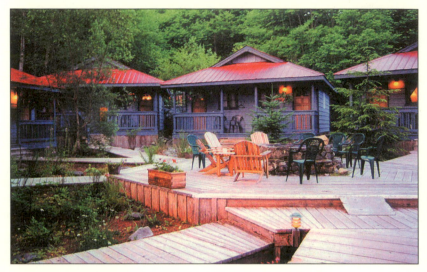

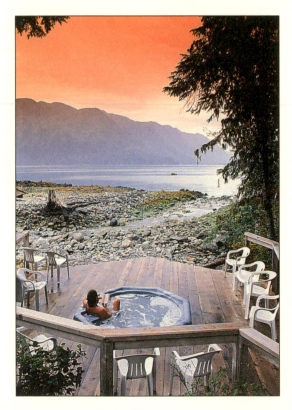

To be the king of salmon fishing, you will need to take a little journey to Rivers Inlet, British Columbia. Here, you will find the famous *King Salmon Resort*. This place gives a new meaning to the word "big," as in *huge* salmon! Although the fishing at the resort is self-guided, the head fishmaster is always nearby in case you need anything. Ask him to share the inside scoop on secret coves and where the big ones are lurking. There are two guests per boat, and everyone starts off with a quick orientation.

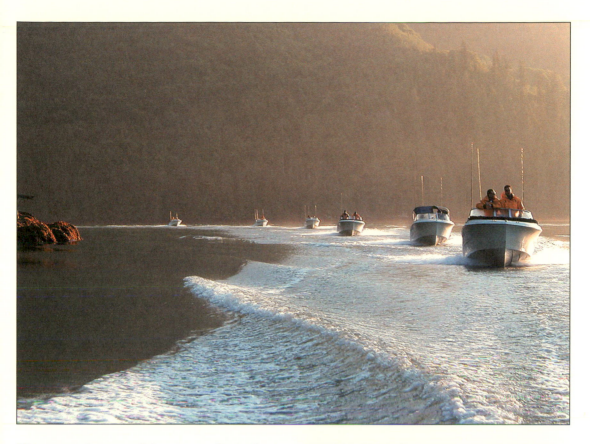

Upon arrival, you will be given unlimited use of boats, tackle and bait. Any fish that you catch and wish to take home with you will be professionally cleaned and packaged by the resort's staff. In addition to fishing, the wildlife viewing is spectacular. Bears, seals, eagles and a huge variety of marine birds await you.

The accommodations are nestled among giant coastal trees with a large central fire pit for socializing and telling fish tales. Prepare to embellish yours beforehand!

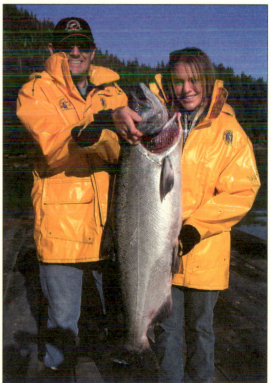

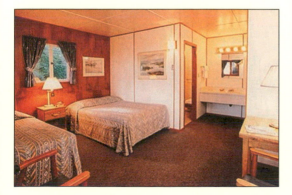

Kootenay Experience, Ymir Yurts

Nelson / Selkirk Mountains
British Columbia, CANADA

ACTIVITIES: Hiking, wildlife viewing, backcountry skiing & snowboarding

PHONE: 888-488-4327
WEB: www.YmirYurts.com
CAPACITY: 16 people: 6-8 people per yurt
OPEN: Year-Round, 4 night minimum stay

RATES: Around $200 USD per yurt per day. Includes unlimited access to backcountry terrain

LOCATION: Just south of Nelson at 6,100 feet in the southern Selkirks

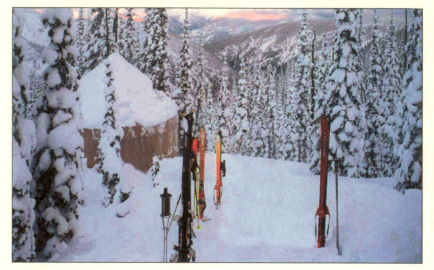

If you are ready to experience the ultimate in backcountry, fresh powder skiing and snowboarding for half the price of heli-skiing, then pack your gear and head to the Selkirk Mountains. Here at *Ymir Yurts*, you will find the deep, untracked powder seen only in ski videos. The long, backcountry runs are quiet, scenic, and fortunately not too intimidating. Say goodbye to long lift lines, which are for people who like to do the ordinary. That's not you!

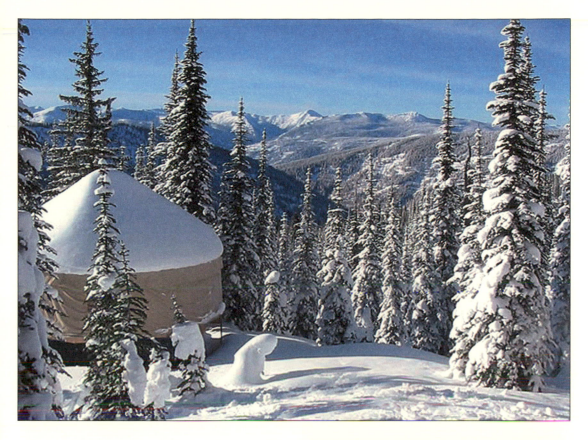

This wonderland is equally exciting in the summer, with unlimited exploring, wildlife viewing and nature photography. The high alpine wildflowers are especially amazing.

The yurts come complete with bunk beds, a kitchen, wood-burning stove, propane stove and plenty of pots and pans. If you're not much of a cook, they offer an excellent catered meal option. Although the yurt doesn't have an indoor bathroom, there is a modern outhouse just a few feet away. Hey, it's the backcountry!

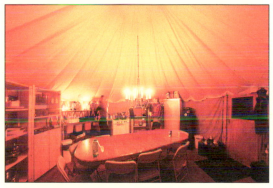

Nature Trails Wilderness Lodge

Tetachuck Lake
British Columbia, CANADA

ACTIVITIES: Canoeing, kayaking, fishing, wildlife viewing & flight-seeing (alpine lakes & glaciers)

PHONE: 888-476-1248 or 250-476-1248
WEB: www.BestCanada.ca
CAPACITY: 25 people: 5 lakefront cabins & 2 family cabins
OPEN: Summer only, no minimum stay

RATES: Around $1,800 USD per person for a 4 day package. Includes meals & transportation to/from Vancouver

LOCATION: 75 air miles north of Nimpo Lake

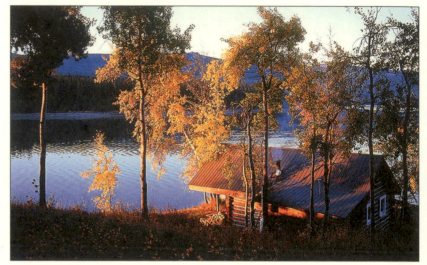

Accessible by float-plane or boat only, *Nature Trails Wilderness Lodge* offers an awesome wilderness experience for people who thrive on adventure and seclusion. With no roads within 100 miles of the lodge, this is the *real* backcountry. You will have the pleasure of seeing animals in their natural environment. Activity options include unlimited use of canoes, sea kayaks, fishing rods, fly-rods and boats. You can also arrange a flight-seeing trip to remote alpine lakes and glaciers.

Nestled on the shore of Tetachuck Lake, at the foot of the Coast Mountains and adjacent to Tweedsmuir Provincial Park (one of the largest protected wilderness areas in B.C.), *Nature Trails* is the perfect place for wildlife viewing and photography.

The property features five lakefront log cabins and two family cabins, complete with shower and toilet, as well as hot and cold running water and a wood-burning stove. There is no electricity, but who needs it!

Pitt River Lodge

Maple Ridge
British Columbia, CANADA

ACTIVITIES: Fishing
(for salmon, cutthroat &
rainbow), relaxation
& good conversation

PHONE: 800-665-6206
WEB: www.PittRiverLodge.com
CAPACITY: 26 people: lodge rooms & private cabins
OPEN: Year-Round, 2-5 day packages

RATES: Around $250 USD
per person per day.
Includes meals & all
necessary fishing gear

LOCATION: 1 hour from
Vancouver to Maple Ridge
plus 1 hour to the lodge

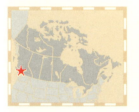

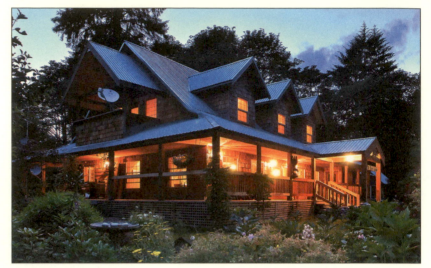

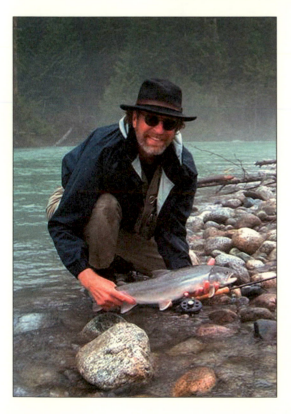

Conveniently close to Vancouver, yet still
incredibly remote, this classic fishing lodge can
only be reached by water or air. Your adventure
will begin with an early morning pickup at
Grant Narrows Regional Park (just outside of
Pitt Meadows). From there, you will take a
45-minute ride in a high-speed commercial
salmon fishing boat across Pitt Lake (the largest
tidal lake in North America). Then it's just a
short ten-minute drive on an old logging road,
and you're there!

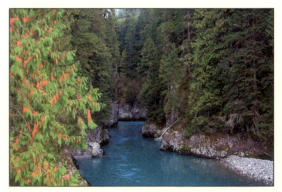

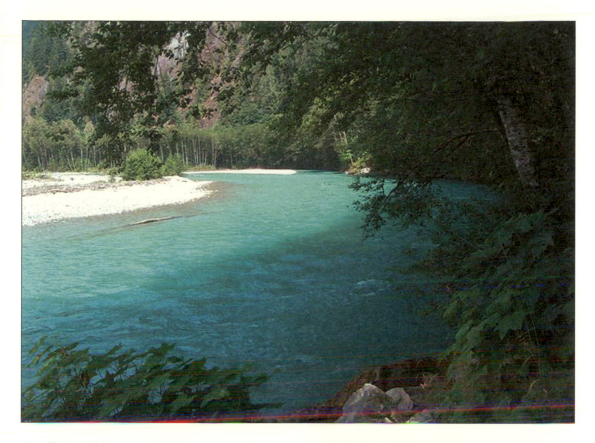

Pitt River Lodge is a gorgeous 5,000-square-foot farmhouse-style lodge with a huge wraparound porch, hardwood floors, cedar bar and comfortable leather furniture. In no time, you will be hanging out on the porch, bragging to all your buddies about the big one you caught that afternoon.

Just as good as the fishing is the food. Their hearty home-cooked meals are served at a huge redwood table. Save room for their delicious desserts and homemade breads.

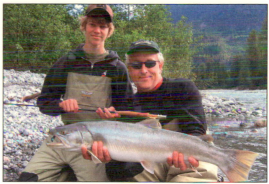

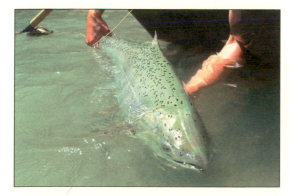

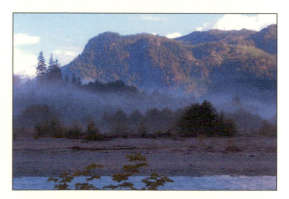

Purcell Mountain Lodge

ACTIVITIES: Guided nature hikes, wildlife viewing, guided backcountry skiing, boarding & snowshoeing

PHONE: 250-344-2639
WEB: www.PurcellMountainLodge.com
CAPACITY: 30 people: 10 private rooms & 1 cottage
OPEN: Year-Round, 2 night minimum stay in summer

RATES: Around $300-$600 USD per person per day. Includes meals & helicopter to/from lodge

LOCATION: 15 minute helicopter ride to the lodge from Golden

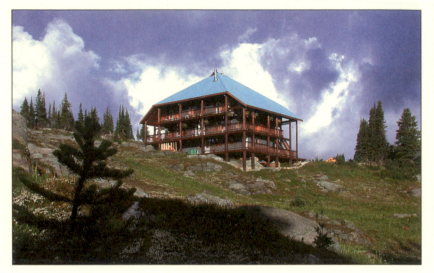

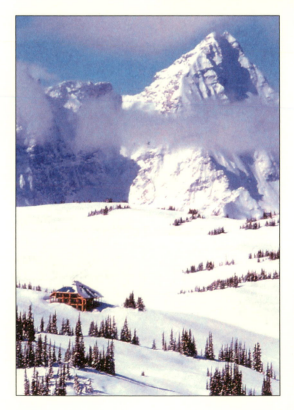

Although remote, rest assured that *Purcell Mountain Lodge* offers the finer things in life when it comes to accommodations, scenery and cuisine. Here, you can start your day off with a spectacular guided hike and finish it with an equally amazing gourmet meal. Accessible only by helicopter, this amazing lodge has a fun "adult summer camp" feel that can't be beat. As you're waiting for the helicopter to pick you up and whisk you away to your mountain top hideaway, you can't help but think, "Life is good."

The lodge boasts amenities often unheard of in the backcountry, including hot showers, flush toilets and electricity. On the top floor, there are ten bunk-style guestrooms and a bright and cozy community reading nook. The main floor consists of the dining area, lounge and fireplace.

Besides all the fantastic hiking and skiing that the lodge offers, one of the most popular activities among guests is just sitting out on one of the many wraparound decks and watching the hummingbirds at their feeders.

Sorcerer Lodge

ACTIVITIES: Hiking, pack trips, mountaineering, backpacking, backcountry skiing & snowboarding

PHONE: 250-344-2804
WEB: www.SorcererLodge.com
CAPACITY: 18 people: 4 rooms & a loft
OPEN: Year-Round, 1 week minimum stay

RATES: Around $1,400 USD per person per week. Includes meals, a guide & helicopter ride to/from the lodge

LOCATION: 35 miles from Golden by helicopter

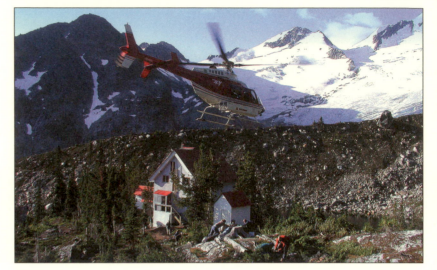

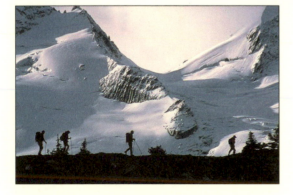

First, you will be picked up by helicopter just outside of Golden, B.C. Then you will be flown over many mountaintops to one of the most remote accommodations in the world. Located just below treeline, *Sorcerer Lodge* is situated in the Selkirk Mountains at an elevation of 6,700 feet. Here, you will have the unique opportunity to cross glaciers and climb 11,000-foot peaks. With an average winter snowpack of 12 feet, skiers and boarders will be in powder heaven.

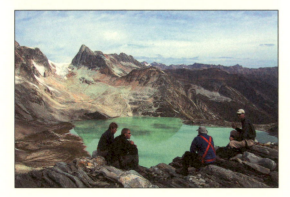

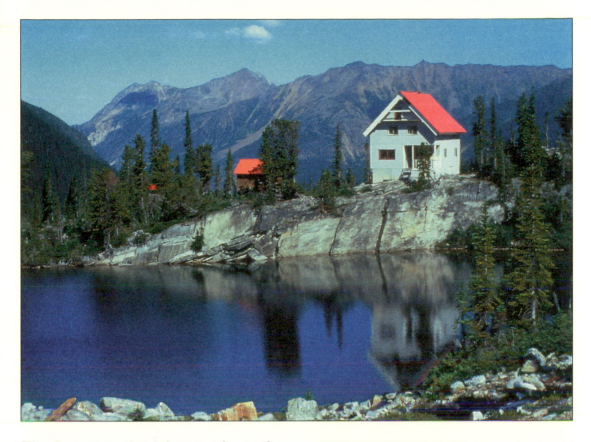

The three-story, brightly painted, wooden lodge sits on its own little lake with stunning, 360-degree views of the surrounding peaks. There are four bedrooms, a funky sleeping loft and a fully equipped kitchen. The lodge is heated by a wood stove and there is a generator, in addition to solar power, for lighting. There's also a wood-heated sauna in a separate building, complete with a changing room. Many of the winter trips can be sold out almost a year in advance, so plan ahead.

Strathcona Park Lodge

ACTIVITIES: Hiking, rock climbing, backpacking, canoeing, sea kayaking & leadership training

PHONE: 250-286-3122
WEB: www.Strathcona.bc.ca
CAPACITY: 200 people: cabins & chalet rooms
OPEN: Year-Round, minimum stay based on season

RATES: Around $100-$200 USD per room per day

LOCATION: 30 miles west of Campbell River on Vancouver Island's Upper Campbell Lake, 4 hours from Victoria

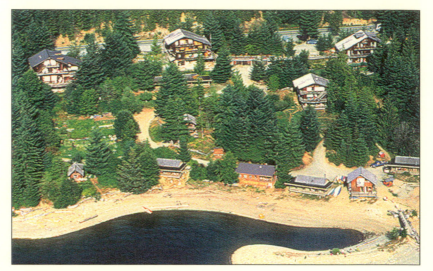

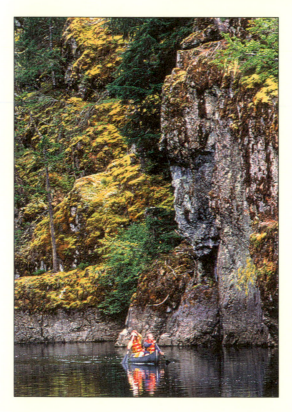

Strathcona Park Lodge is touted as one of the top outdoor education centers in the world. They offer wilderness leadership training courses, fitness workshops, youth summer camps and customized holiday adventures for adults, seniors and families. They also provide a huge variety of guided activities, including rock climbing, high ropes courses, survival skills, whitewater kayaking, canoeing, alpine hiking and backpacking. Whatever you choose to do, it will be an adventure!

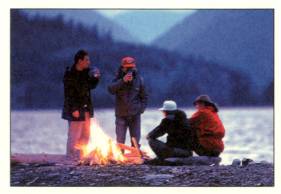

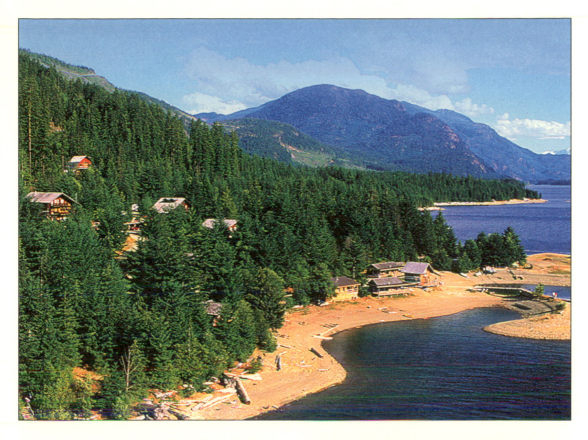

The resort is located on the shores of Upper Campbell Lake, with the towering mountains of the Strathcona Provincial Park in clear view. Accommodations consist of rooms in timber-framed chalets and private self-contained waterfront cabins. They also offer additional accommodations on Mount Washington for families and small groups. Delicious meals are served daily buffet-style and are available for purchase. Summer visitors can enjoy fresh local seafood and seasonal garden vegetables.

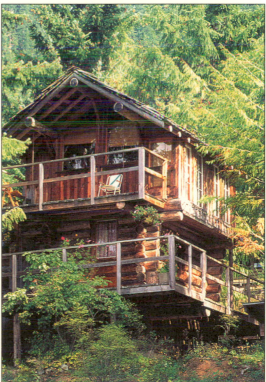

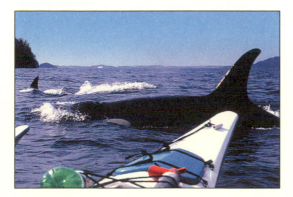

Three Bars Ranch

Cranbrook
British Columbia, CANADA

ACTIVITIES: Horseback riding, hiking, fly-fishing, river rafting, tennis, volleyball & swimming

PHONE: 877-426-5230 or 250-426-5230
WEB: www.ThreeBarsRanch.com
CAPACITY: 40 people: several log cabins
OPEN: Year-Round, 5 night minimum stay in summer

RATES: Around $1,600 USD per adult per week, $1,400 USD for children. Includes meals & ranch activities

LOCATION: 3 hours from Kalispell, MT, 300 miles (5 hours) from Calgary, AB

Three Bars Ranch has all the important features of a great guest ranch, plus many more. For starters, the location is unbeatable. Situated in a region known as the Kootenay Rockies, the area is packed full of wildlife, clear streams and breathtaking views. This serene wilderness setting provides the ideal location for fly-fishing, hiking, river rafting and scenic trail rides. The ranch also offers horseback riding lessons for beginners all the way up to the most advanced. There's even an indoor swimming pool!

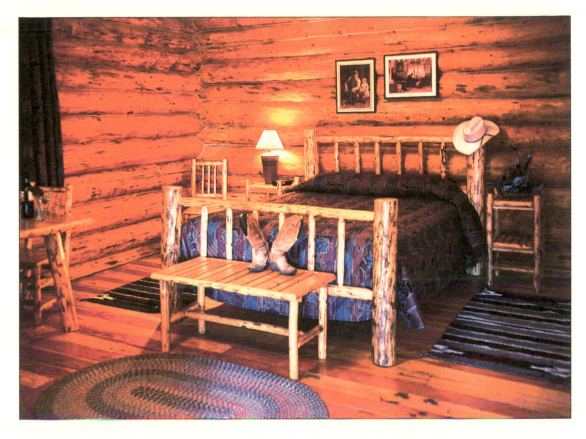

Your home while visiting the ranch will be a uniquely appointed log cabin with queen beds, a private bath, sitting area and sun chairs. They also offer special family units that have a separate bath and sleeping area for the kids, giving parents extra privacy.

In the evenings, you can sit around the campfire, hang out in the hot tub or try your hand at roping. For an authentic, upscale guest ranch that's located in the Canadian Rockies, *Three Bars* is an excellent choice!

Fairmont Kenauk at *Le Chateau Montebello*

Montebello
Quebec, CANADA

ACTIVITIES: Fishing, canoeing, kayaking, hiking, wildlife viewing & family excursions

PHONE: 800-257-7544 or 819-423-5573
WEB: www.Fairmont.com/Kenauk
CAPACITY: 100 people: chalets (up to 16 guests in each)
OPEN: Year-Round, 2 night minimum stay

RATES: Around $200-$300 USD per couple per day

LOCATION: 80 miles (1.5 hours) from Montreal, 390 miles (7 hours) from Boston, MA

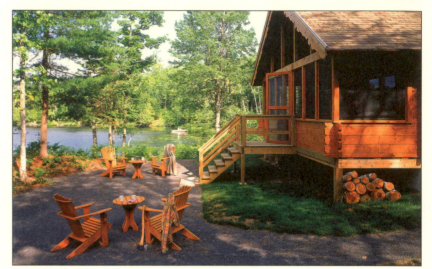

Originally created in 1674 as a 65,000-acre protected wilderness domain by the King of France, today's *Fairmont Kenauk at Le Chateau Montebello* continues to provide a sanctuary for wildlife and guests alike. "Kenauk" comes from the word "mukekenauk," meaning *turtle* in the language of the original inhabitants of the land, the Algonquins. The symbol for the resort is the turtle, which represents earth, longevity, healing, perseverance, tranquility, stability, and always the friendly companion.

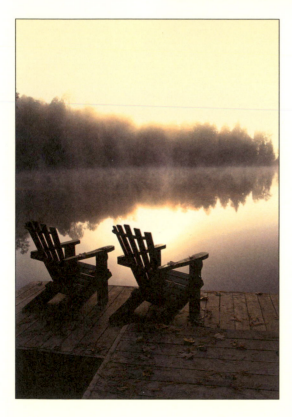

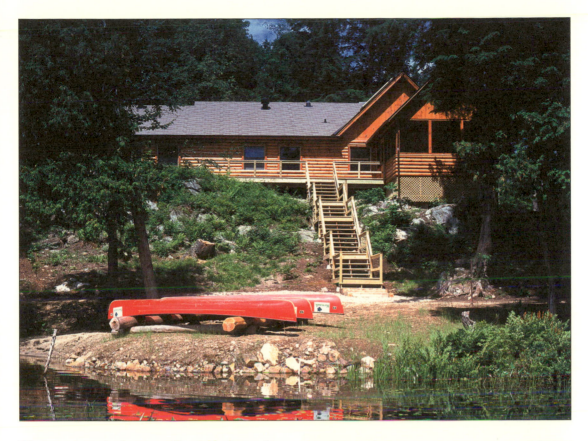

Upon your arrival, you will quickly learn that deer and other animals roam as freely as they did 200 years ago. Of course, it helps that the area is one of the continent's largest and most carefully protected wilderness habitats. With over 70 lakes and countless trails, you can fish, canoe or hike to your heart's content.

The spacious cabins come equipped with propane lights, refrigerator, stove, furnace, hot shower, indoor toilet and a screened porch. The resort has been awarded a four-star rating.

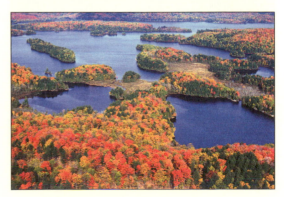

Forest House Eco Lodge

ACTIVITIES: Canoeing, hiking & ecology talks (discussions about edible & medicinal plants)

PHONE: 866-608-7344 or 306-635-2242
WEB: www.ForestHouse.ca
CAPACITY: 10 people: 2 cabins
OPEN: Summer only, 3 night minimum stay

RATES: Around $300 USD per person per day. Includes meals, use of canoes & float-plane ride to/from the lodge

LOCATION: 50 miles north of La Ronge

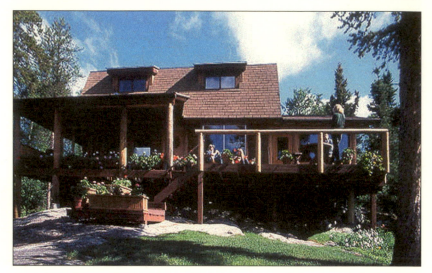

Tucked away on a remote boreal forest lake and surrounded by exquisite terraced gardens, *Forest House* is Saskatchewan's premiere solar-powered eco-lodge. Accessible only by float-plane or canoe, it is the only facility located on the pristine and picturesque Anonymous Lake.

Here, you will have the unique opportunity to get acquainted with ecologically sensitive living by joining in nature walks, forest ecology talks, and day trips exploring the neighboring Precambrian landscape by canoe.

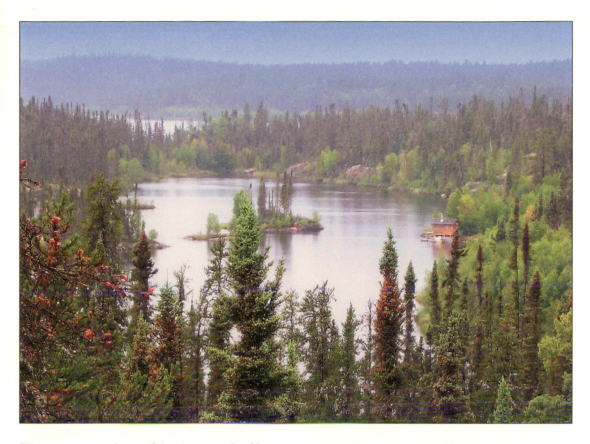

There are two beautiful cabins, each able to comfortably accommodate up to five guests. There's also a main house, which offers all the conveniences of modern living, including a full kitchen and baths.

Packages are all-inclusive. In addition to accommodations and guiding, hearty breakfasts, pack lunches and fabulous dinners are also included. The organic menu includes fresh veggies, wild rice, local fish and fresh fruit that's grown on-site.

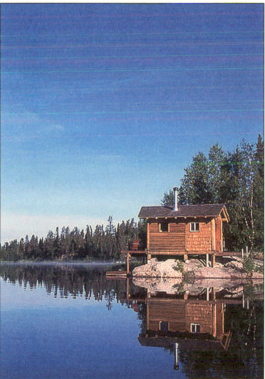

Tincup Wilderness Lodge

Tincup Lake / Whitehorse
Yukon Territory, CANADA

ACTIVITIES: Fishing, canoeing, kayaking, hiking, wildlife viewing & nature photography

PHONE: 604-762-0382
WEB: www.Tincup-Lodge.com
CAPACITY: 10 people: several cedar log cabins
OPEN: Mid June until mid Sept., 4 night minimum stay

RATES: Around $450-$500 USD per person per day. Includes meals, fishing gear, boats & float-plane ride to/from Whitehorse

LOCATION: N.W. Canada, fly into Whitehorse

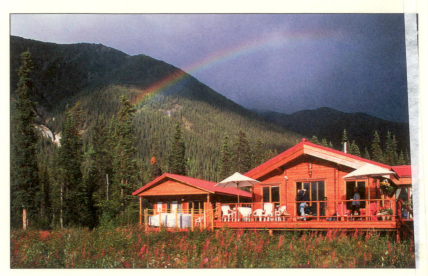

Located deep in the heart of the Yukon's Ruby Range, exciting adventure and luxuriously rustic accommodations are waiting for you at *Tincup Wilderness Lodge*. This remote, fly-in fishing lodge is an oasis of comfort surrounded by untouched wilderness. Although *Tincup* is famous for its fishing (especially lake trout and arctic grayling), they also offer excellent canoeing and kayaking. And for hikers, there are unlimited options, so remember to bring your energy and some good hiking shoes.

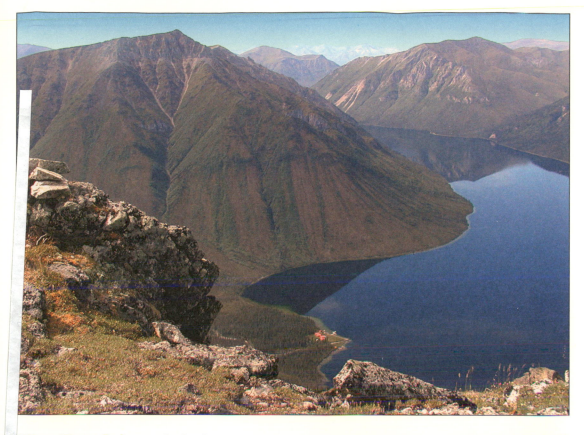

When *Tincup Lodge* was built about 15 years ago, no expense was spared. The main lodge features a dining room, bar, kitchen and large outdoor deck with hot tub. The food is amazing and the views from the lodge and guest cabins are out of this world. Each of the cabins has their own wood stove, covered veranda and private bathroom. Staying at *Tincup Wilderness Lodge* is a fabulous way to enjoy an extreme backcountry location without having to sacrifice comfortable amenities.

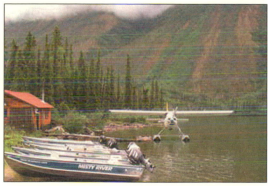

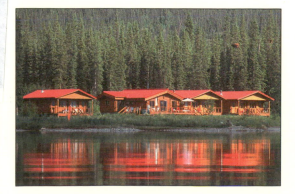

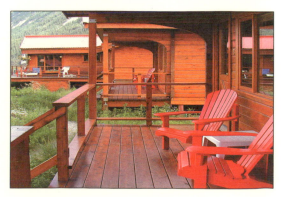

Wilderness Fishing Yukon

Coghlan Lake
Yukon Territory, CANADA

ACTIVITIES: Hiking & fishing for lake trout, whitefish, northern pike & arctic grayling

PHONE: 867-667-2846
WEB: www.FishingYukon.com
CAPACITY: 2-12 people per camp (9 camps in all)
OPEN: June through September, 5 night minimum stay

RATES: Around $300 USD per person per day. Includes round-trip air transportation from Whitehorse to camp

LOCATION: 60 air miles north of Whitehorse

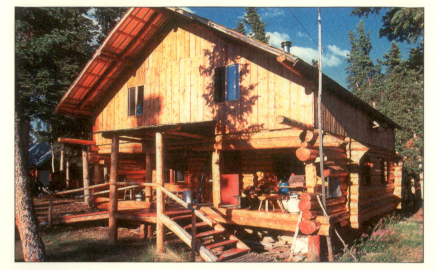

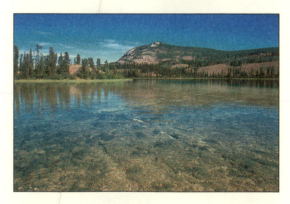

Listen up, fishermen! Sixty air miles north of Whitehorse, you will find some of the purest water in the Yukon. It is so clear that your lure may be visible from as deep as 40 feet. That may sound like a fish tale in itself, but it's true! *Wilderness Fishing Yukon* will fly you and your buddies to one of nine secluded lakes so you can spend your days playing pranks on each other and throwing in your lines for the big one. The fishing is great all summer, but June and July are outstanding.

All the camps are extremely remote and often shrouded by dense forest, but not to worry: They have all the essentials needed for a fun fishing vacation. One camp, The Lodge at Coghlan Lake, is a cozy three-bedroom log home with a comfortable living room, kitchen, several bedrooms and an indoor bathroom.

The fish are big: *real* big! Most guests catch at least one fish over 20 pounds, and some lake trout have even been known to weigh as much as 50 pounds. What are you waiting for?!

MEXICO

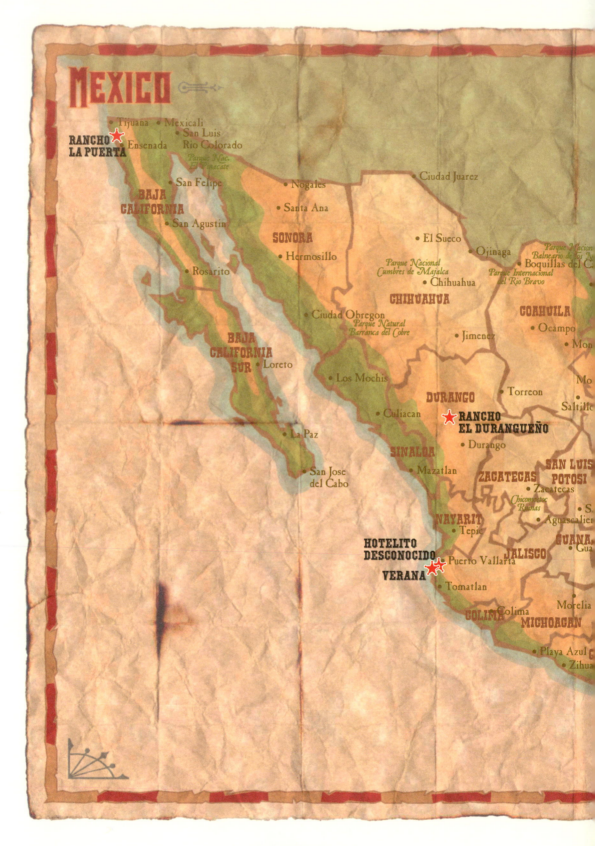

MEXICO

RANCHO LA PUERTA ★

Tijuana • Mexicali
• San Luis
Rio Colorado
Ensenada

Parque Nac.
El Pinacate

• San Felipe

BAJA CALIFORNIA

• San Agustin

• Rosarito

SONORA

• Hermosillo

• Nogales

• Santa Ana

• El Sueco

Parque Nacional
Cumbres de Majalca

• Chihuahua

CHIHUAHUA

• Ciudad Obregon

Parque Natural
Barranca del Cobre

BAJA CALIFORNIA SUR

• Loreto

• Los Mochis

• Jimenez

• Ciudad Juarez

• Ojinaga

Parque Nacional
Balneario de los N
• Boquillas del C

Parque Internacional
del Rio Bravo

COAHUILA

• Ocampo

• Mon

DURANGO

• Culiacan

• Torreon

Saltille

• La Paz

★ **RANCHO EL DURANGUEÑO**

• Durango

Mo

SINALOA

• San Jose
del Cabo

• Mazatlan

ZACATECAS

• Zacatecas

Chicomostoc
Ruinas

SAN LUIS POTOSI

• S.

• Aguascalien

NAYARIT

• Tepic

HOTELITO DESCONOCIDO

VERANA ★

• Puerto Vallarta

• Tomatlan

GUANA
Gua

JALISCO

• Morelia

COLIMA
Colima

MICHOACAN

• Playa Azul

• Zihua

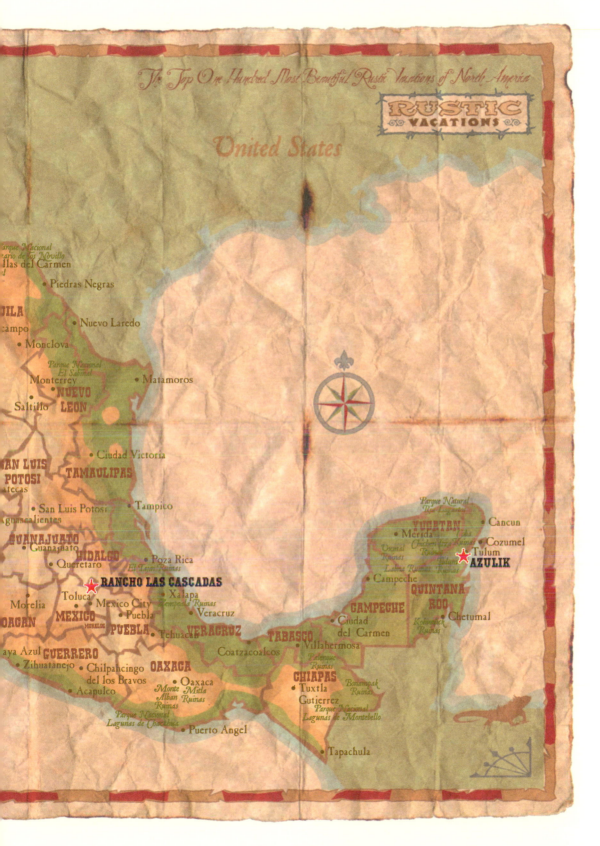

Rancho La Puerta

ACTIVITIES: Hiking, running, swimming, yoga, Pilates, tennis & spa treatments

PHONE: 800-443-7565 or 858-764-5500
WEB: www.RanchoLaPuerta.com
CAPACITY: 125 adults (14 years & up): 87 rooms
OPEN: Year-Round, 1 week minimum stay

RATES: Around $3,000 USD per person per week. Includes meals & classes

LOCATION: 45 miles (1 hour) southeast of San Diego

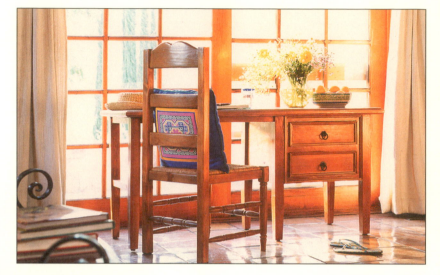

Rancho La Puerta is the ultimate fitness resort and spa. Taking full advantage of their beautiful surroundings, they focus specifically on making healthy people healthier, inside and out. Above all, they provide one very important element that is lacking in most of our lives: space. Space to breathe freely, relax, renew and reflect. With 3,000 acres of mountains and meadows, it won't take long to feel uplifted. Adding to the magical experience, most of their facilities are surrounded by beautiful world-class gardens.

Between the resort's 11 gyms, four tennis courts, three swimming pools, five hot tubs, running track and complete spa, you are certain to find something fun to do at any given moment. In addition, they offer hundreds of instructor-led clinics and classes.

The resort also maintains a six-acre organic farm on the property, where they grow vegetables, herbs and fruit. They even press their own olive oil. Rest assured, your meals will be as healthy as they are delicious!

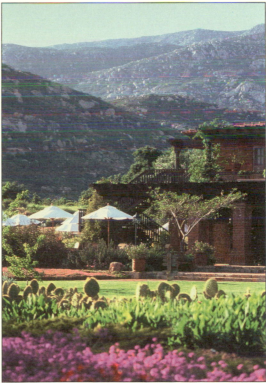

Rancho El Durangueño

ACTIVITIES: Horseback riding, mountain biking, fishing, archery, ping-pong & bird watching

PHONE: 011-52-81-8348-1040 or 1-956-242-4257
WEB: www.DurangoRanch.com
CAPACITY: 19 people in haciendas, 48 people in cabins
OPEN: Year-Round, 2 night minimum stay

RATES: Around $1,000 USD per day for 6 people in a luxury lodge, or $600 USD per day for 6 in log cabins. Includes meals & riding

LOCATION: 2 hours from the city of Durango

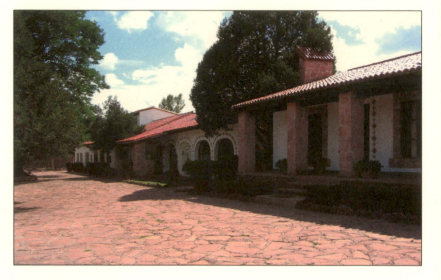

Situated at a comfortable altitude of 8,000 feet, *Rancho El Durangueño* proves that not everywhere in Mexico is unbearably hot. With an average temperature of 72 degrees Fahrenheit, the climate is mild and inviting year-round.

In addition to the ranch's first-class meals, service and accommodations, you will be utterly amazed by the activities. A few of the standouts are horseback riding, fishing, trapshooting, ping-pong, badminton and archery. There's even a driving range and putting green.

With more than 55,000 acres of majestic mountains, canyons, streams and lakes, the wildlife viewing is unbelievable. Along with white tail deer, mountain lions, bobcats and gray foxes, a huge variety of birds call the ranch home. Bird watching enthusiasts will be thrilled at the chance to see Gould's turkeys, quetzal and mountain trogons, Montezuma quail and the Sierra Madre sparrow. Better still, the world's largest woodpecker, the Imperial, was last seen in these very mountains.

Hotelito Desconocido

Cruz de Loreto
Jalisco, MEXICO

ACTIVITIES: Swimming, sailing, windsurfing, horseback riding & sea turtle releases (seasonal)

PHONE: 800-851-1143 or 011-52-322-281-4010
WEB: www.Hotelito.com
CAPACITY: 30 people: several bungalows
OPEN: Year-Round, 2 night minimum stay

RATES: Around $300-$700 USD per bungalow per day. Includes breakfast

LOCATION: 3 miles from Cruz de Loreto, 60 miles south of Puerto Vallarta

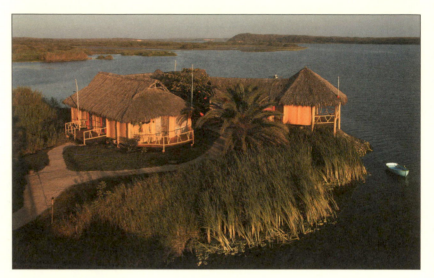

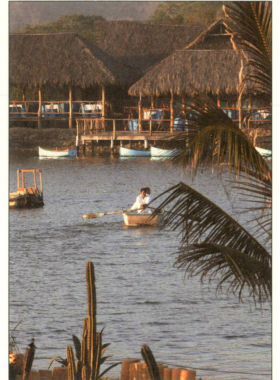

Designed to look and feel like an old Mexican fishing village, *Hotelito* is romance. From the gauze netting draped seductively over the beds to the dim flickering candlelight casting magical shadows on the walls, you will savor every moment of this fashionably primitive resort.

Creating unforgettable memories is their specialty. Imagine galloping for miles on a virgin beach at sunset or participating in the release of baby sea turtles from their protected nesting ground (seasonal). It is a fairy-tale world.

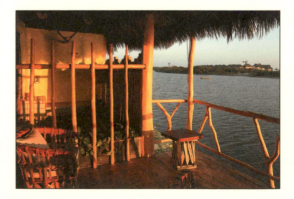

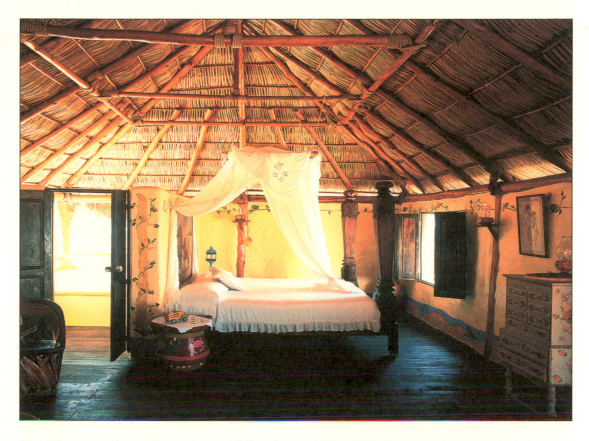

Raised up on stilts and complete with lovely bamboo showers, the bungalows are absolutely enchanting. The fact that there is no electricity actually enhances the experience. Cleverly disguised solar panels provide hot water and power to run the in-room cooling system: ceiling fans. At night, hundreds of candles create a dreamy illumination for the rooms and restaurant, while luminaries light the pathways that meander throughout the resort. Save *Hotelito* for someone very special.

Verana

ACTIVITIES: Jungle treks, spa treatments, fishing, swimming, snorkeling, whale watching & yoga

PHONE: 800-530-7176 or 310-360-0155
WEB: www.Verana.com
CAPACITY: 24 people: 8 private guest bungalows
OPEN: November through May, 5 night minimum stay

RATES: Around $300-$500 USD per bungalow per day. Around $80 USD per day for meals

LOCATION: About 1 hour from Puerto Vallarta via car, boat & then mule

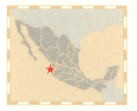

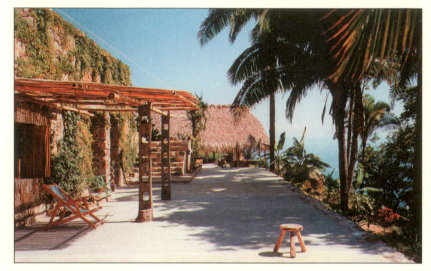

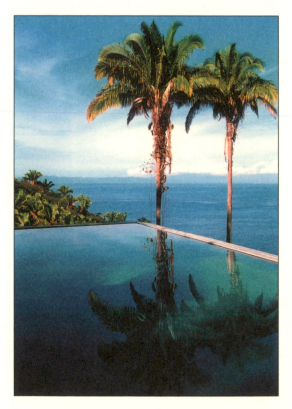

Overlooking Mexico's Pacific coast, this romantic mountaintop retreat will lead you on the path to complete, unrivaled relaxation. Prepare yourself for a jungle paradise where you can immerse yourself in yoga, spa treatments, nature hikes or just relaxing on the beach.

The intimate, private bungalows have been designed and decorated with a uniquely artistic blending of rustic and natural materials and contrasting modern amenities and accents. The colors of the rooms are warm and soothing.

Getting to the resort is a fun little adventure in itself. From Puerto Vallarta's airport, you'll take a short taxi ride to the Boca de Tomatlan Beach. From there, you'll jump on a boat for a quick trip to the small fishing village of Yelapa. Then it's just a short hike up a jungle path, while a mule carries your luggage and/or you.

Food is yet another highlight at *Verana*. Meals, served daily on the outdoor terrace, are prepared by a team of international chefs using the freshest and most authentic Mexican ingredients.

Rancho Las Cascadas

Near Tula & Jilotepec
State of Mexico, MEXICO

ACTIVITIES: Horseback riding (through meadows, rivers & small villages), swimming & relaxing

PHONE: 011-52-55-1248-9800 (direct from US or Canada)
WEB: www.RanchoMex.com
CAPACITY: 20 people: lodge rooms & guest houses
OPEN: Year-Round, 2 night minimum stay

RATES: Around $200–$250 USD per person per day. Includes meals, drinks & horseback riding

LOCATION: 50 miles (1 hour) north of Mexico City

The intimate setting of *Rancho Las Cascadas* offers unsurpassed warm hospitality and an appreciation for the quiet way of life in a small, authentic Mexican village. Aptly named for three spectacular waterfalls located next to the property, the area's wildflowers and sunsets are legendary. Situated at 7,500 feet above sea level, the ranch is generally a little cooler than the Mexico you are used to. Open year-round, this destination offers guests an especially memorable experience, each and every season.

The horseback riding is phenomenal! Nothing can prepare you for the stunningly beautiful and strikingly different array of desert plants and animals that you will see on your rides. And don't forget to pack your swimsuit, so you can take advantage of the refreshing swimming holes and relaxing Jacuzzi.

The hacienda-style guesthouses and rooms are built of handcrafted stone and decorated in a Mexican country-style with lots of attention to detail. The ranch even has high-speed Internet.

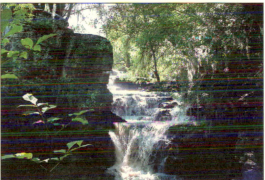

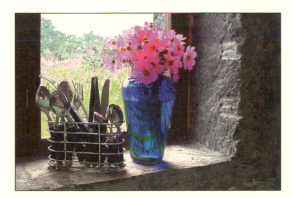

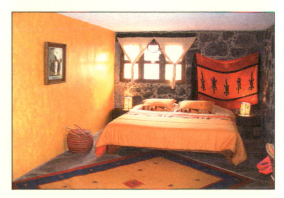

Azulik

Tulum
Quintana Roo, MEXICO

ACTIVITIES: Swimming, snorkeling, sea kayaking, wildlife viewing, jungle hikes & massages

PHONE: 877-532-6737 or 604-628-7077
WEB: www.Azulik.com
CAPACITY: 60 adults: 15 luxury hardwood villas
OPEN: Year-Round, no minimum stay

RATES: Around $250-$300 USD per villa per day

LOCATION: Fly into Cancun then take an arranged shuttle ride to the resort. Shuttle takes 1.5 hours

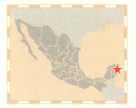

Extreme serenity is an understatement. There is absolutely nothing to disturb you. The only sounds you will hear are the birds chirping and the waves crashing. No phones or electricity, an adults-only atmosphere and a clothing-optional beach make *Azulik* the ideal romantic retreat.

The activities can be as exciting or relaxing as you desire. Take an early morning swim in the sea, get a massage, go kayaking or explore a coral reef. The more adventurous may enjoy a jungle hike in search of spider monkeys.

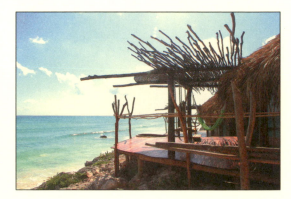

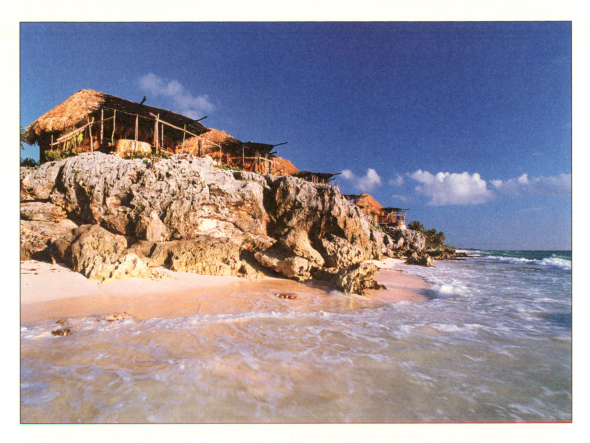

There are 15 beachfront villas, each with their own large deck and spectacular view of the Caribbean. Every villa has a king-size bed and a hanging queen bed. Although the primitive look and feel of the accommodations are what make the experience so special, don't worry: all villas have a bathroom, bathtub and hot water. There's even an outside sea-view bathtub in the common area. To order room service, all you have to do is place a little red flag outside your door. This is Caribbean living at its best!

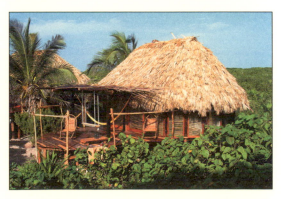

Now that you have
looked through the book
and picked out a few
choice places to visit, you
should really enjoy
the following pages of
fun and entertaining tidbits
of rustic information!

S'MORES & MORE!

HOW TO MAKE S'MORES

Ingredients: Hershey bars, graham crackers, marshmallows & a campfire

(1) Place a Hershey bar on a graham cracker
(2) Toast a marshmallow on a stick over a campfire
(3) Place the toasted marshmallow on the Hershey bar to melt the chocolate
(4) Cover with another graham cracker (optional)
(5) Eat and repeat! When you want another one, yell: "Gimme s'more!"

TWENTY QUESTIONS

One person thinks of an object; it can be anything. The other players start by asking: "Is it a Person, Place or Thing?" After that, they can ask any question about the object as long as it can be answered by a "yes" or a "no." The goal is to be the first person to figure out what the object is in less than 20 questions!

ALPHABET GAME

This game works best on road trips. Start with the letter "A," find a word that begins with an "A" on a sign, truck, building or license plate, say the word, and then move on to the next letter. You can do this as a competition or together as a family for the younger beginning readers. The first one to get to the letter "Z" is the winner!

I PACKED MY GRANDMOTHER'S SUITCASE

This is a game to test your memory. First you say, "I packed my grandmother's suitcase, and in it I packed a _____." In the blank, you say a word that starts with the letter "A." Then the next person says, "I packed my grandmother's suitcase, and in it I packed a _____ (repeat the word used for the letter "A") and a _____ (say a word that starts with the letter "B"). The game becomes more difficult as you go along, because you have to remember all of the words used for each letter of the alphabet. The first person to make a mistake loses.

WILDERNESS CONCEPTS TO PONDER

(1) Work is for people who don't know how to fish.

(2) When camping, always wear a long-sleeved shirt. It gives you something to wipe your nose on.

(3) The number of mosquitoes at any given location is inversely proportional to the amount of repellent that remains.

(4) When smoking a fish, never inhale.

HELPFUL HIKING TIPS

MOST IMPORTANTLY!

Tell someone where you are going and when you plan on returning.

BACKPACK ESSENTIALS

Water, rain jacket, map, compass, flashlight, matches, paper, writing pen, knife, sunscreen, whistle, food and first-aid kit. *Also:* Pack everything in Ziplock bags to keep them organized and dry. People can survive weeks without food but only a few days without water, so make sure to bring plenty of water.

BEST WAY TO KEEP FROM GETTING LOST

Stay on the trail!

IF YOU DO GET LOST

Kids: If you get separated from your group, stop and stay in one place, and yell or whistle until someone finds you. *Adults:* Stop, learn your surroundings, and be able to return to the last known point (pick something nearby that you can recognize, like a landmark, or build your own marker). Try and retrace your steps if possible. If you have to find or make a shelter, or gather firewood, do it before dark or before a storm comes, not during.

IF YOU CANNOT FIND YOUR WAY BACK

Get to a clear, open area and write out "HELP" or "SOS" with branches or rocks, so search helicopters can find you. Make a signal (fire by night and smoke by day). Other signals: artificial patterns such as tracks in the snow, a signal mirror or a flashlight.

AVOID GETTING STRUCK BY LIGHTNING

Lightning usually strikes the highest most-exposed object and you don't want to be that object. Get to lower ground and avoid open or exposed areas such as hills, ridges, fields, lakes or rivers. Also, avoid being around tall single standing objects such as solitary trees or rock spires: they serve as natural lightning rods. Although you don't ever want to seek shelter directly under a tree, an unexposed area within trees of uniform height or an area with low brush and bushes is alright.

HOW TO AVOID BEARS AND MOUNTAIN LIONS

Make lots of noise! They want to avoid you as much as you want to avoid them. While you are hiking, talk, sing, or wear a bear bell. If you do run into a bear or mountain lion, Do Not Run! Put your arms up and make yourself look as big as possible, then (very slowly) back away.

JOKES FOR THE KIDS

ICE FISHING

Ennis got up really early on Saturday morning to go ice fishing. He took his fishing pole, lucky hat, tent, chair and ice pick out onto the ice and began chipping a hole in the ice to fish through. All of a sudden, he heard a loud booming voice: "There Are No Fish Under the Ice!" He looked all around but didn't see anyone, so he continued to chip away. Then he heard the voice again, even louder: "There Are No Fish Under the Ice!" Whoa, maybe it's God, he thought. So he looked up toward the sky and said, "God, is that you?" There was no answer, so he started chipping away at the ice again. The voice boomed again: "There Are No Fish Under the Ice!" Then Ennis asked again, much louder, "God, is that you?" The voice answered, "No, you idiot, I'm the guy that runs the ice rink!"

FAST CAMP

As they pulled into the campsite, all the kids jumped out of the car, and like clockwork, quickly unloaded all the gear, equipment, coolers, etc. In a matter of seconds, they had the tent up and a good fire going. A camper next to them sat and watched in dismay. After a short time, he couldn't stand it anymore, so he walked over to the father and said, "Hey, neighbor, that certainly was an impressive display of teamwork." The father replied, "Thanks. It's rather simple, though. We have a rule: No one goes to the bathroom until camp is set up."

COW MECHANIC

A guy was driving through the country when his car just up and stopped. When he got out to fix it, a big ol' cow walked over to him and said, "Your trouble is probably with your spark plugs." Scared out of his wits, the man took off down the road running as fast as he could. He eventually came across a farmer and told him the story. "Was it a big black and white cow with a bit of a limp?" asked the farmer. "Yep, yep," the man replied. "Oh, that's just Mable, I wouldn't listen to her," said the farmer. "She doesn't know a thing about cars."

CHAPSTICK

A weathered cowboy comes riding up in a cloud of dust and parks his horse in front of the saloon. Before he goes into the bar, he kisses his horse on the rear. An old-timer sees this and asks, "Hey, cowboy, why the heck did ya kiss your horse's rear?" The cowboy replies, "Well, it's cuz I've got me some really bad chapped lips." "Say what?" says the old-timer. "You tellin' me kissin' a horse's rear will cure chapped lips?" "Heck no," says the cowboy, "but it sure keeps me from lickin' 'em!"

JOKES FOR THE KIDS

THE STRANGER

A strange cowboy rode into town and stopped at the saloon for a drink. When he was finished, he went back outside only to find that his horse had been stolen. He stormed back into the bar, flipped a silver dollar high up in the air with his thumb, then, like lightning, he spun his gun around and proceeded to shoot a hole in the coin before it hit the floor. The bar was dead silent. "Which one of you bums stole my horse?" he screamed out. No one answered. "Well, I'll tell ya what, I'm a gonna have one more whiskey, and if my horse ain't back outside by the time I'm finished, I'm gonna do what I done back in Texas...and I don't want to have to do what I done back in Texas!" At that moment, the whole bar ran out the door like a bunch of scared little girls. The stranger had another whisky, walked outside, and his horse was back! As he saddled up and was just about to ride out of town, an onlooker asked, "Hey, mister. What did ya do back in Texas?" The cowboy turned around and said, "I had to walk home!"

FAST FREDDY

Frank and Freddy were hunting one day when they spotted a huge grizzly about a hundred yards off. Before they knew it, the bear was running full speed towards them. Frank took off lickety-split, while Freddy calmly sat down, took out a pair of running shoes and put them on. Frank saw this and was wondering what the heck was going on, so he stopped, ran back and asked, "Why in the world are you putting on your running shoes? You don't really think you can outrun that bear with those, do ya?" Freddy answered back, "I don't have to outrun the bear, I just have to outrun YOU!"

BUGABOO

One day, a farmer was milking his cow when he noticed a fly buzzing up and down and all around. He didn't think much of it until he saw the fly diving straight at him like a rocket. He ducked out of the way just in time, but the fly came back even faster. This time, he ducked out of the way again, but the darn fly kept going and flew right into his cow's ear. Yikes! he thought. Poor Betsy, she can't like that! A second later, the fly squirted into his bucket. Just then, his wife came in after hearing all the ruckus, and asked, "Earl, what on earth is goin' on in here?" The farmer looked at her in amazement, pointed to the cow and said, "Honey, you ain't gonna believe this, but a crazy fly came out of nowhere and flew into Betsy's ear." "Say what?" she said. "Yep, that thing went in one ear and out the udder!"

FRIDAY

Question: How could a cowboy who rode into town on Friday, leave on Friday, if it was only three days later? *Answer:* His horse's name is Friday.

CHARLIE

One rainy day, a city guy was driving down a muddy country road when he slid off into the ditch. Just a short time later, a local farmer was passing by and offered to pull him out with his big Clydesdale, Charlie. As soon as he had Charlie hitched up to the car, he yelled out, "Pull, Chief. Pull!" But Charlie didn't move an inch. Then the farmer hollered, "Pull, Scotty. Pull!" Charlie still didn't budge. Once more the farmer commanded, "Pull, Ollie. Pull!" Still nothing. Then the farmer finally said, "Pull, Charlie. Pull!" And the horse easily pulled the car out of the ditch. The city guy was happy, but he couldn't figure out why the heck the farmer had called his horse by the wrong name all those times, so he asked him. The farmer said, "Well, it's like this. Charlie's blind as a bat, and if he thought he was the only one pulling, he wouldn't even try!"

SMART PILLS

One day, a father took his son rabbit hunting. After a couple of hours, they finally came across some rabbit tracks. Little round pellets were scattered all around the tracks, so the son said to his father, "Dad, what are those?" The father replied, "Those are smart pills. Why don't you try a couple." So the little kid grabbed a handful and put them in his mouth. "Yuk, gross! These taste horrible!" The father replied, "See, you're getting smarter already."

A MONK THAT COOKS

It was raining cats and dogs when a poor fellow's car broke down. Luckily, though, he was not far from a monastery. He walked over to the big temple and knocked on the door. A nice plump monk invited him in to have dinner and to spend the night. The motorist gladly accepted. That evening, the man had an excellent dinner of fish and chips. He decided that he really had to compliment the chef. Entering the kitchen, the man asked the chef, "Are you the fish friar?" "No," the man replied, "I'm the chip monk."

NOT THAT SMART, BUT...

One Sunday, a cowboy went to church. Upon entering, he noticed that he and the preacher were the only ones there. The preacher asked the cowboy if he wanted him to go ahead and preach. The cowboy said, "I'm not that smart, but if I went to feed my cattle and only one showed up, I'd feed him." So the preacher began his sermon. One hour passed, then two hours, then three hours. The preacher finally finished and came down to ask the cowboy how he had liked the sermon. The cowboy answered slowly, "Well, I'm not that smart, but if I went to feed my cattle and only one showed up, I sure as heck wouldn't feed him all the hay."

ADULT HUMOR

TWO WORMS

One afternoon, two worms were crawling through the grass. The male worm said to the sexy female worm, "Why don't we go back to your place?" The female worm said, "Sounds good to me!" So, the two worms went back to her place. Then the male worm noticed that the female worm was wearing a wedding ring. The male worm said, "I'm sorry, darlin', but I don't do this sort of thing with married worms." The female worm replied, "Don't worry. My husband isn't coming home." The male worm asked, "How do you know that for sure?" The female worm answered, "Well, he got up early this morning and went fishing."

EXPENSIVE FISH

Two good ol' boys went on a fishing trip. They didn't have any supplies, so they had to rent it all: a cabin by a lake, a boat, fishing rods, lures and bait. They even had to rent a truck to pull the boat. They spent a small fortune on all the equipment, but they were really excited to get there and get started. The first day they went fishing, they didn't catch a thing. The second and third day were the same. Then, just as they were leaving, they threw a line in one last time and got a tiny little fish. As they were driving home, one of the guys turned to the other and said, "Ya know, that really stinks. Do you realize that this one lousy fish cost us nearly a thousand bucks?" The other guy replied, "Holy cow! It's a damn good thing we didn't catch any more!"

HUNGRY SQUIRRELS

Stuart went out to Georgia to go hunting with his brother-in-law, Hank. Stuart had never been hunting before, so Hank agreed to take him only if he did EXACTLY what he asked him to. The guys got all their gear together and headed off into the woods. Hank told Stuart to sit down on a certain log near a deer trail and to wait quietly until a deer happened along. Hank was going to go to another good spot, but he would be back to check on him in a little while. After a couple hours, Hank heard all kinds of yelling and screaming as Stuart came running down the trail. "What's wrong with you?" he asked Stuart. "Why didn't you stay where I told you to?" Stuart, nearly out of breath, replied, "Well, when the grizzly bear sharpened his claws on the tree right next to me, I didn't move an inch. When the mountain lion sat on the rock just twenty feet away, I didn't move. But when the two squirrels climbed into my lap, and one said to the other, 'Shall we take them with us or eat them here?', well I just couldn't stand it any more!"

WILDERNESS ZEN

If a man is alone in the forest, and there are no women around, is he still wrong?

GHOST STORIES

SEVEN BARNS

About 50 years ago, there was a real nice farmer who had married his childhood sweetheart. They began having children, and before they knew it, they had a whole house full of kids (seven to be exact), and the farmer built seven big red barns, one for each of his kids. Things were going great. The kids were having the time of their lives, picking corn and playing with all the farm animals. Then, for some unknown reason, they started getting sick. Not just sick with a cold, but really sick. One by one, the children died until there was only one child left. The farmer decided to bury each of his kids under the barns that he had built for them. It was a horrible time. Both he and his wife were so sad that they could hardly get out of bed in the mornings. They kept reminding themselves, "At least we have one child left, at least we have one child left." Then, one dreary Sunday morning, just as they were about to leave to go to church, the farmer heard his wife screaming from the child's room. He could tell from her loud screaming that it could only be one thing: His last remaining child had died. The next day, he took the body and buried it under the very last barn. Then, with a heavy heart, he set every barn on fire except the last one. In the last one, he threw two ropes up and over one of the rafters and he and his wife hung themselves. It is said that the last big red barn still stands today, and when there is a full moon, you can see the shadows of the man and his wife swinging in the barn, still holding hands.

THE SCHOOL BUS

One hot summer day, not too long ago, a school bus full of children was heading down a country road. It was a Friday, and all the kids were happy to get home and start enjoying the weekend. The bus was rather old and not in very good condition. Eventually, they came to a small hill and started up it. As the hill got steeper, the bus began going slower and slower until it actually stopped. The problem is that the bus had stopped directly on top of some railroad tracks. The driver couldn't back up because the brakes were just as bad as the engine, so if he started going backwards down the hill, he might not be able to stop the bus. He got out to take a look at the engine and see if he could get it started again. As he was looking at the engine, he heard a train whistle, way off in the distance. Oh, no, he thought, I've got to get this bus off the tracks, even if I have to go back down the hill. He ran to the door of the bus, but it was locked. The kids were playing a joke on him and had locked him out. He screamed at the top of his lungs for them to open the door, but they were all laughing so hard they couldn't hear a word he said. As the train rounded the corner, the driver could only sit and watch in horror as the train smashed into the bus, killing all of the children. It is said that if you park your car on some railroad tracks on a slight hill, leave it in neutral and wait long enough, your car will be pushed off the tracks. If your car is dusty enough, you may see little hand prints on the back of it.

GIDDY-UP COWBOY!

PACKIN' FOR THE RANCH

Suggested stuff to bring along when going to a ranch: A wide-brimmed hat (preferably a cowboy hat) with a stampede string (that's the string that goes around your neck and keeps your hat from fallin' off); cowboy boots (any narrow boots with a heel will do, but cowboy boots look much cooler); jeans (that are worn and faded; holes are good); long-sleeved shirts (to guard against the sun and scratches from branches); sunglasses; and don't forget sun screen and bug spray (very important)!

LOOK LIKE A REAL COWBOY

If you are going to a ranch and you want to look extra-cool (like a real cowboy), your clothes need to be somewhat dirty and smelly. The easiest way to accomplish this is to throw all your clothes outside in the yard for a week or two before you take off for the ranch. Don't forget to kick 'em around in the dirt every once in a while and hope for rain.

YO DUDE!

What is a "dude" as in a "dude ranch" (not to be confused with a surfer dude)? A dude is pretty much anybody that doesn't really work on a ranch. The term originally came from fancy-dressed city folk who went out West for vacations.

A LITTLE HORSE SENSE

If you don't know much about horses, here's a quick overview: Horses are big strong animals, but they scare very easily, so try not to make any quick movements around them. They have amazing peripheral vision, but they can't see directly in front or behind without turning their head. Therefore, it is always best to approach a horse from its side. And, whatever you do, don't go behind a horse without letting him know you are there. If you do, you might get kicked through the barn, shortening your vacation. Always walk at least six feet away from his rear (out of kicking range) or walk right next to him (too close for a kick to do any serious damage), touching his rear with your hand as you go around behind.

HOW TO SPOT A REAL COWBOY

Question: If there are three people in the front seat of a pickup truck, how do you know which one is the real cowboy? *Answer:* Easy: The real cowboy is the one in the middle. He picked that spot so he doesn't have to drive and he doesn't have to get out and open the gate.

INDEX

ADULTS ONLY
Azulik, MEX - 226
Colorado Cattle Co., CO - 50
Flying A Ranch, WY - 154
Lake Placid Lodge, NY - 114
Rancho La Puerta, MEX - 216

CANOEING / KAYAKING
Afognak Lodge, AK - 16
Averill's Flathead Lake, MT - 90
Azulik, MEX - 226
Birches Resort, ME - 78
Bradford Camps, ME - 80
Caribou Lodge, AK - 20
Costanoa Coastal Lodge, CA - 42
Elk Lake Lodge, NY - 112
Fairmont Jasper Park, AB - 168
Fairmont Kenauk, QC - 204
Forest House Eco Lodge, SK - 206
Guest House Cottages, WA - 148
King Pacific Lodge, BC - 186
Lake of the Woods, OR - 126
Mountain Springs, WA - 150
Nature Trails Lodge, BC - 192
Papoose Creek Lodge, MT - 94
Paradise Lodge, AB - 172
Rebel Hill Ranch, OK - 124
Sadie Cove Lodge, AK - 24
Strathcona Park Lodge, BC - 200
Timberlock, NY - 116
Tincup Lodge, YT - 208
Weasku Inn, OR - 132

CATTLE DRIVES
4D Longhorn Ranch, ID - 70
Colorado Cattle Co., CO - 50
Double JJ Ranch, MI - 82
Hideout at Flitner, WY - 156

DOGSLEDDING
Caribou Lodge, AK - 20
Fairmont Jasper Park, AB - 168

EXTREMELY REMOTE
Amiskwi Lodge, BC - 174
Blackfish Lodge, BC - 176
Bradford Camps, ME - 80
Caribou Lodge, AK - 20
Crazy Bear Lake Lodge, BC - 178
Forest House Eco Lodge, SK - 206
Golden Alpine Holidays, BC - 182
King Pacific Lodge, BC - 186
Kootenay Experience, BC - 190
Nature Trails Lodge, BC - 192
Purcell Mtn. Lodge, BC - 196
Sorcerer Lodge, BC - 198
Tincup Lodge, YT - 208
Wilderness Fishing, YT - 210

FISHING
320 Guest Ranch, MT - 86
Afognak Lodge, AK - 16
Alisal Guest Ranch, CA - 40
Alpine Village, AB - 166
Averill's Flathead Lake, MT - 90
Bear Track Inn, AK - 18

Blackfish Lodge, BC - 176
Bradford Camps, ME - 80
Coulter Lake Ranch, CO - 52
Cow Creek Ranch, NM - 102
Crazy Bear Lake Lodge, BC - 178
Dry Island, NY - 110
Echo Valley Ranch, BC - 180
Elk Lake Lodge, NY - 112
Fairmont Kenauk, QC - 204
Flying A Ranch, WY - 154
Indian Creek Ranch, ID - 72
Island Lake Lodge, BC - 184
King Pacific Lodge, BC - 186
King Salmon Resort, BC - 188
Lazy L & B Ranch, WY - 158
Lodge at Red River, UT - 140
Nature Trails Lodge, BC - 192
North Fork Ranch, CO - 58
Olallie Lake Resort, OR - 128
Papoose Creek Lodge, MT - 94
Paradise Lodge, AB - 172
Pitt River Lodge, BC - 194
Resort at Paws Up, MT - 96
Smith Fork Ranch, CO - 60
Three Bars Ranch, BC - 202
Waterfall Resort, AK - 26
Weasku Inn, OR - 132
Wilderness Fishing, YT - 210
Wit's End Guest Ranch, CO - 68

GOLF
Alisal Guest Ranch, CA - 40
Double JJ Ranch, MI - 82
Fairmont Jasper Park, AB - 168
Grand View Lodge, MN - 84
Guest House Cottages, WA - 148
Lajitas, The Hideout, TX - 136
Weasku Inn, OR - 132

HIKING / BACKPACKING
Abbott Valley, MT - 88
Alta Lakes Observatory, CO - 48
Amiskwi Lodge, BC - 174
Azulik, MEX - 226
Caribou Lodge, AK - 20
Crazy Bear Lake Lodge, BC - 178
Echo Valley Ranch, BC - 180
Elk Lake Lodge, NY - 112
Evergreen Lodge, CA - 44
Fairmont Kenauk, QC - 204
Forest House Eco Lodge, SK - 206
Golden Alpine Holidays, BC - 182
Hidden Treasure Yurts, CO - 56
Highland Ranch, CA - 46
Holiday on Horseback, AB - 170
Inn at Cedar Falls, OH - 122
Island Lake Lodge, BC - 184
King Pacific Lodge, BC - 186
Kootenay Experience, BC - 190
Lake of the Woods, OR - 126
Moose Meadow Lodge, VT - 144
Nature Trails Lodge, BC - 192
Olallie Lake Resort, OR - 128
Out 'n' About Treesort, OR - 130
Paradise Lodge, AB - 172
Phantom Ranch, AZ - 32

Purcell Mtn. Lodge, BC - 196
Rancho La Puerta, MEX - 216
Rye Creek Lodge, MT - 98
Sorcerer Lodge, BC - 198
Sorrel River Ranch, UT - 142
Sperry Chalet, MT - 100
Strathcona Park Lodge, BC - 200
Sun Valley Trekking, ID - 74
Three Sisters Log Cabin, VA - 146
Tincup Lodge, YT - 208
Turnstone Log Cabins, NC - 118
Verana, MEX - 222

HORSEBACK RIDING
320 Guest Ranch, MT - 86
4D Longhorn Ranch, ID - 70
Alisal Guest Ranch, CA - 40
Averill's Flathead Lake, MT - 90
Colorado Cattle Co., CO - 50
Coulter Lake Ranch, CO - 52
Cow Creek Ranch, NM - 102
Double JJ Ranch, MI - 82
Echo Valley Ranch, BC - 180
Elkhorn Ranch, MT - 92
Fairmont Jasper Park, AB - 168
Flying A Ranch, WY - 154
Hacienda del Cerezo, NM - 104
Heartland Country, OH - 120
Hideout at Flitner, WY - 156
Highland Ranch, CA - 46
Holiday on Horseback, AB - 170
Hotelito Desconocido, MEX - 220
Indian Creek Ranch, ID - 72
Lajitas, The Hideout, TX - 136
Lazy L & B Ranch, WY - 158
Mountain Springs, WA - 150
N Bar Ranch, NM - 106
North Fork Ranch, CO - 58
Papoose Creek Lodge, MT - 94
Rancho de la Osa, AZ - 34
Rancho El Durangueno, MEX - 218
Rancho Las Cascadas, MEX - 224
Rebel Hill Ranch, OK - 124
Resort at Paws Up, MT - 96
Smith Fork Ranch, CO - 60
Sorrel River Ranch, UT - 142
Tanque Verde Ranch, AZ - 36
Tarryall River Ranch, CO - 62
Three Bars Ranch, BC - 202
Timberlock, NY - 116
Trail Creek Ranch, WY - 160
Twin Peaks Ranch, ID - 76
White Stallion Ranch, AZ - 38
Wilderness Trails Ranch, CO - 64
Wind River Ranch, CO - 66
Wit's End Guest Ranch, CO - 68

MOUNTAIN BIKING
4D Longhorn Ranch, ID - 70
Echo Valley Ranch, BC - 180
Evergreen Lodge, CA - 44
Paradise Lodge, AB - 172
Pipe Creek Ranch, TX - 138
Rancho El Durangueno, MEX - 218
Resort at Paws Up, MT - 96
Tanque Verde Ranch, AZ - 36

INDEX

PACK TRIPS (horseback)
Cow Creek Ranch, NM - 102
Holiday on Horseback, AB - 170
North Fork Ranch, CO - 58
Resort at Paws Up, MT - 96
Tarryall River Ranch, CO - 62
Twin Peaks Ranch, ID - 76

PET FRIENDLY
320 Guest Ranch, MT - 86
Abbott Valley, MT - 88
Alta Lakes Observatory, CO - 48
Catskills Retreat Cabin, NY - 108
Colorado Cattle Co., CO - 50
Heartland Country, OH - 120
Highland Ranch, CA - 46
Justin Trails Resort, WI - 152
Lajitas, The Hideout, TX - 136
Olallie Lake Resort, OR - 128
Rye Creek Lodge, MT - 98

RIVER RAFTING
Abbott Valley, MT - 88
Alpine Village, AB - 166
Birches Resort, ME - 78
North Fork Ranch, CO - 58
Paradise Lodge, AB - 172
Sadie Cove Lodge, AK - 24
Sorrel River Ranch, UT - 142
Tarryall River Ranch, CO - 62
Three Bars Ranch, BC - 202
Twin Peaks Ranch, ID - 76

ROMANTIC
Azulik, MEX - 226
Catskills Retreat Cabin, NY - 108
Costanoa Coastal Lodge, CA - 42
Dry Island, NY - 110
Dunton Hot Springs, CO - 54
Guest House Cottages, WA - 148
Hacienda del Cerezo, NM - 104
Highland Ranch, CA - 46
Hotelito Desconocido, MEX - 220
Justin Trails Resort, WI - 152
Lake Placid Lodge, NY - 114
Three Sisters Log Cabin, VA - 146
Turnstone Log Cabins, NC - 118
Verana, MEX - 222
Weasku Inn, OR - 132

SKIING (backcountry)
Alta Lakes Observatory, CO - 48
Amiskwi Lodge, BC - 174
Golden Alpine Holidays, BC - 182
Hidden Treasure Yurts, CO - 56
Island Lake Lodge, BC - 184
Kootenay Experience, BC - 190
Purcell Mtn. Lodge, BC - 196
Sorcerer Lodge, BC - 198
Sun Valley Trekking, ID - 74

SKIING (cross-country)
320 Guest Ranch, MT - 86
Abbott Valley, MT - 88
Alta Lakes Observatory, CO - 48
Amiskwi Lodge, BC - 174

Birches Resort, ME - 78
Caribou Lodge, AK - 20
Coulter Lake Ranch, CO - 52
Double JJ Ranch Resort, MI - 82
Fairmont Jasper Park, AB - 168
Hidden Treasure Yurts, CO - 56
Justin Trails Resort, WI - 152
Kootenay Experience, BC - 190
Lake of the Woods, OR - 126
Lake Placid Lodge, NY - 114
Moose Meadow Lodge, VT - 144
Mountain Springs, WA - 150
Purcell Mtn. Lodge, BC - 196
Resort at Paws Up, MT - 96
Sorcerer Lodge, BC - 198
Three Sisters Log Cabin, VA - 146

SNOWMOBILING
320 Guest Ranch, MT - 86
Alta Lakes Observatory, CO - 48
Birches Resort, ME - 78
Double JJ Ranch Resort, MI - 82
Fairmont Jasper Park, AB - 168
Lake of the Woods, OR - 126
Moose Meadow Lodge, VT - 144
Mountain Springs, WA - 150
Resort at Paws Up, MT - 96

SPA TREATMENTS
Azulik, MEX - 226
Cow Creek Ranch, NM - 102
Dunton Hot Springs, CO - 54
Echo Valley Ranch, BC - 180
Grand View Lodge, MN - 84
Island Lake Lodge, BC - 184
King Pacific Lodge, BC - 186
Lajitas, The Hideout, TX - 136
Rancho La Puerta, MEX - 216
Resort at Paws Up, MT - 96
Verana, MEX - 222

SUPERVISED CHILDREN'S PROGRAMS
Averill's Flathead Lake, MT - 90
Coulter Lake Ranch, CO - 52
Double JJ Ranch, MI - 82
Elkhorn Ranch, MT - 92
Island Lake Lodge, BC - 184
North Fork Ranch, CO - 58
Tarryall River Ranch, CO - 62
Wilderness Trails Ranch, CO - 64

SWIMMING POOL
Colorado Cattle Co., CO - 50
Coulter Lake Ranch, CO - 52
Double JJ Ranch, MI - 82
Fairmont Jasper Park, AB - 168
Grand View Lodge, MN - 84
Hotelito Desconocido, MEX - 220
Lajitas, The Hideout, TX - 136
Out 'n' About Treesort, OR - 130
Rancho La Puerta, MEX - 216
Sorrel River Ranch, UT - 142
Tanque Verde Ranch, AZ - 36
Tarryall River Ranch, CO - 62
Three Bars Ranch, BC - 202

Trail Creek Ranch, WY - 160
Twin Peaks Ranch, ID - 76
Verana, MEX - 222
White Stallion Ranch, AZ - 38
Wilderness Trails Ranch, CO - 64

TENNIS
Alisal Guest Ranch, CA - 40
Fairmont Jasper Park, AB - 168
Grand View Lodge, MN - 84
Hacienda del Cerezo, NM - 104
Highland Ranch, CA - 46
Lajitas, The Hideout, TX - 136
Rancho La Puerta, MEX - 216
Tanque Verde Ranch, AZ - 36
Three Bars Ranch, BC - 202
White Stallion Ranch, AZ - 38
Wit's End Guest Ranch, CO - 68

WILDLIFE VIEWING
Abbott Valley, MT - 88
Afognak Lodge, AK - 16
Alpine Village, AB - 166
Amiskwi Lodge, BC - 174
Azulik, MEX - 226
Bear Track Inn, AK - 18
Blackfish Lodge, BC - 176
Bradford Camps, ME - 80
Caribou Lodge, AK - 20
Costanoa Coastal Lodge, CA - 42
Cow Creek Ranch, NM - 102
Crazy Bear Lake Lodge, BC - 178
Fairmont Kenauk, QC - 204
Golden Alpine Holidays, BC - 182
Hidden Treasure Yurts, CO - 56
Holiday on Horseback, AB - 170
King Pacific Lodge, BC - 186
King Salmon Resort, BC - 188
Kootenay Experience, BC - 190
Lake of the Woods, OR - 126
Nature Trails Lodge, BC - 192
Papoose Creek Lodge, MT - 94
Purcell Mtn. Lodge, BC - 196
Rancho El Durangueno, MEX - 218
Rye Creek Lodge, MT - 98
Sadie Cove Lodge, AK - 24
Sorcerer Lodge, BC - 198
Sperry Chalet, MT - 100
Sun Valley Trekking, ID - 74
Tincup Lodge, YT - 208
Twin Peaks Ranch, ID - 76
Waterfall Resort, AK - 26
Weatherbury Farm, PA - 134
Wilderness Fishing, YT - 210

WORKING CATTLE RANCH
Colorado Cattle Co., CO - 50
Hideout at Flitner, WY - 156
N Bar Ranch, NM - 106
White Stallion Ranch, AZ - 38

YOGA
Costanoa Coastal Lodge, CA - 42
Highland Ranch, CA - 46
Rancho La Puerta, MEX - 216
Verana, MEX - 222

PHOTO CREDITS

Abbott Valley Homestead, Montana
Small Stream - Marion Foley
Little Barn (bottom right) - Marion Foley

Averill's Flathead Lake Lodge, Montana
South Lodge - Jeff Goodman
Trail Rides - Jeff Goodman
Aerial - Jeff Goodman
Lobby - Jeff Goodman
Cabin Interior - Jeff Goodman

Azulik, Quintana Roo, Mexico
Photos by - Mark Squires & Mick Slivecko

Caribou Lodge, Alaska
Jumping Dog (large & top) - Randy Kerr
Dog Mushers (bottom right) - Randy Kerr

Elk Lake Lodge, New York
Photos by - Mavis Miller, Virginia
Weinland and Gary Randorf

Evergreen Lodge, California
Photos by - Jae Feinberg

Flying A Ranch, Wyoming
Four Cowboys in a Row - Melissa Cliver

Golden Alpine Holidays, British Columbia
Lodge on Lake, Summer (first photo)
- Peter Haas

Guest House Log Cottages, Washington
Photos by - Keith Lazelle

Indian Creek Ranch, Idaho
Fall Colors Fishing (large image)
- Steve Bly
Three Riders - Steve Bly

The Inn at Cedar Falls, Ohio
Hammock - Jim Crotty
Waterfall - Jim Crotty

Justin Trails Resort, Wisconsin
Barn & Field on 2nd Page - Allyson &
Josh Johnson

Lake Placid Lodge, New York
Red Room - Gary Hall
Lodge by Blue Water - Gary Hall
Outdoor Fireplace - Kindra Clineff
Living Room - Gary Hall
Bedroom with Deck - Gary Hall

Sorcerer Lodge, British Columbia
Hikers Silouetted (Moraine Walk)
- Chic Scott
Looking at Venlego Lake - Daniel Bonsi
Single Skier (White Russian Col)
- Jon Walsh

Sperry Chalet, Montana
Foggy Chalet & Small Chalet (first page)
- Ben Hayes

Timberlock, New York
Boy on Rope Swing - John Dolan

Verana, Jalisco, Mexico
Porch & Stool - Verana
Pool & Palms - Verana
Beautiful Sink - Jae Feinberg
Palm with Bananas - Jae Feinberg
Bedroom with Netting
- Dominique Vorillon
Chair & Pottery - Jae Feinberg
Columns & Trees - Jae Feinberg